Arthur Szyk

Steven Luckert

United States Holocaust Memorial Museum
Washington, D.C.

The publication of this volume was made possible in part by the support of the Abramson Family Foundation, Inc., Anne and Ronald Abramson, and the Lester Robbins and Sheila Johnson Robbins Temporary and Traveling Exhibition Fund. Published in association with the exhibition *The Art and Politics of Arthur Szyk*, held at the United States Holocaust Memorial Museum, Washington, D.C., April 10 to October 14, 2002.

Library of Congress Cataloging-in-Publication Data

Luckert, Steven.
The art and politics of Arthur Szyk / Steven Luckert.
p. cm.
ISBN 0-89604-708-3
1. Szyk, Arthur, 1894–1951—Exhibitions.
2. Jews in art—Exhibitions. I. Szyk, Arthur, 1894–1951. II. Title.
ND3039.S98 A4 2002
745.6'7'092—dc21 2001007066

Project Director: Stephen Goodell
Editor: Edward Phillips

Publications Director: Mel Hecker
Production Editor: Mariah Keller
Art Director: Lea Caruso
Production Manager: Dwight Bennett

Project Coordinator: Laura Surwit
Project Assistance: Nancy Gillette, Gregory Naranjo
Photography: Max Reid

Book Design: Studio A, Alexandria, Va.
Typeset in Eureka

Printed in Canada by Friesens Corp.

Page ii:
Self-portrait, 1941
Pen and ink on paper
Rinjiro Sodei, Japan

CONTENTS

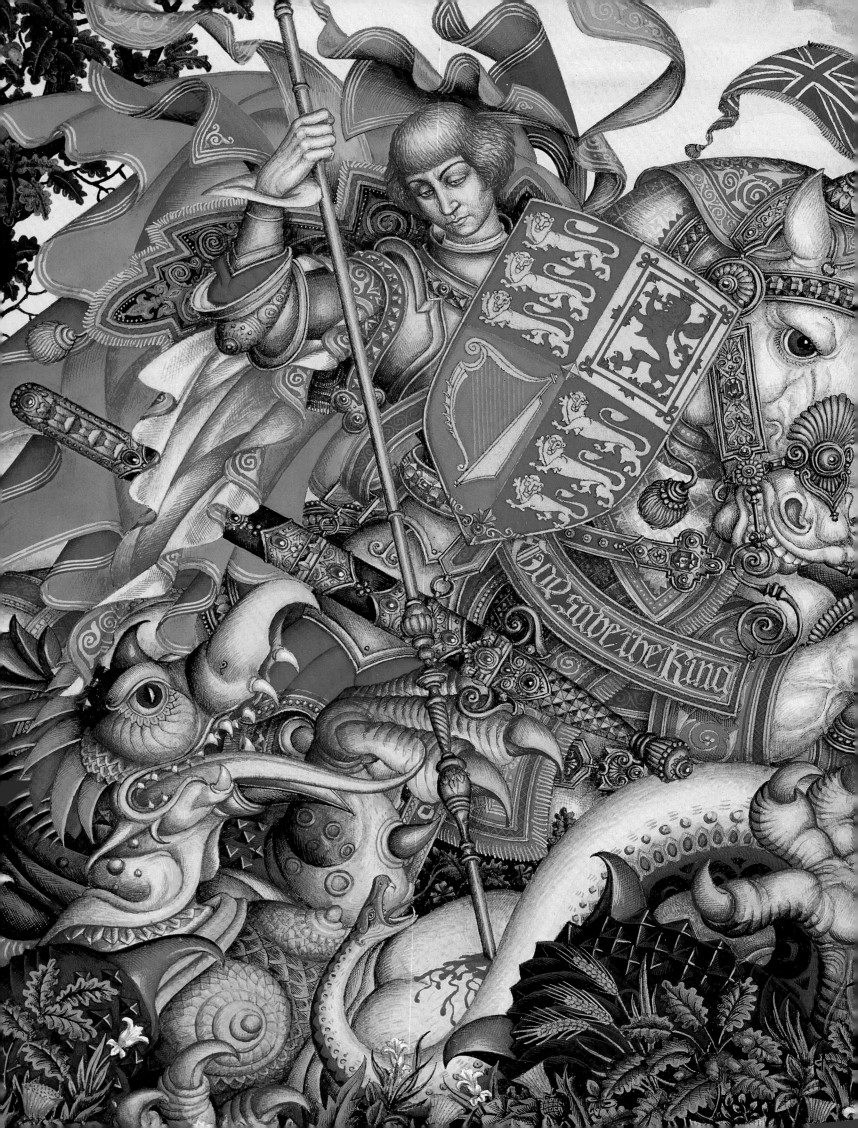

ACKNOWLEDGEMENTS

Museum collections grow in a variety of ways, sometimes through strategic acqui-
sition efforts, more often than not through the serendipity of donations. In 1994,
not long after the opening of the United States Holocaust Memorial Museum, these
two means of collecting coincided with an extraordinary result. Then Director of
Collections and current Collections Research Director Jacek Nowakowski and Asso-
ciate Curator of Art and Artifacts Susan Goldstein Snyder traveled to Florida to
meet with potential donors as part of a routine acquisitions field mission. Quite
incidentally, they were introduced to Alexandra and Joseph Braciejowski, who
possessed materials of exceptional relevance to this Museum's core mission of edu-
cation, remembrance, and conscience.

The daughter of Arthur Szyk, Alexandra Braciejowski was determined that
her father's artistic legacy—in particular, his biting satirical cartoons and visual
commentary on the Holocaust—find an appropriate repository. In making her
donation of 79 original drawings and works on paper to this institution, Mrs.
Braciejowski observed, "[This] is his life's work, and [the Museum] is where it
belongs." Her gift was moreover an act of memorialization, serving to honor the
memory of her grandmother and uncle—the artist's mother and brother—who
had perished in the Holocaust.

The Braciejowskis' generous donation became the springboard for intense
curatorial research into the fascinating life, passionate commitments, and prodi-
gious *oeuvre* of this remarkable, activist artist. Forming the core of a landmark
exhibition entitled *The Art and Politics of Arthur Szyk*, the gift also prompted a world-
wide search for widely dispersed Szyk originals. With the invaluable assistance of
Irvin Ungar of the Arthur Szyk Society, and Szyk scholar Joseph P. Ansell of

Saint George and the dragon, 1939 vii
Watercolor and gouache on paper (detail)
The Royal Collection © 2001, *Her Majesty*
Queen Elizabeth II

Auburn University, the curatorial team found rare Szyk works in such diverse places as the United States Naval Academy, the Queen's Royal Collection at Windsor Castle, The Coca-Cola Company, and The Kosciuszko Foundation. The team also located individual collectors in Poland, Israel, Canada, and Japan, further testifying to Szyk's sustained international recognition.

Illuminator and miniaturist, cartoonist and caricaturist, propagandist for the Allied cause and champion of American democracy, Polish patriot and tireless partisan for a Jewish state, anti-fascist humanist and freedom fighter . . . how does one define this man? In the case of Arthur Szyk, it is his corpus of work—in all its magnificent depth of color and precision of line, its passionate intensity and brutal honesty, and its uncompromising demand for response and reaction on the part of the viewer—that remains his testimony. We are privileged to invite you to enter the world of Arthur Szyk through this legacy of art, and to provide the lens through which we can begin to understand the immediacy and urgency of the issues he addressed.

Early in his career, Szyk took on an exceedingly ambitious project, to illustrate *The Statute of Kalisz*, a thirteenth-century charter of privileges accorded to Polish Jews. The royal charter opens with this cautionary observation by the duke of Kalisz, Boleslaw the Pious: "The deeds of man when unconfirmed by the voices of witnesses or by written documents, are bound to pass swiftly away and disappear from memory." We will never know if Arthur Szyk took these words to heart as a personal challenge, but we do know that the man who once declared that "his granddaughter's dictatorship" was the only totalitarian regime he would ever accept was highly self-conscious about his role as a witness to history. Eschewing indifference, Szyk used his artistic talent to resist tyranny. In his words: "I am a soldier. You seldom hear of art as an army in this country. That is my purpose. There is a saying, 'If Szyk is making cartoons that means there is a war.' When it is over, I shall go back to my miniatures, but not before. You see, I do not believe art can afford to remain neutral in these times."

On behalf of the United States Holocaust Memorial Museum, I want to express heartfelt appreciation to all who have helped bring *The Art and Politics of Arthur Szyk* to fruition. Exhibitions are true collaborations, made possible through the efforts and enthusiasm of dedicated staff and volunteers, the generosity of supportive lenders and donors, the expertise of advisors and consultants, and the encouragement of the governing board. Our work, now and in the future, is fundamentally dependent upon the creative partnership of all these parties and even more, upon the recognition of a common mission: that, like Arthur Szyk, we will not remain neutral in the face of Holocaust history.

Sara J. Bloomfield
Director
United States Holocaust Memorial Museum

CREDITS

Exhibition Sponsors

Abramson Family Foundation, Inc.
Anne and Ronald Abramson
Lester Robbins and Sheila Johnson Robbins
 Temporary and Traveling Exhibition Fund

Artifact and Photograph Donors

Alexandra Braciejowski
Dr. Samuel Halperin
Mr. F. Peter Rose
Eileen Shneiderman
Leo Solet

Individual Artifact and Photograph Lenders

Anne and Ronald Abramson
Forest Group LLC (Janger Family Collection)
Louis Girling, Jr., and Alejandro C. Lajes
Gluckselig Family Collection
Joan and Daryl Hill
Philip and Ruth Holmes
Philip House
Sidney Iwanter
Hillel and Nili Kook
Ann and Alex Lauterbach
In Memory of Clarence H. Low
Anthony J. Mourek
Jeanne and Terry Persily
Gillian Raffles
Hugh Raffles and Sharon Simpson
Joanna and Daniel Rose
Rinjiro Sodei
Warren D. Starr
Sussi Collection
Dade Thieriot
Irvin Ungar through the Arthur Szyk Society
Wm. Hallam Webber
Roslyn Winard
Art Wood

Exhibition Design and Production

Lauriston Marshall, Director of Exhibition
 Design and Production
Richard Ernst, Production Manager
Nancy Gillette, Exhibition Coordinator
Jane Klinger, Chief Conservator
Allison Olson, Paper Conservator
Cleveland Conservation of Art on Paper, Inc.,
 Laurel, Md.
Lanfordesign, Silver Spring, Md.
Nash Brookes Associates, Rockville, Md.

Brenda Bernier
Charles Bills
David Bobeck
Judith Cohen
Lizou Fenyvesi
David Ferraro
Nancy Hartman
Curtis Millay
Sharon Muller
David Stolte
William Trossen

Translators

Manya Friedman
Rabbi Joel Levenson
Yelena Luckert
Tina Lunson
Sarah McNiece
Rae Meltzer
Teresa Pollin

*In addition the Museum would like to thank the
following individuals and institutions for their research
assistance and advice:*

Mark Akgulian, Bette J. Chachkes, Ida Davidoff,
Laura G. Einstein, Jay H. Geller, J. K. Holman,
Eric Chaim Kline, Jacek Korpetta, Wanda
Kotunia, Janet Lindstrom, Kenneth Loiselle,
Teresa Milczewska-Korpetta, Steve G. Paulsson,
Polly Petit, Monika Rudolf, Jack Schwartz, Ben
Shneiderman, Flora Singer, Geraldine Wolff
Snyder, Sam Spiegel, Marek Szukalak, Herman
Taube, Hanna Wroblewska, Karen Youman

Archives of Audio Visual Records, Warsaw;
Art Angles Gallery, Los Angeles; Central Archives
of Modern Records, Warsaw; Federal Bureau of
Investigation, Washington, D.C.; Fine Arts
Society PLC, London; International Institute of
Social History, Amsterdam; James Cummins
Bookseller, New York; Jewish Theological
Seminary of America, New York; Łódź State
Archive, Łódź, Poland; Museum of Caricature,
Warsaw; Museum of the History of the City
Łódź, Poland; Museum of Modern Art, Łódź,
Poland; Muzeum Sztuki, Łódź, Poland; National
Library, Warsaw; New Canaan Historical Society,
Conn.; New York Post Archives, New York; The
Polish Institute, Warsaw; The Polish Institute
and Sikorski Museum, London; Princeton
University Libraries, New Jersey; Public Records
Office, London; Robert Hunt Library, London;
The Rosenbach Museum and Library, Philadelphia;
Spertus Institute of Jewish Studies, Chicago;
University of Maryland Library, College Park;
Yale University Libraries, New Haven, Conn.

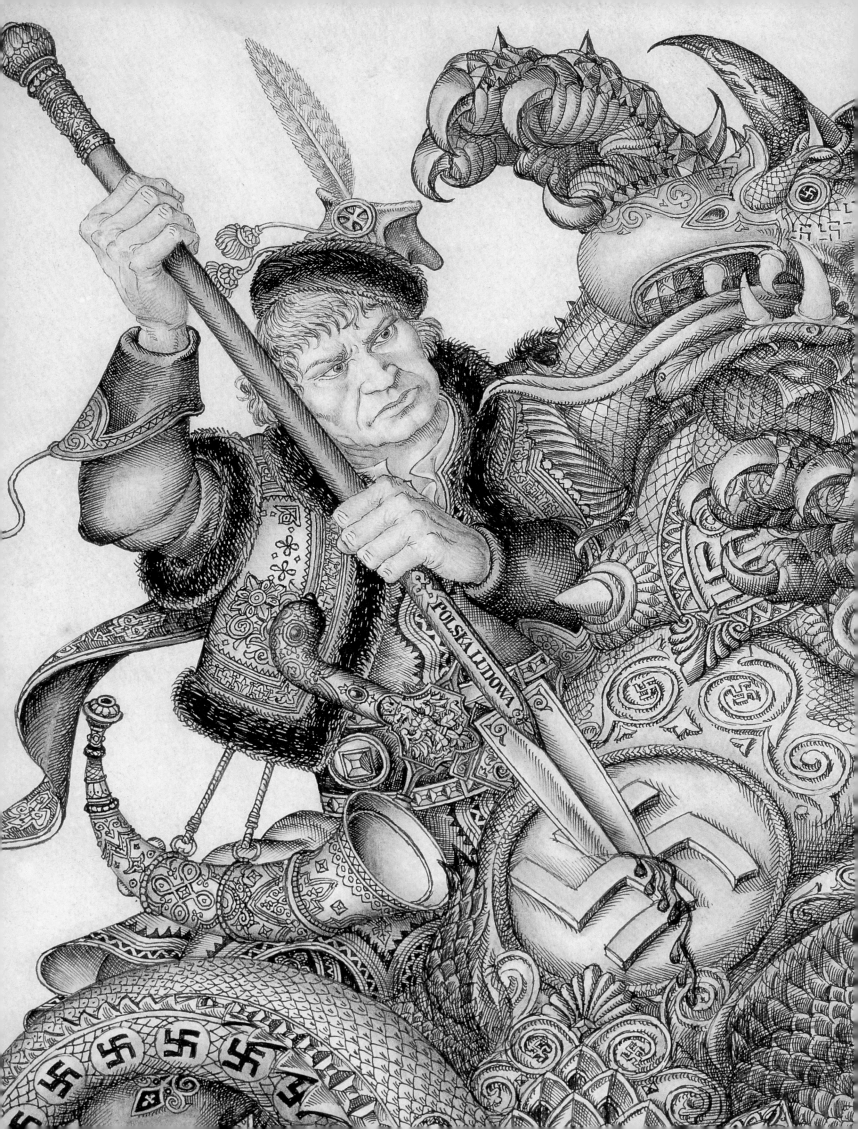

FOREWORD

With *The Art and Politics of Arthur Szyk*, the United States Holocaust Memorial Museum puts Arthur Szyk and his work before the public front and center, as they rightfully deserve to be. Szyk's greatness comes less from his aesthetics than from his heart. He is a role model of the engaged artist—a man who fought against Nazi aggression and American apathy on behalf of the oppressed Jewish people of Europe.

Above all, Arthur Szyk represents the artist as witness—against evil, for liberation. The Bible warns that if a person is a witness (to evil), whether he sees or knows it—if he does not speak out then he bears a sin (Leviticus 5:1). How many people saw the unfolding evils of antisemitism and malign oppression growing cancerously in the twenties, thirties, or forties and averted their eyes or suppressed their testimony? Not so Arthur Szyk. In 1934, he understood the threat that Hitler posed, and resolved to use his art to defend the Jewish people and attack their enemies.

Following the conquest and division of Poland between Nazi Germany and the Soviet Union in 1939, Szyk, then living in England, put aside his other work and became a propagandist for the Allied democracies. The term propagandist is not generally used honorifically—but Szyk made it into an honorable calling. In his cartoons and caricatures, he portrayed "the brutality of the Germans . . . the heroism of the Poles and the suffering of the Jews." He went to the United States and exhibited there because he passionately believed that an isolationist America would allow Germany to triumph in Europe and, ultimately, in America itself.

As the reality of the ongoing Holocaust sank in, Szyk grasped and portrayed the distinctiveness of the Nazi persecution of Jews. Throughout World War II, he

Poland Fights the Nazi Dragon, 1943
Pen and ink on paper (detail)
The Kosciuszko Foundation, New York

xiii

published a voluminous body of work. But Szyk not only protested against the murder of Europe's Jews, he also articulated three important lessons that are fundamentally at the core of ethical behavior.

First, he believed that the victims must endeavor to prevent evil from crushing them. Even as early as 1925, Szyk drew Jewish fighting heroes. Similarly, after Hitler's rise to power, he portrayed Jews fighting their victimization—as is demonstrated in his repeated depictions of the 1943 Warsaw ghetto uprising. As the war and the Holocaust escalated, Szyk also fought for the creation of a Jewish army through his artwork and as a member of the Committee for a Jewish Army.

Second, in consideration of the Nazi dehumanization of the Jews and the degradation of individual's lives, Szyk felt that it was urgent to restore the dignity of every human being in the image of God—whatever color, race, or creed. For example, Szyk used vicious caricatures of the Japanese as inhuman beasts during World War II, but he also featured African American soldiers as heroes and countered segregated army units with portraits of African American GIs working in harmony with white soldiers. He pledged to work for their enfranchisement and social equality.

Finally, Szyk understood that the victims must liberate themselves psychologically and culturally. Only by affirming their own identity and culture would they be free to recognize their dignity and take steps to defend themselves. He illustrated the Book of Esther twice as the paradigm of spiritual and physical liberation. He supported Vladimir Jabotinsky and the Revisionist Zionists' call to arms, and illustrated Ludwig Lewisohn's novel, *The Last Days of Shylock* (1931), which warned against assimilation and the loss of Jewish identity. In all his work, Szyk affirmed the universal cause of democracy even as he upheld—often militantly proclaimed—a distinctive Jewish history, culture, and identity.

These lessons of the Holocaust have since been embraced by potential victims of every race, color, gender, and nationality, and have stimulated liberation movements throughout the world. Thus Szyk's witness rises to the level of prophecy—prophetic as to the Jewish future but, like the biblical prophets of old, carrying a powerful message for all of humanity.

Rabbi Irving Greenberg
Chairman
United States Holocaust Memorial Council

INTRODUCTION

Arthur Szyk (1894–1951) enjoyed a well-deserved reputation during his life as a gifted illuminator and book illustrator, a skillful caricaturist, and a crusader for various causes. He combined the talents of an expert craftsman schooled in the arts of medieval manuscript illumination and Persian miniature painting with the instincts and skills of a political cartoonist who knew how to unmask the face of the enemy and mobilize popular opinion. Though the techniques and audiences differed, Szyk made clever use of both art forms to carry his political messages. His illustrations of biblical books and Jewish themes, though portraying events from the historical past, often addressed contemporary issues, much like his wartime satires or his pro-Zionist cartoons. His artwork sought to redefine the (self-) image of the Jews, to call attention to their persecution, and to demand action on their behalf. He was, as one American journalist noted, an "artist-warrior,"[1] and during the Holocaust there was no more fervent artistic advocate of Jewish rescue than Arthur Szyk.

Since his death in 1951, Szyk's art has been displayed in a number of exhibitions in the United States; in the year 2000 alone, five galleries devoted shows to his work. *The New Order*, a compilation of many of his finest anti-Nazi drawings and cartoons first published in 1941 in the United States, was reissued in French and German translations in 1979. His *Haggadah*, once one of the most expensive books ever printed, has been republished several times in less costly editions, helping to fulfill Szyk's dream of bringing his powerful vision of the Passover Seder text to many Jewish homes.

Despite this seeming popularity, neither Szyk nor his artwork has yet to receive the scholarly attention they merit. To date, there has been only one biography of

Arthur Szyk, New York, 1941
Irvin Ungar through the Arthur Szyk Society

1

Arthur Szyk, which was written by S. L. Shneiderman and published in 1980.[2] A noted Yiddish journalist and author, Shneiderman drew on the extensive interviews and articles he had done in the 1940s as well as the unpublished memoirs of the artist's widow, Julia Szyk. In 1998, Szyk authorities Irvin Ungar and Joseph P. Ansell contributed to the Spertus Institute of Jewish Studies exhibition catalog, *Justice Illuminated: The Art of Arthur Szyk*. These essays have extended our knowledge of the artist and shown the breadth of his *oeuvre*.[3] Ansell is currently preparing a book-length manuscript on Arthur Szyk for publication.[4] In Poland, Szyk's artwork has received some attention from Marek Szukalak and Beate Jegier-Filipiak.[5]

Arthur Szyk's work has been largely ignored or minimized by art historians, even those specializing in Jewish art and artistic representations of the Holocaust. Szyk did not belong to the *avant-garde* in modern art. He seemed to be a throwback to a bygone era—his artwork was representational rather than abstract, uninformed by contemporary Cubism, Expressionism, or Futurism. His artwork encompassed both the high art of the illuminated manuscript and the miniature and the low art of the cartoon and the caricature, a dichotomy that has affected the ways in which Szyk's artwork has been perceived. Even in his own day, critics, scholars, and others debated whether works of "propaganda" could or should be considered art, and whether the artist who "debased" his craft by producing "propaganda" could still be called an artist.

In 1940, an art critic for the *Jewish Chronicle* of London lamented the fact that Szyk had abandoned his illuminations for wartime satires:

Szyk is a poor propagandist, and when he is a propagandist a poor artist. His caricatures of Hitler, Göring, or Stalin are stock figures, and his cartoons of Russian soldiers or inhuman war-lords do not live as vital comment on man or type. . . . Szyk is not by nature a caricaturist: the quality of his line is contemplative, searching, and intellectual—not sensual or fiery.[6]

A decade later, Rachel Wischnitzer, one of the pioneers in Jewish art history, summarized his contributions in a vastly different way:

Arthur Szyk . . . cultivates a miniature technique which is too smooth and delicate for the rendering of Biblical characters; Szyk is at his best in his war cartoons, owing to the striking contrast between the thoroughly exact execution and the grim topics.[7]

In the early 1960s, art critic Edouard Roditi downplayed Szyk's originality, describing him only as "an imitator and popularizer of the Oriental and mediaevalist styles and techniques of [Russian Jewish artist Leon] Bakst."[8]

In more recent years, while there has been a major upsurge of interest in both Jewish art and art of the Holocaust, Szyk has fared no better. When his artwork has received any attention, it has been only as a passing reference in text or footnotes.[9]

While Arthur Szyk did not revolutionize the art world or generate a new movement, his art reveals much about his politics and his era. Unlike other twentieth-century artists, whose political works or commentaries on the Holocaust are often obscured by abstraction, symbolism, or their own private language, Szyk's messages were overt and accessible to large audiences. He brought to much of his work the clarity and succinctness of a newspaper cartoonist. He understood how to seize the reader's attention and quickly make his point.

It is difficult to measure the influence of any artist's work. The popularity of Szyk's wartime satires and anti-Axis cartoons in the 1940s, which filled the covers and pages of major magazines and newspapers, suggests that his messages resonated with millions of readers.[10] His images of the Holocaust, too, reached many Americans, though their effect on public opinion is hard to gauge. Scholars have studied how the press reported on the mass murder of Europe's Jews and how individuals, organizations, or the government responded to this news,[11] but little research has been done on the impact of Holocaust imagery on Americans during the war.

3

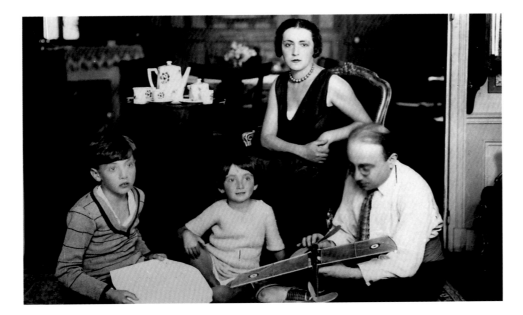

Arthur Szyk, wife Julia, and children George and Alexandra, Paris, 1929
Alexandra Braciejowski, Florida

4

The present volume aims not to detail every aspect of the artist's life or survey his complete body of work. Its goals are much more modest, namely, to examine how Arthur Szyk used his art to support the Jewish people, to attack their enemies, and to awaken the world to the threat of Nazism. To that end, the book is divided into three sections: his work as a Jewish artist, his career as a wartime caricaturist, and his efforts to call attention to the Holocaust together with his political activism on behalf of rescue and the establishment of a Jewish state in Palestine.

Despite the passage of time, Arthur Szyk remains a rather enigmatic figure. Still, it is possible to make a few introductory remarks about the complicated nature of this remarkable man's politics. He was a non-observant Jew who was widely known and is best remembered for his illustrations of Jewish religious texts. He became a tireless crusader for a Jewish homeland in Palestine, yet he chose not to live there even after the founding of the State of Israel. In his Zionism, one finds more questions than answers. He clearly departed from the mainstream, supporting the Revisionist "party" of his longtime friend Vladimir Jabotinsky, yet his liberal politics seemed to be at odds with this generally right-wing movement. At the same time, he was a proud Polish patriot who fought against Soviet Russia in 1919 and 1920, but left Poland shortly thereafter. He approved of Marshal Józef Piłsudski's coup in 1926, then soured on the Polish leader's successors in the late 1930s. When Poland was occupied by Nazi Germany in 1939, he became a strong advocate in the Polish Jewish community for the Polish government-in-exile, but in 1943 he turned bitterly against it and eventually threw his support to the Soviet-backed government. During World War II, he made full use of the prevailing anti-Japanese racial stereotypes to dehumanize

the drama concerned an early modern Jewish figure, Szyk's artwork drew heavily upon ancient Assyrian models, an influence that one sees in his *Livre d'Esther* (Book of Esther) published more than ten years later. Aside from highlighting his skills as a draftsman and as an imaginative artist with a keen appreciation for decorative detail, the work reveals the influence of "the romantic-orientalist trend in art," perhaps best exemplified in some of the Zionist artwork of E. M. Lilien.[8]

Szyk's interest in Jewish history and Zionism was further stimulated by a trip, sponsored by the Ha-Zomir (Nightingale) choral and literary society,[9] which he and a group of Jewish artists and writers took in the spring of 1914 to Palestine. There he composed a series of miniatures on biblical themes, such as the Queen of Sheba's visit to King Solomon and the Song of Songs. He was even invited to teach a drawing class at Jerusalem's Bezalel Institute of Art, an institution established by Boris Schatz in 1906 to collect artifacts relating to the Jewish past and to advance the cre-

Patriotic Polish poster, 1920
USHMM Collection

ation of a Jewish national art.[10] At the outbreak of war in 1914, Szyk—a Russian subject in enemy Ottoman territory—was forced to return to Europe, where he was promptly conscripted into the Russian army.

With the end of World War I in 1918 came the birth pangs of a new Polish republic that went to war with Soviet Russia in 1919. Szyk joined a propaganda unit in Łódź and created artwork aimed at boosting public morale. Soon thereafter, he donned an officer's uniform and joined the troops on the eastern front, where he was attached to the White Russian army of Stanisław Bułak-Bałachowicz, then under Polish general Władysław Sikorski's command. During the 1919–1920 war, Szyk learned about the bloody pogroms carried out by Russian and Polish forces against the Jews. It was widely rumored that Bałachowicz permitted his troops to brutalize and pillage the Jewish population in areas under his control.[11] According to Shneiderman, Szyk joined Bałachowicz's unit under an assumed name specifically to prevent pogroms and to bring their perpetrators to justice.[12] While many of these details are difficult to verify, there is no doubt that the tragic events of this time deeply influenced Szyk's politics and art.

Following the Polish-Soviet War, Szyk returned to his hometown and to Jewish themes in his art. Łódź was perhaps the center of Jewish art in Poland at this time. It was the birthplace of the *Yung Yiddish* group, a coterie of young artists and writers whose work one author has characterized as "Jewish expressionism."[13] Although Szyk is not generally identified with this group, his artwork appears in several volumes written by its founder, the poet Moshe Broderson. In 1921 a series of Szyk's miniatures, showing heroic Jewish figures such as Judith, David, and

Program cover for *Uriel Acosta,* 1913

The Central Zionist Archives, Jerusalem

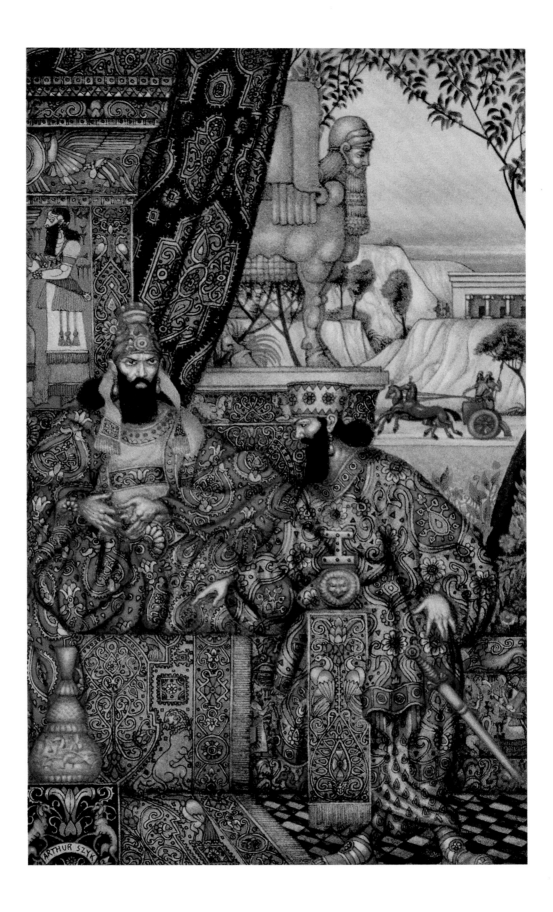

11

Haman and King Ahasuerus

From *Le Livre d'Esther*, 1925
Print
Warren D. Starr, New York

Bar Kochba, were included in an exhibition of Jewish art sponsored by the Tel Aviv Publishing House in Łódź. In 1924, he published illustrations for the Song of Songs, a work of sensual poetry that has been described as an allegory on God's love for the people of Israel and their steadfast love for him.[14]

At this stage in his career, there already was a common thread running throughout much of Szyk's Jewish art: a clear interest in portraying Jews as militant fighters against their oppressors. Framed by his own personal experiences and politics, Szyk sought to redefine the image of the Jewish people, perhaps to refute the common antisemitic canard that the Jews were a craven and cowardly "race" that allowed others to fight for them. Adopting a central tenet of Zionist culture, Szyk used heroic figures from the ancient past as models for the new Jew, "courageous and proud, healthy in body, living by the sweat of his brow, attuned to nature and to the soil, the very antithesis of the 'Diaspora Jew.'"[15]

Szyk's portrayals of Jewish heroism are central to his *Livre d'Esther*, published in France in 1925, just several years after his return to Paris. The biblical Book of Esther describes the planned destruction of the Jews in ancient Persia, their resistance, and their eventual triumph over their enemies. Jews traditionally have turned to the Book of Esther for support and inspiration in times of crisis, and each year the story is read during the spring holiday of Purim. Shneiderman suggests that the impulse to create this work came from the postwar pogroms in Poland, while Ansell believes that it "can be read as a commentary on officially sanctioned antisemitism in Poland in the early 1920s."[16]

Le Livre d'Esther demonstrates Szyk's continued fascination with orientalist images of ancient Jewish history. Composed in the style of Persian miniatures and set against a backdrop of Assyrian-inspired sculptures and quasi-Persian cuneiform script, the paintings depict Haman's plot to murder the Jews, the resistance of Esther and Mordechai, the hanging of Haman, and the destruction of his forces by Jewish fighters. The series concludes with an image of the artist as the chronicler of these events. As Julia Szyk recalls in her unpublished memoirs,

He considered this not only as an important piece of artistic work to be done but also for his people. To him it was the story of the liberation of his people, the story of their cruel persecution. It was part of his proud answer to the anti-semitism of his times.[17]

That the Book of Esther had a clear fascination for him is well illustrated by the fact that in 1950, in the wake of the Holocaust, he illustrated this biblical book again, albeit in a very different style and iconography.

During his second sojourn to Paris, from 1921 to 1937, Szyk became close friends with Vladimir Jabotinsky, the charismatic and controversial leader of Revisionist Zionism, the main opposition "party" within the world Zionist movement. Though all Zionists came to agree on the need for a Jewish homeland in Palestine, the Revisionists were perhaps the most vocal in demanding a state with a Jewish majority that would encompass both sides of the Jordan River, and they advocated military training for youth and the formation of Jewish self-defense units.

12

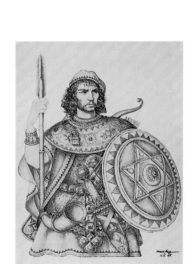

Szyk's frontispiece to Vladimir Jabotinsky's *Prelude to Delilah*, 1945
Irvin Ungar through the Arthur Szyk Society

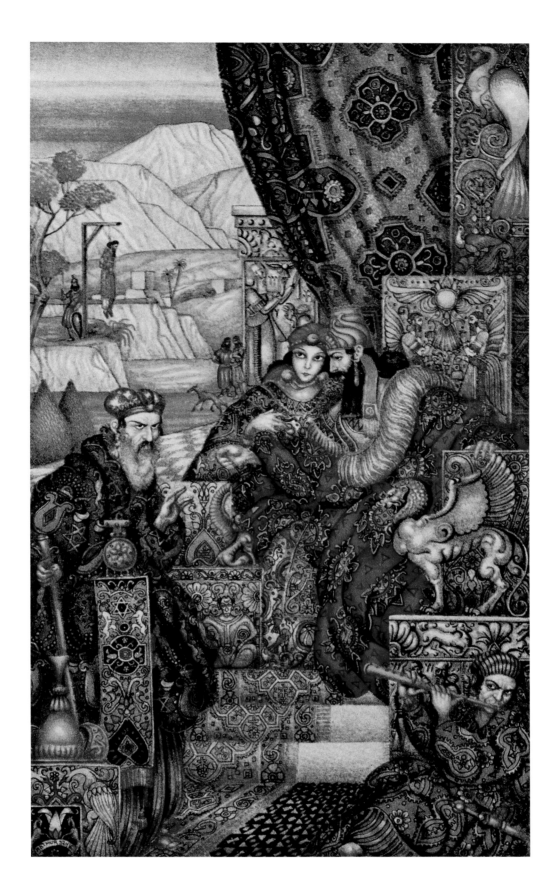

**Mordechai, Esther, and King Ahasuerus,
with Haman hanging in the background**
From *Le Livre d'Esther*, 1925
Print
Warren D. Starr, New York

14

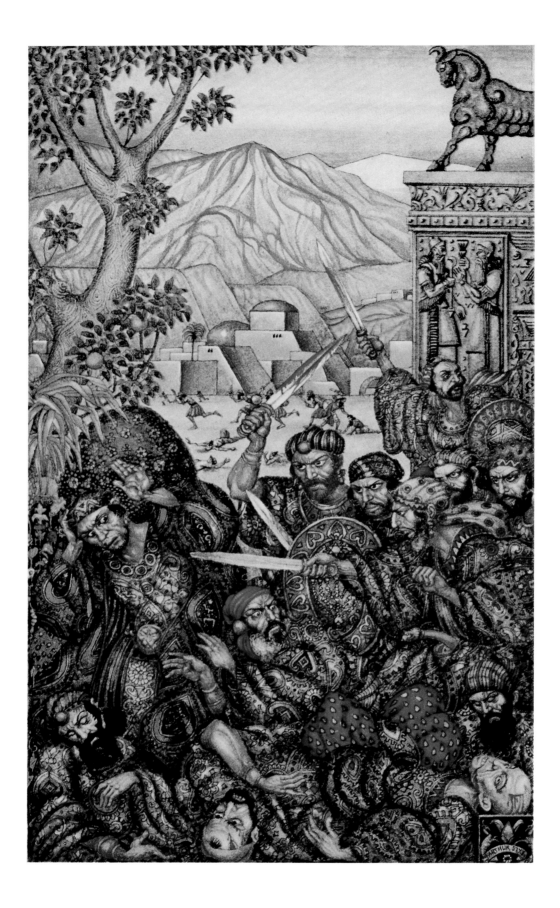

Jewish resistance to Haman's plan

From *Le Livre d'Esther*, 1925

Print

Warren D. Starr, New York

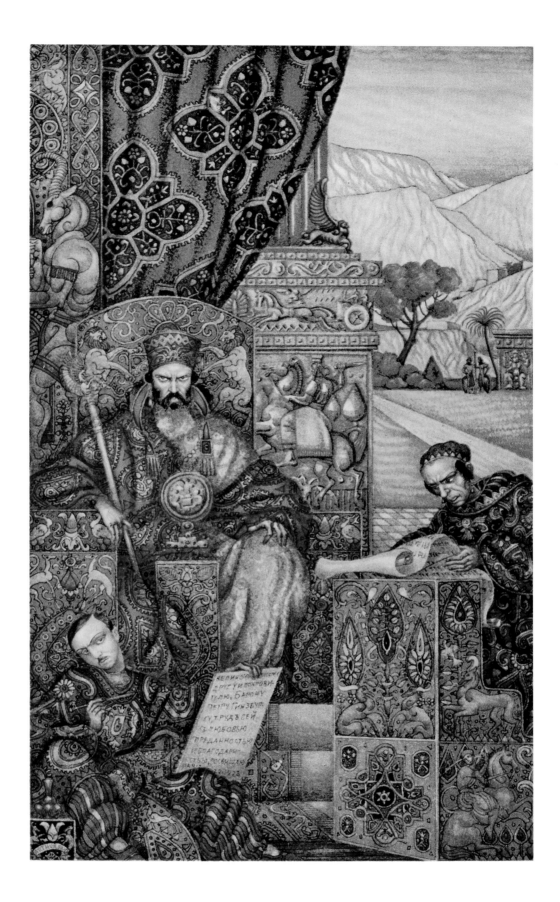

Mordechai with Szyk as scribe
From *Le Livre d'Esther*, 1925
Print
Warren D. Starr, New York

**Image from *Le Puits de Jacob*
(Jacob's Well),** 1927
Collotype print
Wm. Hallam Webber, Maryland

Szyk and Jabotinsky came from Russian-speaking families, shared a strong devotion to the Jewish people and *Eretz Israel*, and advocated some form of Jewish militancy. Although it is unclear whether Szyk ever formally joined a Revisionist organization in the 1920s or 1930s, he greatly admired its leader and his goals. Moreover, there was much in Szyk's artwork that seemed to meld well with the militant Revisionist ethos. Yaakov Shavit describes the impact Polish nationalism had on Jabotinsky's movement in the following way:

Revisionists made much of their claim that the renaissance of a national Jewish culture was anchored in the ancient national Jewish heritage, in its values, symbols, heroes and exploits . . . The Polish experience taught the Revisionists that a national movement needs heroes, and appropriate figures from Jewish history were identified. The Revisionist Hebraismus militantis crystallized in a Poland saturated with national romantic motifs, national heroism, and national eschatology, fluctuating between desperation and messianic expectation; between realistic national policy and dreams of greatness and glory that might compensate for generations of humiliation, repression and suffering.[18]

As an artist with a love of history, Szyk appreciated the power that symbols, myths, and heroes had in Polish and Zionist political cultures, and he made full use of those resources to convey his message.

While living in Paris, he illustrated not only a collection of Jabotinsky's writings but also two novels with pronounced Zionist messages. The first of these, *Jacob's Well* (1927) by noted French author Pierre Benoit, details the life of Agar Moses, a young Jewish woman born in the Constantinople ghetto, who finds fame as a dancer and true happiness as a pioneer in a Jewish settlement in Palestine.[19] The second, *The Last Days of Shylock* (1931) by German-born American Zionist writer Ludwig Lewisohn, is a historical novel that picks up where Shakespeare's *The Merchant of Venice* leaves off but transforms the figure of Shylock into a Jewish national hero. Written after the author's trip to Palestine and in the wake of both the 1929 Arab riots and the growth of the Nazi party in Weimar Germany, the novel pays tribute to the efforts of sixteenth-century figures David Reubeni, Doña Gracia Mendes, and Joseph Nassi to save Jews from persecution in Christian Europe and create Jewish settlements in Palestine. The book also warns of the dangers of assimilation and the loss of Jewish identity.[20]

At the news in 1926 of Marshal Józef Piłsudski's *coup d'état* against Poland's elected rightist government, Szyk turned his attention to his native homeland. Like many other Polish Jews who had been disillusioned with Poland's postwar stance on the issue of Jewish rights, Szyk welcomed the coup because Piłsudski was viewed by many as a friend of the Jews. In response, Szyk worked diligently for the next several years on an illuminated manuscript of a medieval law issued in 1264 by Polish duke Boleslaw the Pious of Kalisz that guaranteed Jews particular rights in his domains.[21] Dedicated to Piłsudski, Szyk's *Statute of Kalisz* is a paean for religious toleration and a defense of Jewish rights in a time of political uncertainty.

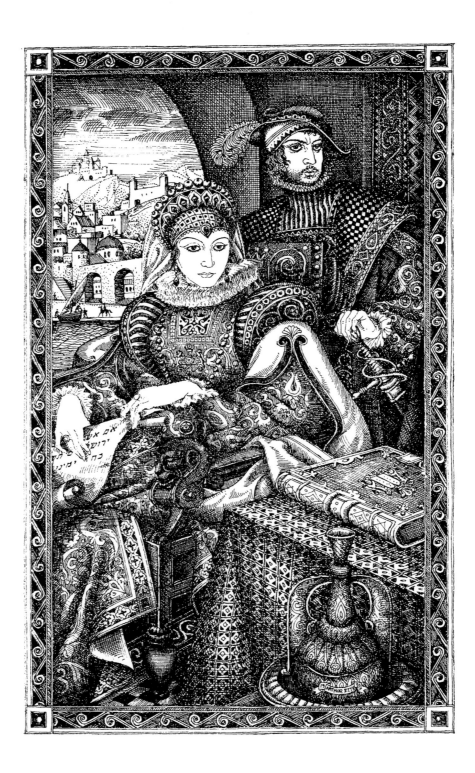

Portrait of Doña Gracia Mendes and Joseph Nassi

From *The Last Days of Shylock*, 1931
Print
Dr. Samuel Halperin, Washington, D.C.

English page, 1928

From *The Statute of Kalisz*, 1926–1930

Watercolor and gouache illumination on paper

The Jewish Museum, New York, Gift of Andrew A. Lynn

Composed of 45 plates, *The Statute of Kalisz* illustrates scenes from Polish history against a background of translations of the law in English, Hebrew, Yiddish, German, Polish, Italian, and Spanish. The artist adopted a rather unique approach to the project. Instead of depicting the Polish-Jewish relationship in terms of the benefits accrued to the Jews as a result of the statute, Szyk showed the contributions that Jews made to increase the prosperity and security of Poland. Jews not only fostered trade but also defended the country against foreign oppression. He included the heroic deaths of Berek Joselewicz, a Jewish officer who died fighting Austrian forces during the Napoleonic Wars, and Bronisław Mansperl, a Polish Legion officer who fell in battle against tsarist troops in 1915.

Szyk wanted to show that Jews had fought for Polish liberties, so he portrayed them throughout the illuminated manuscript as strong figures who are not afraid to die for the cause. On the Italian language page, he depicted Jews and Poles fighting together on the Łódź barricades against tsarist troops during the 1905 Russian Revolution. The heroes hold aloft flags with the Hebrew and Polish letters for the PPS (Polish Socialist Party) to which Marshal Piłsudski had belonged. The bottom inscription bears a dedication to his hometown, describing it both as a memory of his childhood and as a "moving image of the heroic struggle against the oppressor." On the Hebrew page, Szyk pictured Berek Joselewicz's Jewish regiment engaged in fierce hand-to-hand combat with Russian troops during the defense of the Praga district of Warsaw on November 7, 1794. He dedicated the piece to his Polish co-religionists who died for their country. By highlighting scenes such as this one from Tadeusz Kosciuszko's legendary revolt, the Napoleonic Wars, and more recent twentieth-century events, Szyk was promoting the idea that Jews had consistently and continually fought for Polish freedom.

Not unexpectedly, the Polish government praised Szyk's *Statute* and even awarded him with the Gold Cross of Merit. Jabotinsky too paid tribute to the artist, whom he claimed had given lie to the idea that art cannot serve politics and remain art. In Szyk's works, the Revisionist leader remarked, there is "always a fight for an idea." His art serves as a monument to the idea that peoples of different races, creeds, and lifestyles can live together in honest and peaceful coexistence. Jabotinsky lauded the artist for illustrating the national uniqueness of the Jewish people, even in the tiniest details of his artwork.[22]

That Jabotinsky, a vocal Jewish nationalist, should take such an interest in the *Statute* may seem surprising, but he had a great love for Polish literature and understood the complicated nature of Polish-Jewish relations throughout history. On a political plane, he and his Revisionist Zionist colleagues sympathized with the plight of the Poles, likening their own struggle for a Jewish state to the Polish efforts to regain national independence. They also came to view Piłsudski as a role model: a former fighter in the socialist underground in tsarist Russia, a military hero in World War I, and a nationalist head of state in Poland.[23]

In May 1933—four months after Hitler had come to power in Germany—Szyk's *Statute of Kalisz* traveled to London, where the audience and the press understood the contemporary political significance of the work. At the exhibition

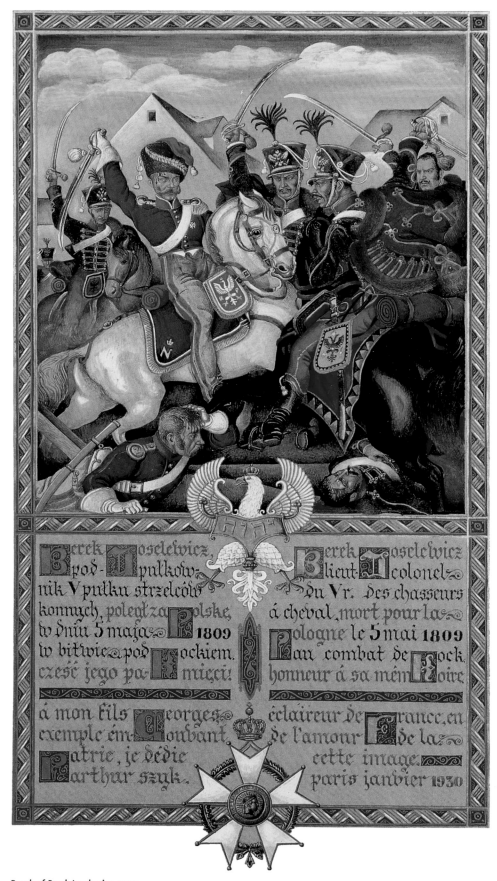

Death of Berek Joselewicz, 1930
From *The Statute of Kalisz,* 1926–1930
Watercolor and gouache on paper
The Jewish Museum, New York, Gift of Andrew A. Lynn

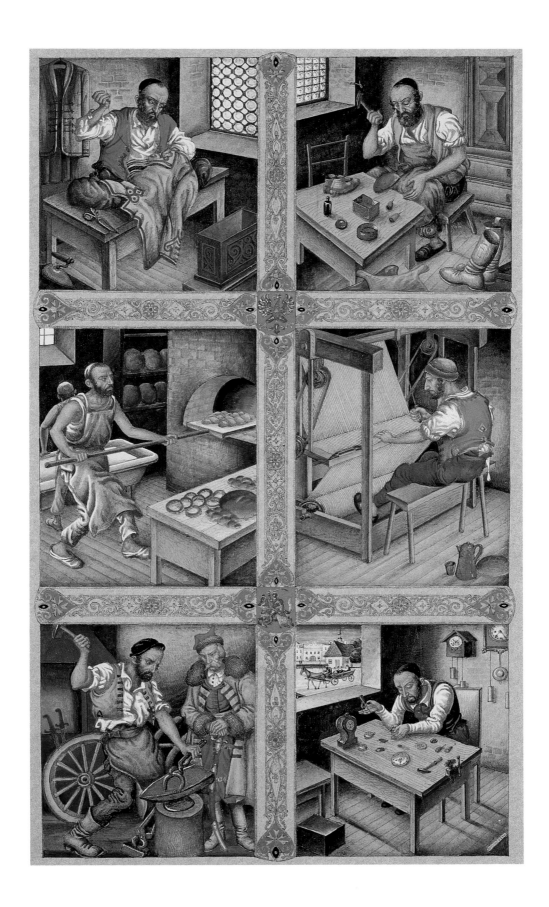

Jewish craftsmen and tradesmen, 1927

From *The Statute of Kalisz,* 1926–1930

Watercolor and gouache illumination on paper

The Jewish Museum, New York, Gift of Andrew A. Lynn

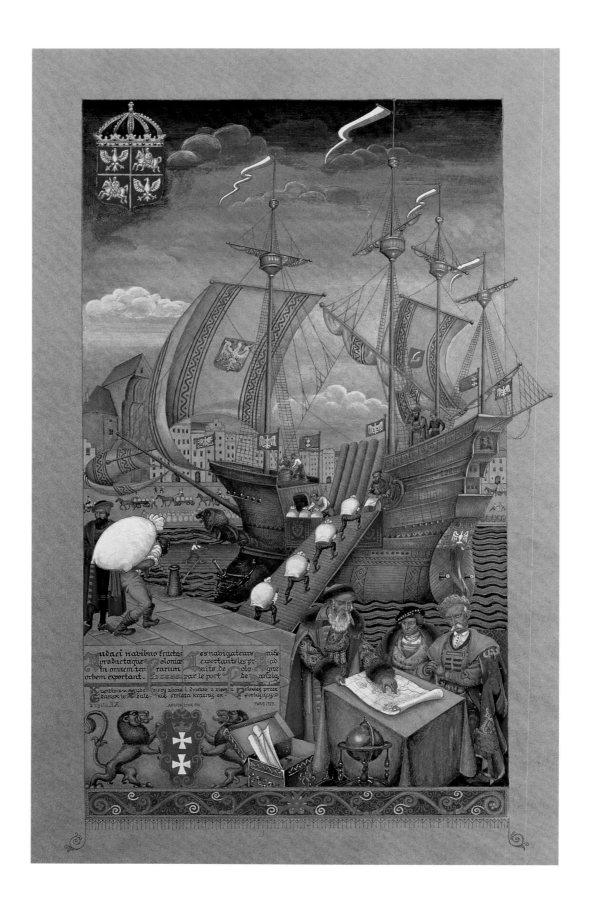

22

Jewish Sailors Exporting Polish Products through the Port of Danzig, 1927

From *The Statute of Kalisz,* 1926–1930

Watercolor and gouache on paper

The Jewish Museum, New York, Gift of Andrew A. Lynn

opening, Nachum Sokolow, the president of the Jewish Agency for Palestine and the World Zionist Organization, praised Poland's medieval rulers for admitting Jewish refugees fleeing persecution in the German states and for guaranteeing them certain rights.[24] Vladimir Poliakoff, a noted writer, also addressed the importance of the *Statute* in his introduction to the exhibition program:

Its origin is significant. Those were the days of the First Crusade, which in what is now Germany was accompanied by Jewish pogroms of as ferocious a nature as anything we have witnessed in our time. The Jews, who had lived in that part of the world even before the Germans, were rooted out by sword and fire. Their remnants fled to Poland, where in a spirit of respect for the freedom of conscience, which became a tradition of the country for centuries, they were granted asylum. . . . The document makes interesting reading, especially in these days when the mediaeval persecution has been revived.[25]

The press also recognized the exhibition's key message. "What a striking contrast," the Jewish Telegraphic Agency reported, "with the present condition of the Jews under German antisemitism! What a reactionary setback from the twentieth to the thirteenth century! Would not the present antisemitic rulers of Germany brand Boleslaus the Pious, prince of Kalisz, as a 'Judenknecht' [servant of the Jews] and destroy by fire all the copies of his 'Statute'?"[26] Fittingly, the World Alliance for Combating Antisemitism chose to stage another London showing of Szyk's *Statute of Kalisz* in July 1933.

As Nazi power solidified in Germany, Szyk realized that all artists, and especially Jewish artists, had to combat the Nazi threat. He clearly understood that minority rights and toleration depended upon the goodwill of the government, and he warned that, as in Germany, this too could change in Poland. "We have our Hitlers, we have our antisemites too. But the government—the government of Piłsudski—is ready to defend the Jews. While this government stands we'll have tolerance."[27]

When Hitler and the Nazi party came to power in Germany in 1933, Szyk was just beginning to work on another prominent Jewish religious text, the Haggadah. The text describes the persecution of the Jews in ancient Egypt, Jewish resistance, the destruction of the enemy's forces, and the Exodus from Egypt to the Promised Land. Traditionally read every year at the Passover Seder, the Haggadah serves as a reminder of oppression, eventual triumph, and the longing for a Jewish homeland.

For Szyk, the Haggadah had clear contemporary relevance. He declared in 1934 to an American reporter that

an artist, and especially a Jewish artist, cannot be neutral in these times. He cannot escape to still lifes, abstractions, and experiments. Art that is purely cerebral is dead. Our life is involved in a terrible tragedy, and I am resolved to serve my people with all my art, with all my talent, with all my knowledge.[28]

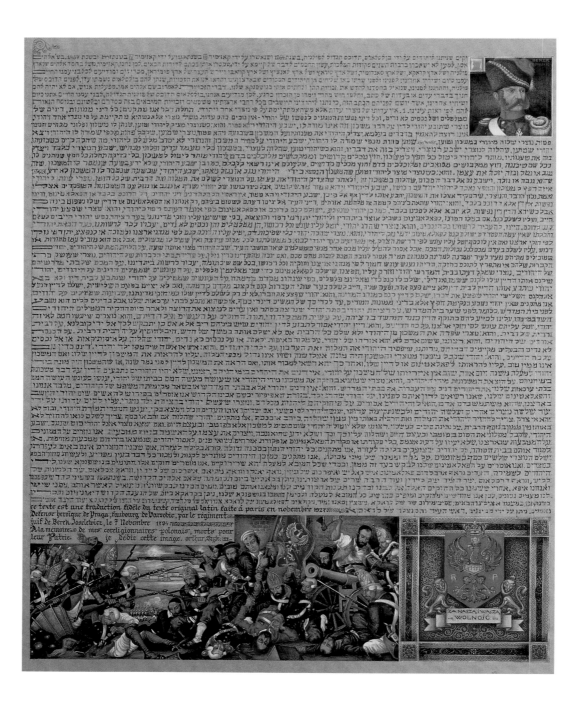

Hebrew page, 1927

From *The Statute of Kalisz*, 1926–1930

Watercolor and gouache illumination on paper

The Jewish Museum, New York, Gift of Andrew A. Lynn

24

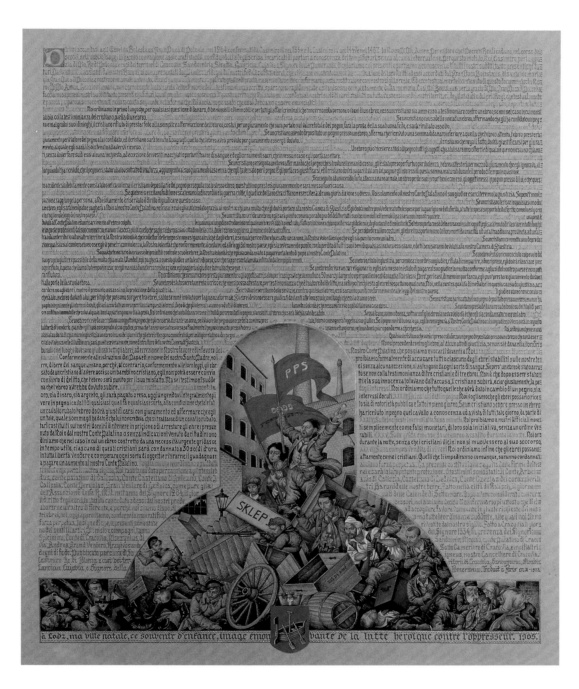

Italian page, 1928

From *The Statute of Kalisz*, 1926–1930

Watercolor and gouache illumination on paper

The Jewish Museum, New York, Gift of Andrew A. Lynn

French dedication page, 1935

From *The Haggadah*, 1934–39

Watercolor and gouache on paper

Forest Group LLC (Janger Family Collection), Chicago

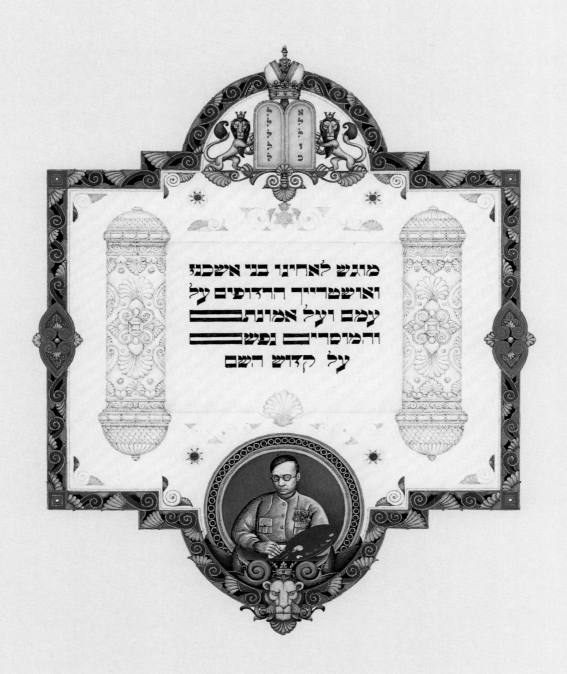

Dedication page to the German and Austrian Jews, 1938

From *The Haggadah*, 1934–39

Watercolor and gouache on paper

Irvin Ungar through the Arthur Szyk Society

As part of this pledge, he promised to paint a swastika on every Egyptian in his *Haggadah*, and to dedicate the book to the persecuted Jews of Germany. When the book was being readied for publication, printers first in Czechoslovakia and then in England, concerned about the political implications, forced Szyk to remove the swastikas.[29] Nevertheless, the allusions to events then taking place in Nazi Germany remain clearly recognizable.[30]

In contrast to many other *haggadot*, Szyk's interpretation sounds a militant tone and is filled with Zionist symbolism. Throughout the volume, he added ancient warriors and heroic biblical figures that are not mentioned in the Seder text. Certainly images of David and Judith are not unique to his *Haggadah*, yet he gives the Jewish heroes special prominence. A portrait of Judith, holding the head of Holofernes and surrounded by the twin lions of Judah that symbolize Jewish power and sovereignty, illustrates the French dedication page. On the English dedication page, an ancient Hebrew warrior bearing a shield emblazoned with the Star of David is slaying a dragon. The figure of David with the head of Goliath appears several times throughout, including on the page illustrating the children's song *Had Gadya* (An Only Kid). While such a pairing may seem odd, *Had Gadya* has sometimes been interpreted as an allegory for the repeated conquest and final redemption of the land of Israel. The incorporation of the Jewish warrior David here may be Szyk's subtle message that redemption will come from human effort, with or without divine aid. As Yosef Hayim Yerushalmi pointed out about the Prague Haggadah of 1526, Jewish heroes such as Judith "represent the periodic retribution achieved with the help of the Lord against the enemies of Israel in the past, a portent for the final judgment against the nations in the future."[31]

Not surprisingly, Szyk represented Moses several times in his *Haggadah*, as the Jewish fighter who strikes back at Egyptian oppression and as the leader who parts the Red Sea and takes his people to the Promised Land. He also found particular inspiration in the biblical passage from Exodus (17:8–13) that describes the battle of the Jews against their enemy, Amalek, as they marched toward the Promised Land. Szyk portrayed a muscular Moses, whose weary arms are held high by Aaron and Hur to guarantee triumph over their enemies. This image, which Szyk was to return to on several occasions in the 1940s, symbolized both the need for Jews to battle continually against "Amalek" in every generation as well as the struggle for a Jewish homeland in *Eretz Israel*.

Other illustrations also point to a clear Zionist message. The biblical figure Ezekiel, the priestly leader of the Jewish community in exile, stands in the Valley of Dry Bones, prophesying the return of the people of Israel. In a more contemporary reference, a group of disheartened eastern European Jews are shown against a background of the pyramids, the symbol of oppression, perhaps illustrating the plight of Jews in the *Galut* (exile). Another image shows *halutzim* (Zionist pioneers) bidding goodbye to their aged father who blesses them as they head off to till the soil of Palestine and reap the harvest of oranges. Such scenes are common in Zionist iconography: the elderly religious father

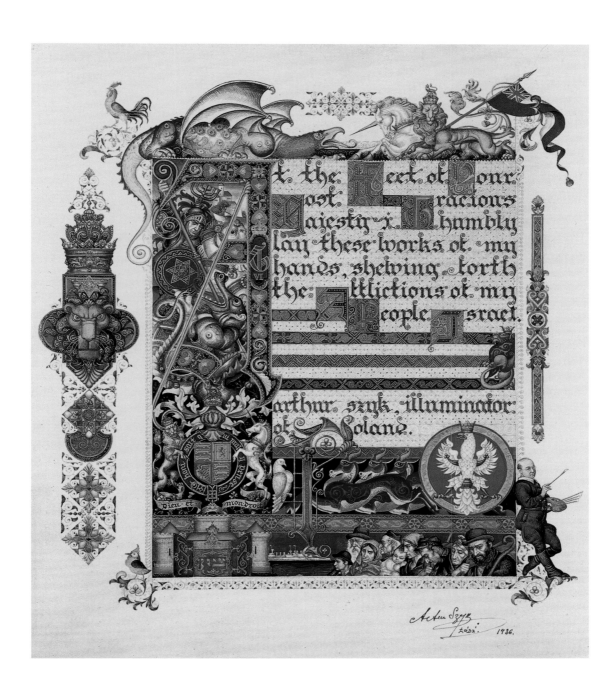

English dedication page, 1936
From *The Haggadah*, 1934–39
Watercolor and gouache on paper
Forest Group LLC (Janger Family Collection), Chicago

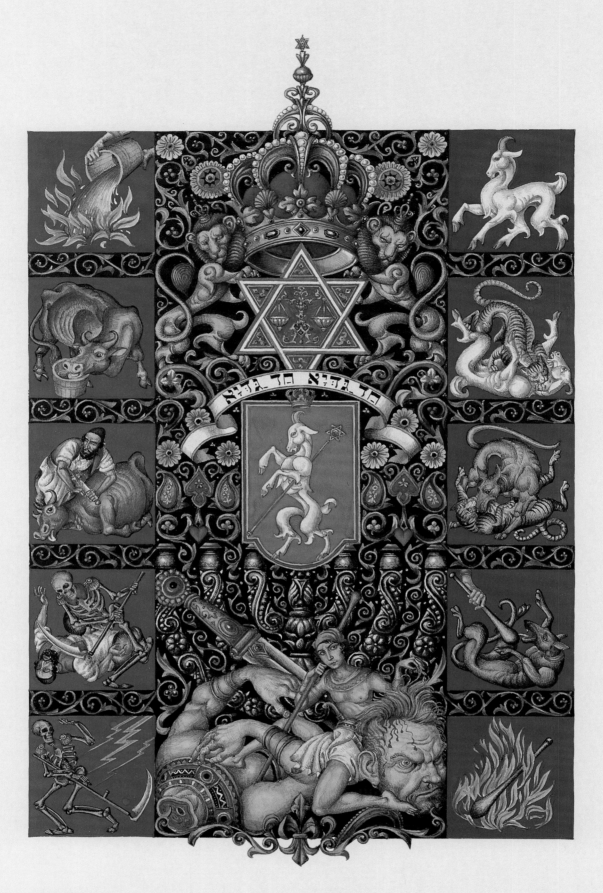

30

Had Gadya, 1934
From *The Haggadah,* 1934–39
Watercolor and gouache on paper
Forest Group LLC (Janger Family Collection), Chicago
Photo: *John Weinstein*

representing Jewish life in the Diaspora, and the youthful progeny standing for the new Jewish men and women.[32]

Perhaps the clearest Zionist statement in Syzk's *Haggadah* appears on the English dedication page. Szyk not only added an image of himself dressed in quasi-military uniform with palette and brushes as his weapons, but also included an inscription to the current British monarch, George VI:

At the Feet of Your Most Gracious Majesty i humbly lay these works of my hands, shewing forth the Afflictions of my People Israel.

Surrounding the inscription are drawings filled with symbols relating to the English monarchy, Judaism, and Poland. At the bottom of the page, a group of disheartened Jewish men, women, and children look either at the gated fortress inscribed as Zion or toward the viewer, while a navy ship patrols in the background. The fact that some of the Jewish figures look to the British ruler for help suggests that it is an appeal. Almost certainly, Szyk was urging the English king to end restrictions on Jewish immigration to Palestine that barred the Jews from safety and their homeland.

By the mid-1930s, the issue of providing safe havens for Europe's oppressed and impoverished Jews was a pressing one for Jewish activists. While Nazi Germany pursued a policy of forced Jewish emigration, using violence and state power as a cudgel, few countries were interested in accepting large numbers of needy immigrants. The Depression had left millions of people unemployed worldwide and had fueled the fires of antisemitism, xenophobia, and nativism. Moreover, by the end of the decade, Nazi Germany was not alone in seeking to solve its "Jewish problem" by forced emigration. After Piłsudski's death in 1935, Polish government officials openly expressed their desire for the mass emigration of most of the country's 3.5 million Jews. At the popular level, violence and boycotts were directed against Poland's Jews. Zionist representatives also hoped to get Jews in danger of persecution for their political beliefs out of Stalin's Soviet Union.

Palestine, under a League of Nations mandate that ceded administrative authority over the former Ottoman territory to Great Britain, served as one of several possible havens for European Jewish refugees. From 1920 onward, British authorities regulated Jewish immigration there through the issuance of immigration certificates. Potential settlers were divided into one of several economic

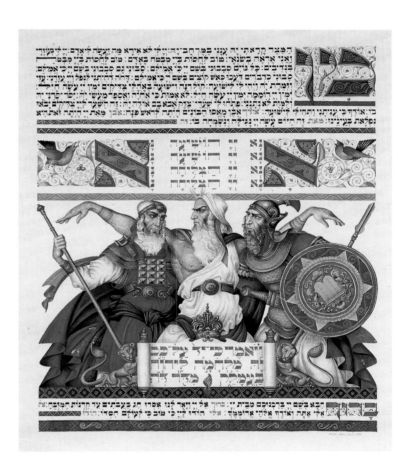

Moses, Aaron, and Hur, 1935
From *The Haggadah*, 1934–39
Watercolor and gouache on paper
Forest Group LLC (Janger Family Collection), Chicago

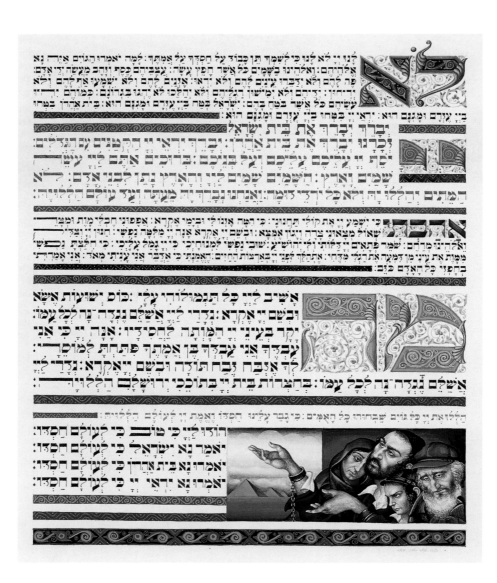

European Jews and the pyramids, 1935

From *The Haggadah,* 1934–39

Watercolor and gouache on paper

Forest Group LLC (Janger Family Collection), Chicago

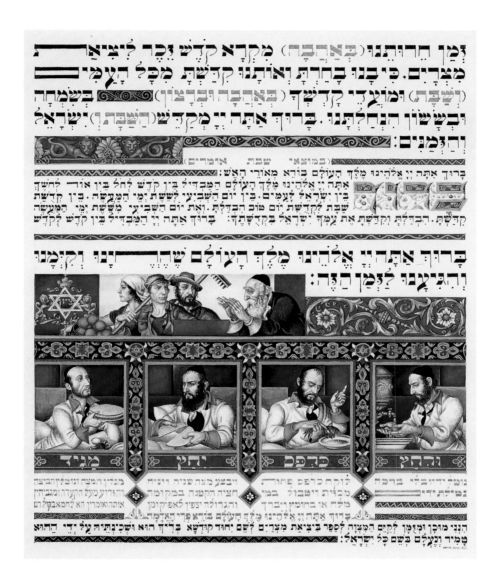

Image of Zionist pioneers, 1935

From *The Haggadah*, 1934–39

Watercolor and gouache on paper

Forest Group LLC (Janger Family Collection), Chicago

or occupational categories, such as persons of independent means, laborers, students, and those without sufficient financial support. The Jewish Agency for Palestine could request and distribute immigration certificates, but final authority for admission rested with mandate officials, who determined the number of certificates that would be available. In 1935, for example, British authorities granted 56 percent of the Jewish Agency's request for 38,100 certificates. In April 1936, Arab leaders launched a revolt aimed at putting an end to Jewish immigration, resulting in widespread destruction to Jewish property and the deaths of some 80 Jews. In response, British authorities further restricted Jewish immigration to Palestine and set up the Peel Commission to examine the growing conflict. When the Jewish Agency requested almost 22,000 immigration certificates for 1937, British officials granted only 6,300, less than 30 percent.[33] On May 17, 1939, the British government issued a White Paper that restricted Jewish immigration to Palestine to 75,000 persons over the next five years and required Arab consent for additional immigration after March 31, 1944.

Britain's White Paper was issued six months after *Kristallnacht*—the "Night of Broken Glass" (November 9–10, 1938)—when the Nazi persecution of Germany's Jews intensified and pressure to emigrate dramatically increased. But at the same time, more countries were restricting immigration. Fearful of future developments in Europe, Zionist leaders began pressing for more immigration to Palestine. David Ben-Gurion, leader of the Jewish Agency for Palestine, warned of the need to bring one million Jews to *Eretz Israel*.[34] In the mid- to late 1930s, Jabotinsky called for a mass evacuation of 1.5 million Jews, half of them from Poland, believing that unless Jewry liquidated the Diaspora, "the [D]iaspora would liquidate Jewry."[35] To rescue Jews from what he believed was an impending disaster and to create a Jewish majority in Palestine, Jabotinsky began negotiating with leaders of the Polish government to facilitate Jewish emigration from Poland, to provide military training and munitions to the Irgun, and to assist in "illegal" immigration to Palestine.[36]

In this context, Szyk's *Haggadah*, in his words a "symbol of the Jewish problem today," echoed the Zionist solution to the problem: increased immigration to Palestine. Szyk thus attacked the Nazi persecution of the Jews as well as made a Zionist appeal. His *Haggadah* held out to Jews models of ancient heroism as well as the optimistic belief that the Jewish people would triumph once again over their enemies in this darkest of times. Szyk's version also offered examples of Jewish behavior that should *not* be followed. In the parable of the Four Sons, he attacked the loss of Jewish identity and alienation that came from assimilationism, which to him was epitomized by Germany's Jews. "We are always Polish Jews," he remarked in 1934, "they [the German Jews] called themselves only Germans."[37] The wicked son, traditionally depicted in *haggadot* as a soldier, is shown here in German garb with a Hitler-like mustache.

The Haggadah went on exhibition in London in 1939, and visitors and critics doubtless understood its political messages. A reviewer for the *Jewish Chronicle*, the main journal for British Jewry, praised the work, remarking that

34

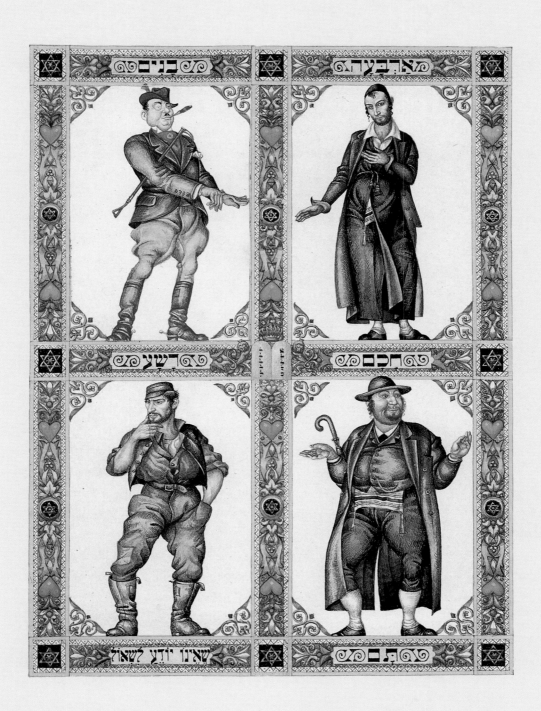

The Four Sons, 1934

From *The Haggadah,* 1934–39

Watercolor and gouache on paper

Forest Group LLC (Janger Family Collection), Chicago

the work is in no sense archaistic. It is completely modern in conception, expressing in impressive fashion the requirements and atmosphere of the present day: a permanent monument of the reaction of the Jewish spirit against the brutalities that have disgraced the twentieth century in Central Europe. . . . The Eternal Amalek reappears, time after time, in these pages as a reminder that he is doomed to fail, in his twentieth-century manifestations, no less surely than at the time of the Exodus.[38]

Two years later, an American reviewer commented that "an intense racial pride flows through Szyk's veins, and this is reflected in the militant note which characterizes much of the pictorial content of his *Haggadah*."[39]

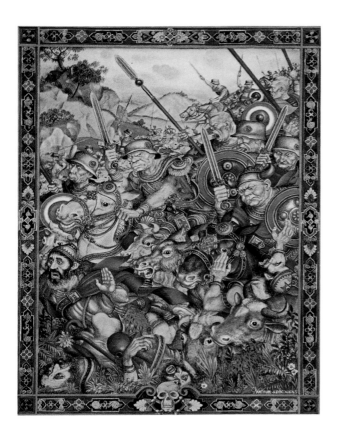

When World War II broke out in September 1939, Szyk temporarily abandoned the production of illuminated manuscripts and most book illustrations, choosing to devote his energies instead to wartime caricatures and cartoons. Yet as the war in Europe escalated and Nazi terror against the Jews intensified in the 1940s, Szyk, like fellow Jewish artists Abraham Rattner and Jakob Steinhardt, turned for inspiration to the Bible's Book of Job. For Szyk, the plight of Job—a righteous and innocent man whose faith is severely tested when he is stricken with disease, the loss of his possessions, and the senseless destruction of his family—served as an allegory for the unjust sufferings and persecutions of the Jewish people. In 1941, he detailed to a journalist the intent behind his illustration of this biblical story, likening it to Emile Zola's late-nineteenth-century biting indictment of those who sought to persecute the innocent French Jewish captain, Alfred Dreyfus:

The attack of the Sabeans, 1943
From *The Book of Job*, 1946
USHMM Collection, Gift of Dr. Samuel Halperin

> *The Book of Job is the greatest picture of what we, the Jews, are living through today. It is our 'J'Accuse' to the Gentiles. My work will have a dedication which I believe sums up our case against the persecution which we have suffered. This dedication will read: 'To Cain—from Abel.'*[40]

That the war had affected his vision of the text is clear. He portrayed the Sabeans and the Chaldeans, the invaders who attacked Job's family, pillaged his property, and killed his servants, as Germans and Japanese, respectively. Originally he painted the figure of Satan, the instigator of Job's persecution, as a Hitler-like figure tattooed with a swastika on his arm, but when Syzk's *Book of Job* was published in 1946, this particular allusion was deleted.

In the postwar years, Szyk repeatedly returned to biblical themes for inspiration, illustrating *The Book of Ruth* (1947), *Pathways through the Bible* (1946), and the story of *Joseph and His Brothers* (1949) from the Book of Genesis. In the year prior to his death, he began work on a new *Book of Esther* (1950). The tale of the Jews' triumph in ancient Persia took on special significance in the post-Holocaust years, and

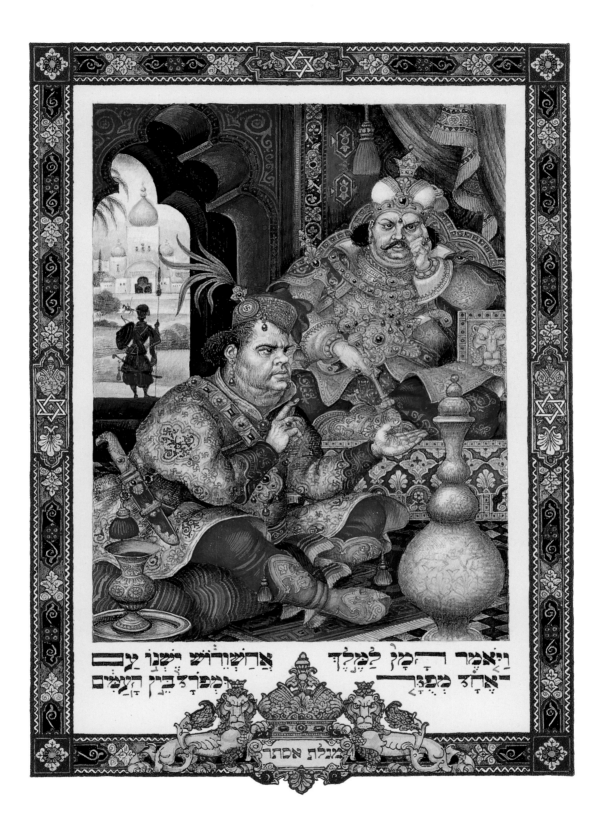

Haman's plot

From *The Book of Esther*, 1950

Watercolor and gouache on paper

Sussi Collection, Chicago

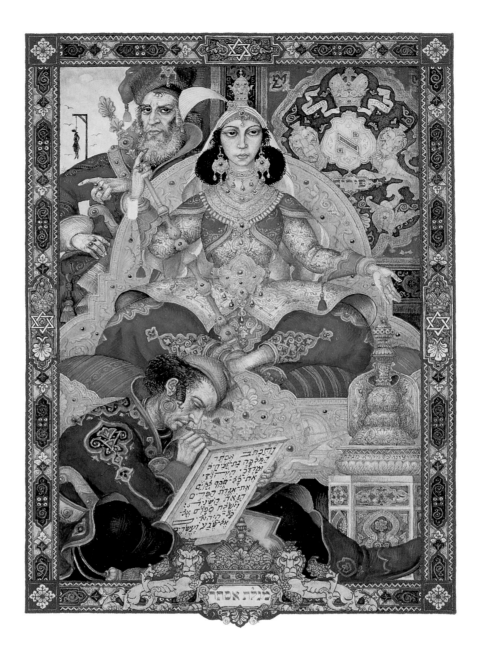

Mordechai and Esther

From *The Book of Esther*, 1950
Watercolor and gouache on paper
Sussi Collection, Chicago

Szyk again portrayed himself as the interpreter of Jewish history. Haman, who plotted the mass murder of Persia's Jews, now appeared garbed in black with swastikas emblazoned on his clothing. The final image of the work showed Szyk at his desk, looking at Haman hanging on the gallows built to kill the Jewish leader Mordechai. The text, which the artist is seen having just completed, reads: "The people of Israel will be liberated from their persecutors." In more than one way, the image serves as a fitting conclusion to Szyk's artistic career. He had witnessed the darkest period in Jewish history, Jewish resistance and heroism, and his people's eventual triumph over their enemies.

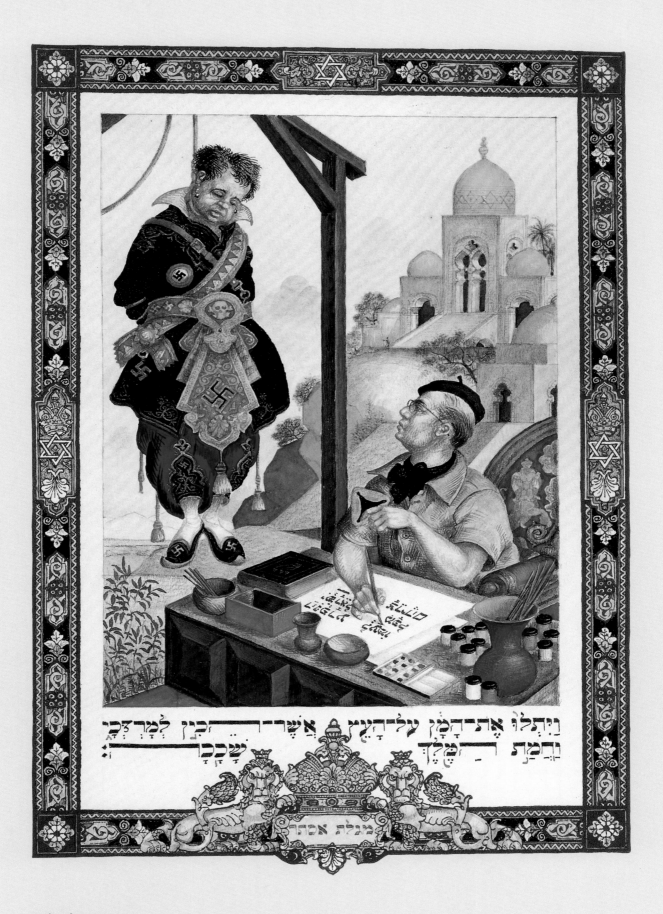

Szyk and Haman

From *The Book of Esther*, 1950

Watercolor and gouache on paper

Sussi Collection, Chicago

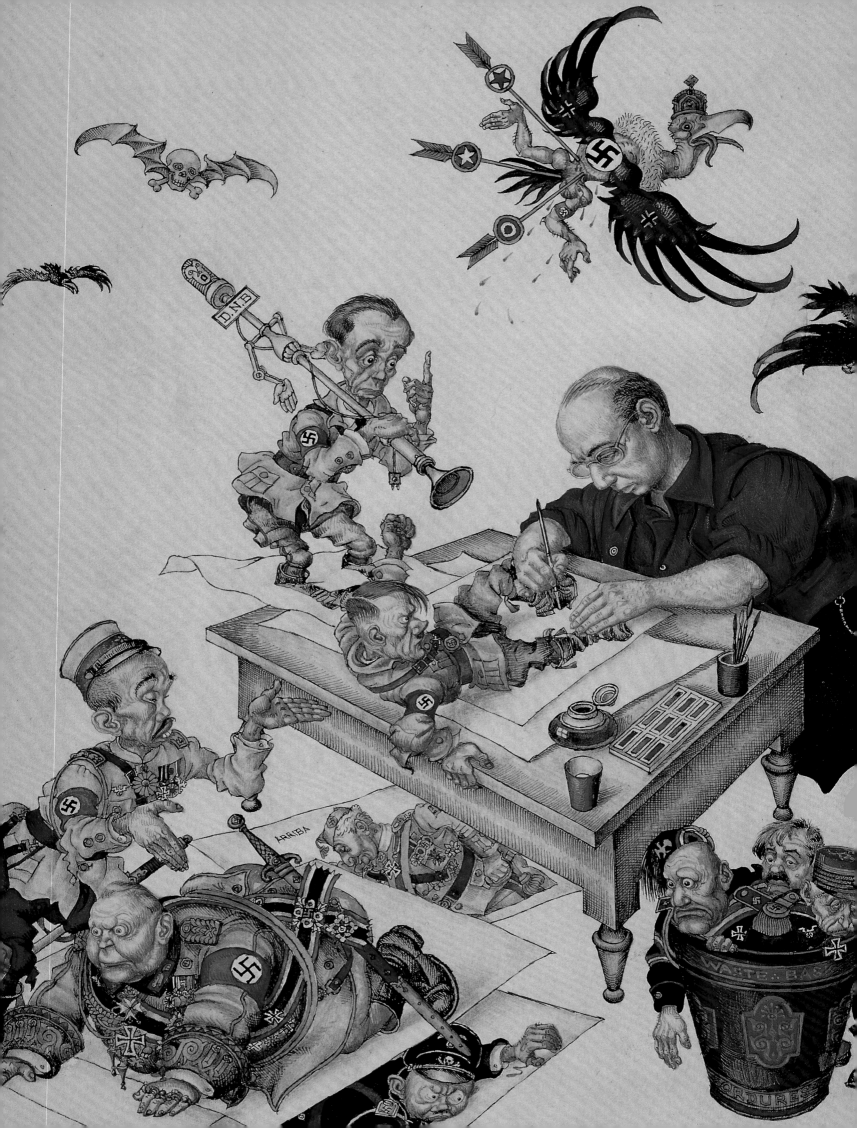

Arthur Szyk became one of America's most prominent cartoonists and caricaturists during World War II. Throughout the 1940s, his images reached millions of people through exhibitions, magazines, and newspapers. During the darkest periods of the war, his work provided Americans with a reason to fight by exposing the villainous threat that Nazism posed to Western civilization, and it boosted morale by glorifying the heroic deeds of the Allied soldiers. Often described as "a one-man army," Szyk prided himself on being a propagandist for the Allies. Responding to those who questioned whether propaganda could be considered art, he remarked: "The origin of all art is what we call propaganda. The art of Egypt, Greece, Rome, the Renaissance, was the propaganda of religion. I do not say that art is my aim; art is my means."[1] Thomas Craven, among America's leading art critics of the day, applauded Szyk and his wartime paintings and drawings:

A patriot and a man of intense conviction, Arthur Szyk has used his artistry on behalf of humanity and in the interest of the great war effort. For several years, in fact, since the beginning of Hitler's death-march through the smaller nations, he has relentlessly depicted in line and color the evils and horrors of Fascism and Nazism, and the sinister operations of butchers and traitors everywhere. . . . I know of no other instance in which the decorative apparatus of miniature painting has been combined with the onslaught of direct cartooning to produce an instrument of such deadly effectiveness.[2]

From his early years in Poland, Szyk had a fascination with portraying current events. As noted, in the years before World War I, he earned a living creating satirical images for the Polish humor journal *Śmiech*. He lampooned local figures

Ink and Blood, 1944
Watercolor, graphite, colored pencil, and ink on paper (detail)
USHMM Collection, Gift of Alexandra and Joseph Braciejowski

41

Over There a Polish Peasant Cries
Śmiech cover, November 2, 1912
National Library, Warsaw

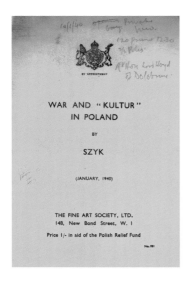

War and "Kultur" in Poland, 1940
Exhibition program cover
*Mass-Observation Archive, University of
Sussex, Brighton*

and portrayed the coming clouds of war. After the war, he joined forces with the gifted Polish Jewish poet Julian Tuwim to create *Revolution in Germany* (1919), a satirical work that ridiculed the country's militarism and intellectuals. Those ideas changed little over the course of time, and even before the Nazis came to power in 1933, Szyk was raising the spectre of a revanchist Germany eager to destroy European peace to satisfy its territorial claims on France and Poland. The pairing of the German military and the figure of Death would become a common iconographic theme in his wartime art.

Szyk was in London when World War II began in September 1939 and his beloved Poland was dismembered by Nazi Germany and the Soviet Union during the ensuing weeks. In a January 1940 letter to the British newspaper *Free Europe*, Szyk articulated his feelings as a Polish Jew in this time of crisis. Calling himself a "loyal son of Poland and of Polish Jewry," Szyk wrote:

Polish Jews have always called the Germans amalek, a term which requires no explanation to anyone who knows his Bible. The Jews have not always realized that the Germans are their implacable enemies. The history of the German Drang nach Osten [Drive to the east] is closely connected with the problem of destroying Jewry in Eastern Europe. The Jews, owing to their commercial abilities, have always been an obstacle on the road of German economic expansion in the East. . . . A similar situation was observed in Poland, where, especially after the death of Marshal Piłsudski, the ruling group practised a new type of antisemitism, which however was not a product of Polish origin. It was an export article from Germany, who during the last few years has pursued a policy of sapping the strength of the countries of Eastern and South-Eastern Europe by a threefold method: by encouraging the governments of so-called "strong men" opposed to democratic "anarchy"; by organizing "fifth columns" from among members of the German minorities; and by stirring up antisemitism of the exterminatory brand. . . . Under the sledge-hammer blows of their traditional enemy both the Poles and the Jews are bleeding, and from their common suffering a new spirit of mutual understanding, tolerance, and collaboration will arise. . . May this purgatory through which both the Polish and the Jewish peoples are now passing be a warning. The time of hatred belongs in the past.

After pledging his support to the Polish government-in-exile, Szyk concluded his letter by paraphrasing the oft-quoted passage from Psalm 137:5, "If I forget thee, Poland, let my arm be withered. . . ."[3]

Szyk's wartime art was the subject of major exhibitions at Fine Arts Society, Ltd., in London (January 1940), the Mellors-Laing Galleries in Toronto (September 1940), and the Knoedler Galleries in New York City (May 1941). On display was a growing collection of what was described in gallery catalogs as "cartoons & caricatures of the war," versions of what Szyk titled *War and "Kultur" in Poland*. British newspapers quickly recognized the strength and appeal of his new artwork. The London *Times* reviewer of the exhibition commented on its key themes and the potency of its imagery:

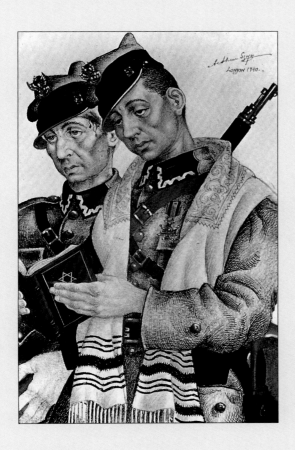

43

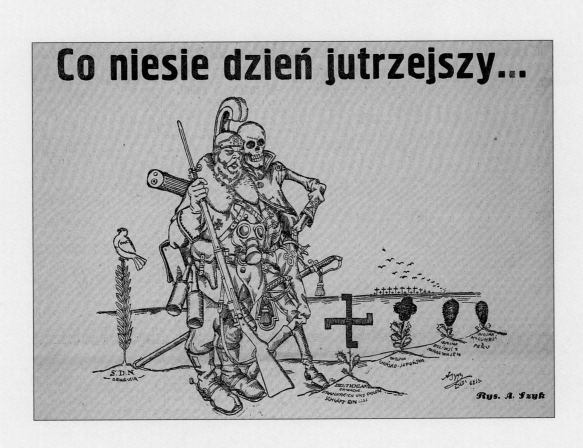

44

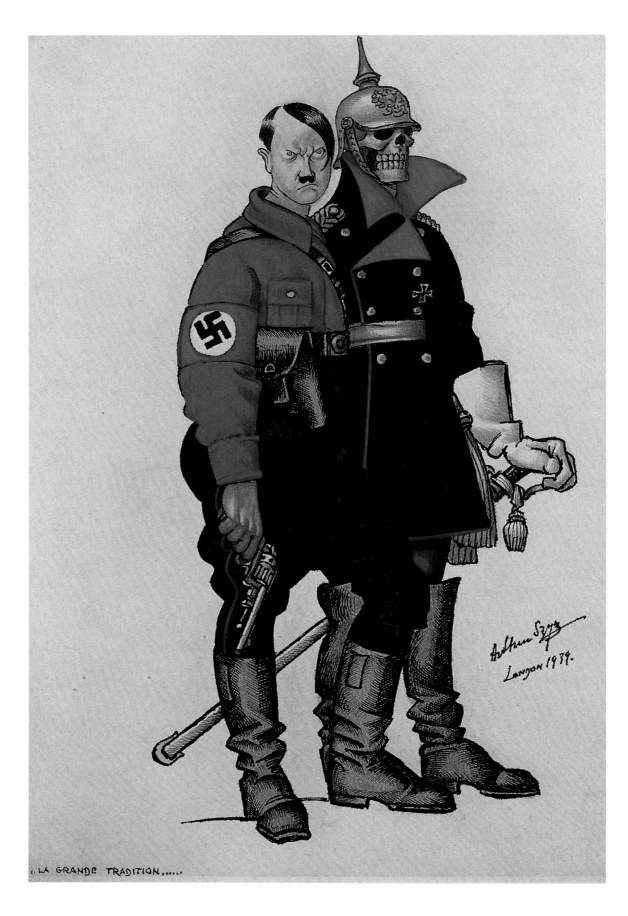

La Grande Tradition, 1939
Pen, ink, and wash on paper
Fine Arts Society PLC, London

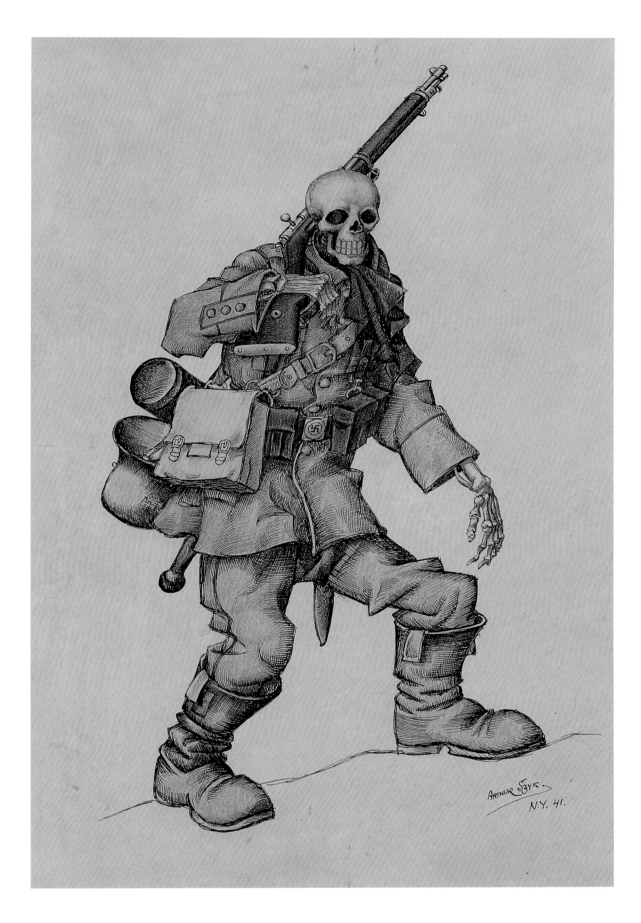

Nordic Hero, 1941
Ink, graphite, colored pencil, and pastel on paper
U.S. Naval Academy Museum, Annapolis

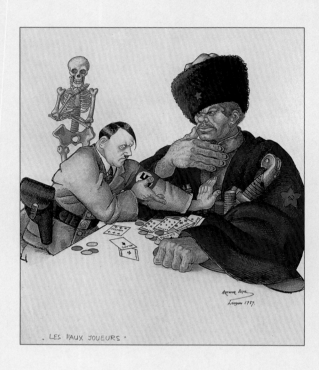

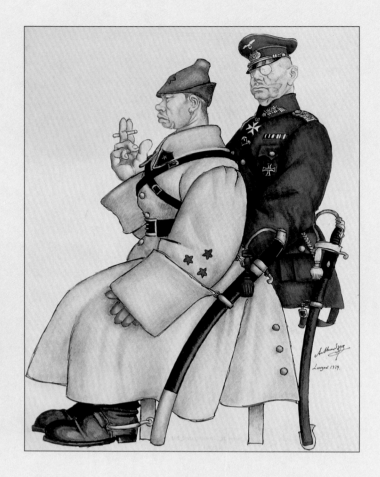

46

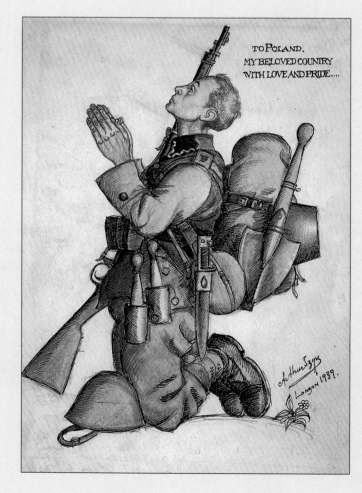

Les Faux Joueurs, 1939
Pen, ink, and wash on paper
Grosvenor Gallery, London
ABOVE LEFT

Nazi and Soviet overlords, 1939
Location of original artwork unknown
Photo: *Irvin Ungar through the Arthur
Szyk Society*
ABOVE RIGHT

"O Lord, Let Us Not Lose Courage," 1939
Watercolor, graphite, pen, and ink
on paper
The British Museum, London
RIGHT

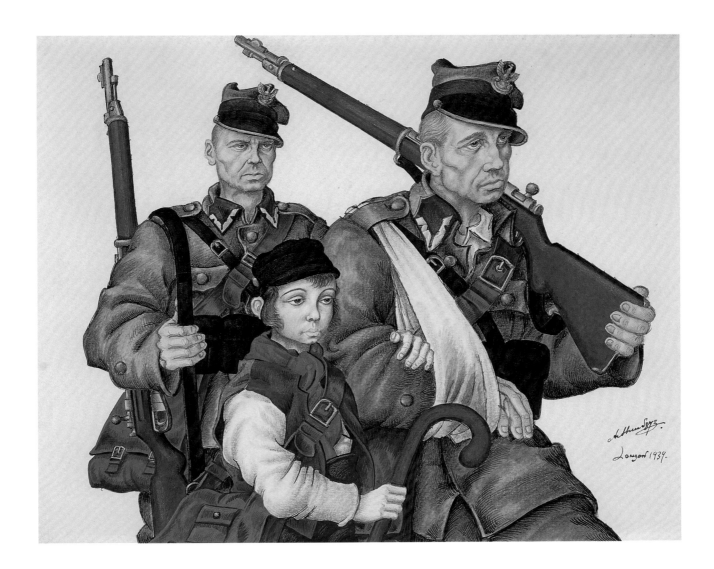

Retreat, 1939
Graphite, watercolor, gouache, pastel, and ink on paper
Hugh Raffles and Sharon Simpson, California

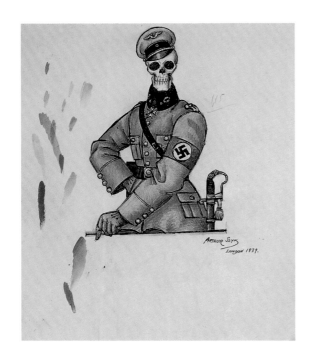

The German "Authority" in Poland, 1939
Graphite and ink on paper
Irvin Ungar through the Arthur Szyk Society

48

There are three leading motives in the exhibition: the brutality of the Germans—and the more primitive savagery of the Russians, the heroism of the Poles, and the suffering of the Jews. The cumulative effect of the exhibition is immensely powerful because nothing in it appears to be a hasty judgment, but part of the unrelenting pursuit of an evil so firmly grasped that it can be dwelt upon with artistic satisfaction.[4]

Significantly, a number of Szyk's images show Poles and Jews fighting together. The exhibitions were intended to invoke sympathy and support for Great Britain, then fighting alone with only the remnants of their Polish, Czechoslovak, and French allies. Sales of the works raised funds for the British American Ambulance Corps and Polish war relief agencies.

Following the German invasion and occupation of much of western Europe during the first half of 1940, Szyk earnestly felt that exhibitions of his artwork could help win precious public support in the United States for the European Allies. To that end, he solicited aid from both British and Polish representatives. In a confidential letter to officials of the Polish government-in-exile, written in June 1940, he proposed a plan to carry out propaganda activities on behalf of the Allies, which he claimed had official British sanction. He specifically wanted to appeal to American Jews, who were already fully opposed to Hitler but not yet totally behind the Allied war effort. He cited several reasons for this attitude: America's non-interventionist policy, the Allies "absolute silence" on the issue of solving Jewish problems after the war, the lack of a "concrete declaration" on behalf of the Polish government-in-exile on this issue, and Great Britain's White Paper, which restricted Jewish immigration to Palestine. To win American Jewish opinion, he proposed placing his anti-Nazi images in American magazines and exhibiting his *Statute of Kalisz, Haggadah,* and other wartime drawings, as well as his works *The History of the Poles in America* and *George Washington and His Times.*[5] He envisioned the exhibition opening in Washington, D.C., from where it would travel to Hollywood, "the center of the most powerful representatives of Polish Jews in America." There Szyk hoped to meet with actors Paul Muni and Eddie Cantor, and the studio heads of Metro-Goldwyn-Mayer, Warner Brothers, and Paramount.

Whether the British or Polish governments accepted his plan is not clear. Britain certainly hoped the United States would join the war effort, but it also was well aware of the deep suspicion that many Americans held toward "propaganda," especially from foreign sources. Many Americans believed that British propagandists had manipulated American public opinion and dragged the United States into World War I. In response to these sentiments, British officials adopted a "no propaganda" approach to their operations in America. They instead worked through sympathetic American journalists and funneled "information" through the news media. Still, the British Foreign Office, which did not want to be discovered funding covert propaganda actions by foreign operatives, did provide

assistance to the Polish government-in-exile and other Allied governments to work in the United States.[6]

While no conclusive proof has yet surfaced—and may not because the records of the American Division of Great Britain's Ministry of Information apparently were destroyed or lost after the war—Szyk provided the Polish government-in-exile with certain details that seem to suggest that the British were anxious to use him as a propagandist:

The Ministry of Information supports my plan and thinks my trip is much desired. As proof, there is a confidential note from the above ministry in the possession of Major [Arthur] A. Longden from the British Council, who organized my exhibition in England. I can depart only at the wish of the Polish government. From the British note I assume that the money needed for my trip and to organize the exhibit in America would be, if needed, supplied for our propaganda, but in no case to me personally, or officially, but strictly confidentially. That is my impression from reading that note.

The English regard their propaganda situation in the U.S.A. the weakest among the Allies and prefer that the initiative should come from us.[7]

Szyk's points are certainly in keeping with British propaganda methods in America in 1940, and they document his initial willingness to serve British and Polish wartime interests.

Following a meeting with Władysław Sikorski, the head of the Polish government-in-exile and his former commander in the Polish-Soviet War, Szyk and his family sailed for Canada, where they spent several months in Ottawa. After moving to New York City in late 1940, he quickly embarked upon a campaign to alert isolationist America—Fortress America—to the deadly evil of the fascist aggressors in Europe. Although anti-Nazi sentiment was strong in the United States, most Americans, hoping that Germany would be defeated, did not want to get involved in a war in Europe. In the summer of 1940, the Gallup polls indicated

Greeting the Luftwaffe, 1940
Graphite, colored pencil, and ink on paper
USHMM Collection, Gift of Alexandra and Joseph Braciejowski

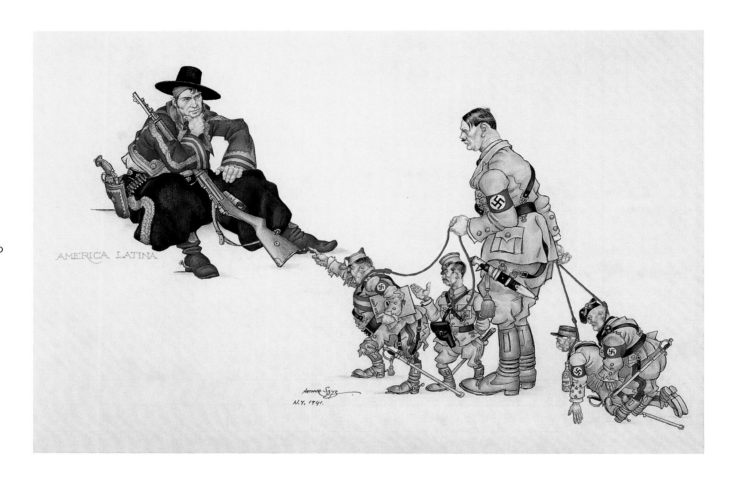

AMERICA LATINA

America Latina, 1941
Watercolor, gouache, pastel, graphite, and ink on paper
Anne and Ronald Abramson, Washington, D.C.

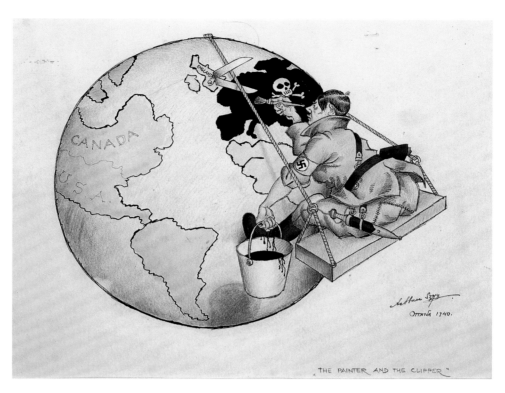

The Painter and the Clipper, 1940
Graphite, colored pencil, and ink on paper
USHMM Collection, Gift of Alexandra and Joseph Braciejowski

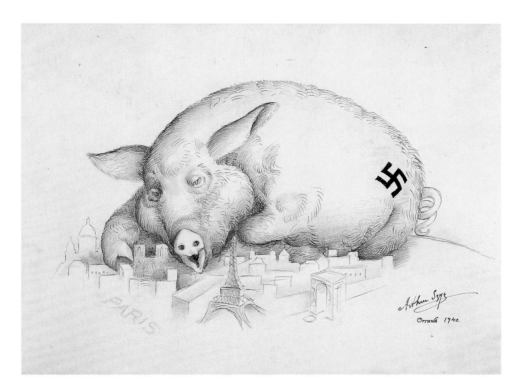

Occupied Paris, 1940
Graphite, watercolor, and ink on paper
Private Collection, California

that 80 percent of those surveyed opposed an American declaration of war against the Axis powers.[8]

For those supporting intervention in Europe on the side of Great Britain, the news of France's quick defeat by German troops in June 1940 was disheartening. Some attributed the collapse to defeatism and the "failure of national will" and worried that, in the event of war, the United States could suffer the same fate.[9] Interventionists frequently accused America's isolationists of fostering defeatism and sought to boost public morale and support for Britain.

Szyk, for his part, created images that showed a valiant and defiant England fighting alone against Nazi Germany. Though shaken by France's defeat, he retained an impassioned optimism in Britain's final victory. In a letter to his friend Tuwim, Szyk tried to bolster the poet's sagging morale:

I never had any doubts, because I know the English. They do not like to be conquered. This is a completely unknown phenomenon to them, and even a thought of their conquest is unacceptable. But if you think that we caught God by his coat, you are mistaken. We have horrible, difficult moments ahead of us in this war, when we will feel that this is the end of us, but this will be just an optical illusion. The Germans want to weaken us by exhausting us emotionally. It worked till now, because the opponents have emotions and too many of these. What can the Germans do to England? The British are not emotional "Lasciate ogni speranza" [Abandon all hope]—nothing will save the Germans. So stop thinking about the results of this struggle. Eliminate from your thoughts the supposition that you can change fate. If one could talk about a "Chosen Nation" it is the British Nation. Never before did any nation take such a mission upon itself.[10]

Although Szyk's attitude toward Great Britain changed dramatically during the war over the issue of Jewish immigration to Palestine, he never lost faith in the ultimate victory of the Allies or in the just nature of their cause.

Within a year after arriving in the United States, Szyk started to win notice for his provocative cartoons and satires. In June 1941, G. P. Putnam's Sons published a hardback edition of his works under the title *The New Order*, after the Nazi's self-proclaimed state. The book accompanied a concurrent nationwide tour of his artwork. In his introduction, Roger W. Straus, Jr., remarked that "as yet, the work of Arthur Szyk may not be widely familiar to the American public, but there are first-rate critical minds who think that it should be—and that it will be."[11] In 1941, Szyk's caricatures had become regular features in the New York daily newspaper *PM* and the monthly magazine *American Mercury*, but these reached only a limited and liberal-leaning readership.

In the months prior to the December 1941 Japanese attack on Pearl Harbor, Szyk aimed satirical barbs at the America First Committee and its leading spokesmen Charles Lindbergh and Gerald P. Nye. In his mind, they were subversives, eating away at the health of the nation. As the most recognized proponent of American isolationism, Lindbergh was a special target, particularly after the famed flier accused the British, the Jews, and the Roosevelt administration of pushing the country toward war in a September 1941 speech in Des Moines, Iowa.

Christmas over England, 1940
Pencil and ink on paper
Anne and Ronald Abramson, Washington, D.C.

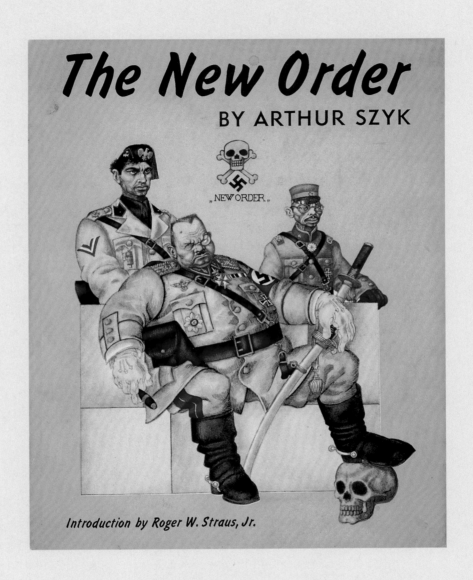

The New Order, 1941

Slipcover

U.S. Naval Academy Museum, Annapolis

54

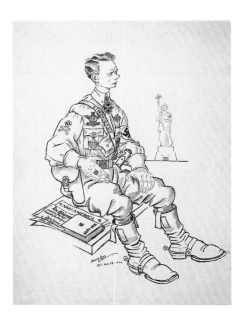

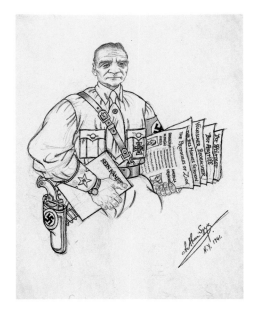

The artist not only played up Lindbergh's prior associations with German leaders like Hermann Göring, the head of the German air force, but he portrayed Lindbergh as a would-be member of the Nazi *Sturmabteilung* (SA, Storm Troopers), just waiting to be appointed leader of a Nazi America. Likewise, he denounced Gerald P. Nye, the populist senator from North Dakota who had earned notoriety for his zealous isolationism and his vociferous attacks on the munitions industry, the Roosevelt administration, and Hollywood. In language that smacked of antisemitism, Nye boldly accused the film industry of promoting pro-war, interventionist propaganda.[12] Szyk caricatured the senator as a brown-shirted Storm Trooper peddling antisemitism to the American people via Nazi newspapers like the *Völkischer Beobachter*, *Der Angriff*, and *Der Stürmer*; copies of Lindbergh's Des Moines speech; *The Protocols of Zion*; and a book, *Sein Kampf* (His Struggle), a parody on Hitler's autobiography *Mein Kampf*.

In the aftermath of the Japanese strike at Pearl Harbor on December 7, Szyk was propelled into the front ranks of American writers, artists, and intellectuals who mobilized their talents for the coming conflagration. The "day of infamy" occasioned no fewer than five Szyk images, two of which appeared on magazine covers. Suddenly, Szyk's biting satires appeared everywhere, his messages attuned to an America incensed by the Japanese treachery and awakened to the Nazi threat. In 1942 and 1943, Szyk's war-driven political satires found their way into *Esquire*, *Collier's*, *Look*, *Liberty*, and the *Saturday Review of Literature*. He became the regular feature cartoonist of the *New York Post* and the *Chicago Sun*. The National Press Service Features syndicated his anti-Axis cartoons to hundreds of newspapers throughout the United States and South America.

Like other artists of the period, Szyk believed that the Nazis were a menace not just to European society but to world civilization. The comic image of bloated Nazi figures festooned with sashes, belts, medals, and other accoutrements was in pointed, sober counterpoint to the slogan, in German, "Today Europe, tomorrow the world." His wartime artwork also highlighted the common fear of Axis infil-

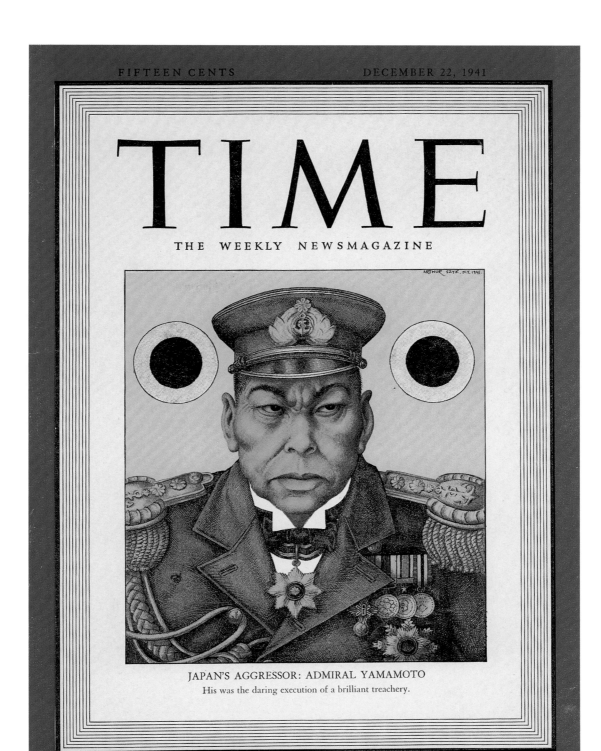

Admiral Yamamoto

Time, December 22, 1941

Wm. Hallam Webber, Maryland

Hawaiian Melodies, 1941
Watercolor, gouache, crayon, pencil,
and ink on board
The Library of Congress, Washington, D.C.

56

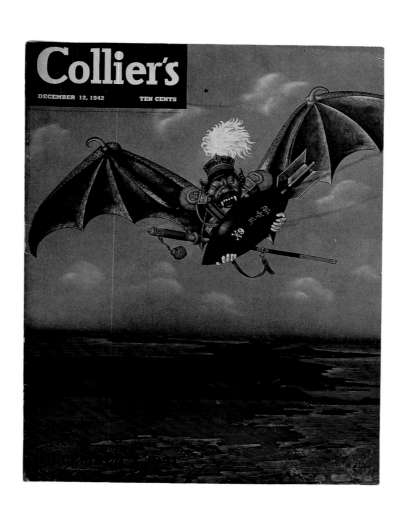

December 7, 1941
Collier's, December 12, 1942
Wm. Hallam Webber, Maryland

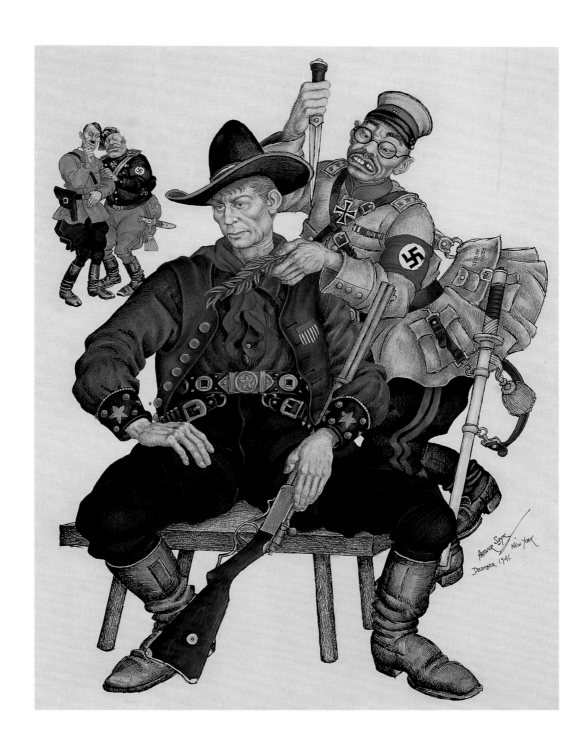

December 7, 1941, 1941
Watercolor, gouache, pastel, graphite, and ink on board
U.S. Naval Academy Museum, Annapolis

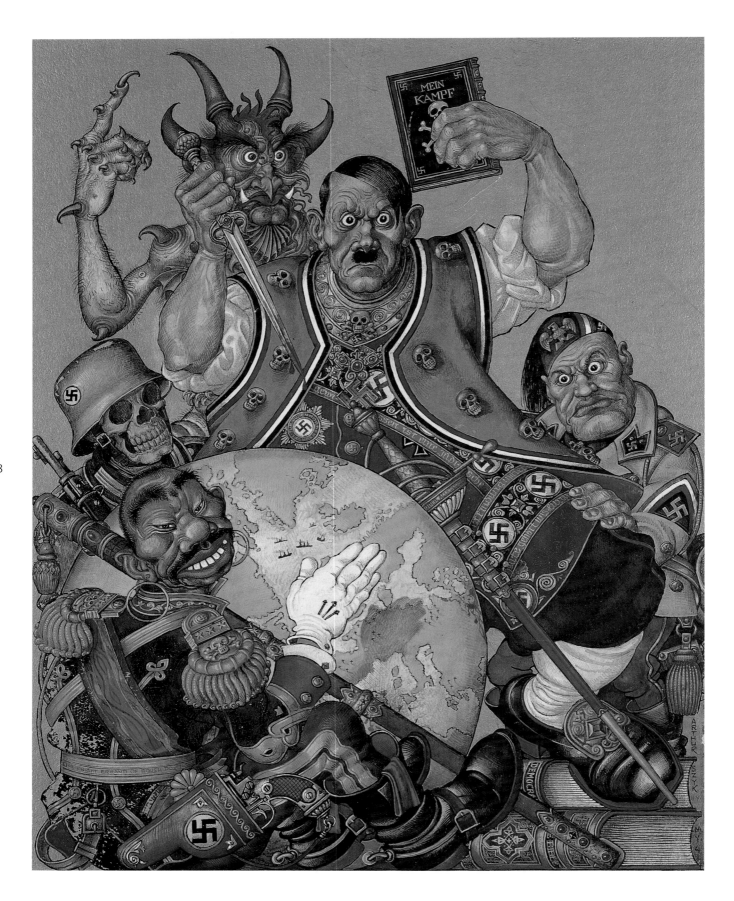

He Who Rules by the Sword, 1942
Watercolor, gouache, and ink on board
Art Gallery of Ontario, Toronto

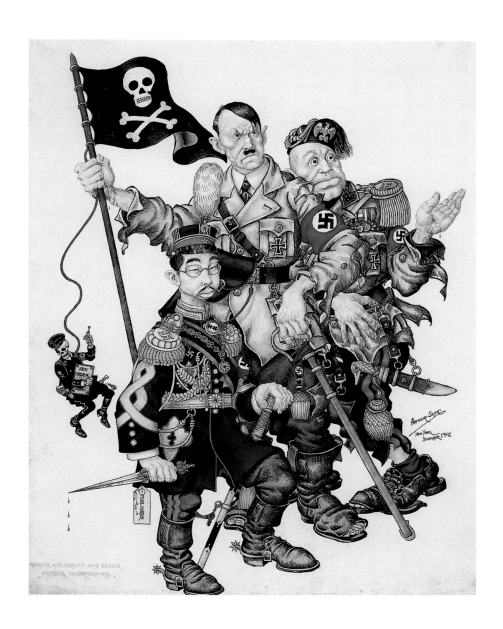

Murder Inc., 1941
Watercolor, gouache, pastel, graphite, and ink on board
Joanna and Daniel Rose, New York

60

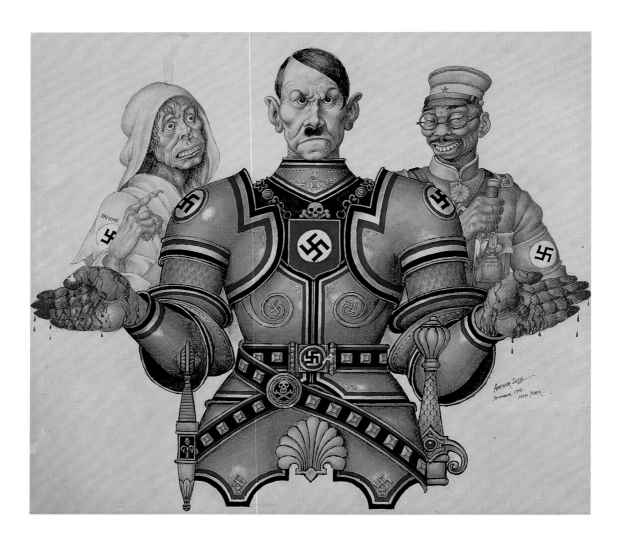

Bloody Hands, 1941
Watercolor, gouache, pastel, graphite, and ink on paper
U.S. Naval Academy Museum, Annapolis

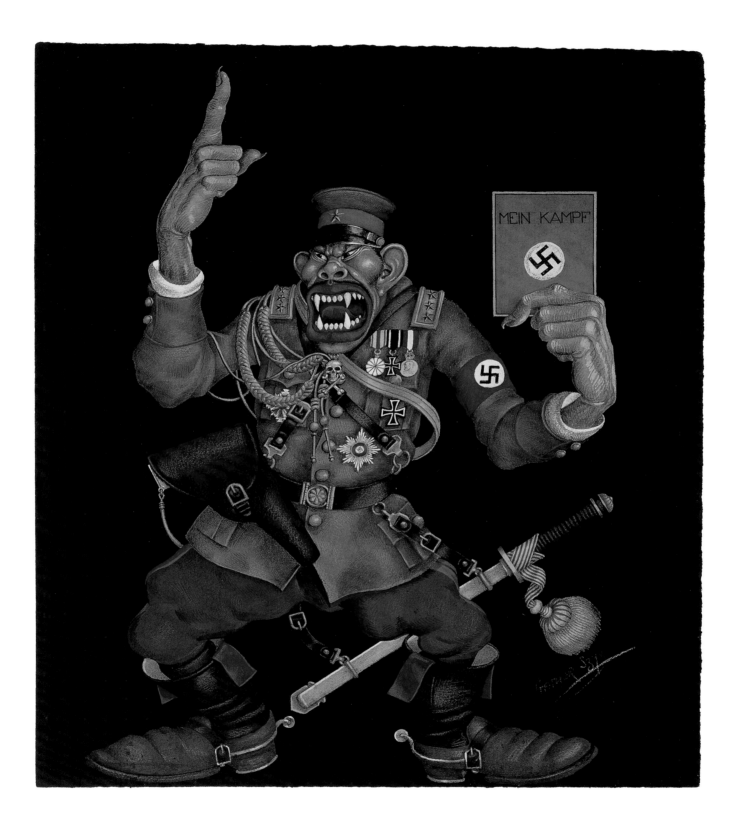

Mein Kampf, 1943
Watercolor, gouache, pastel, and graphite on paper
U.S. Naval Academy Museum, Annapolis

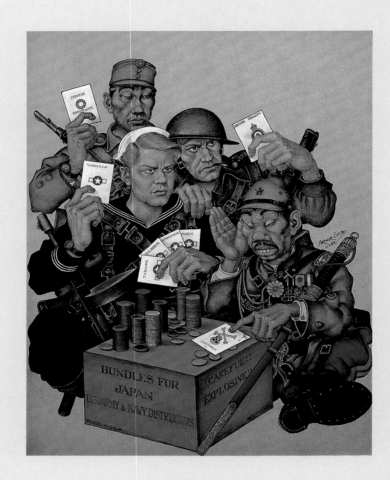

Bundles for Japan U.S. Army and Navy Distributors, 1944
Watercolor, gouache, colored pencil, graphite, and ink on paper
U.S. Naval Academy Museum, Annapolis

62

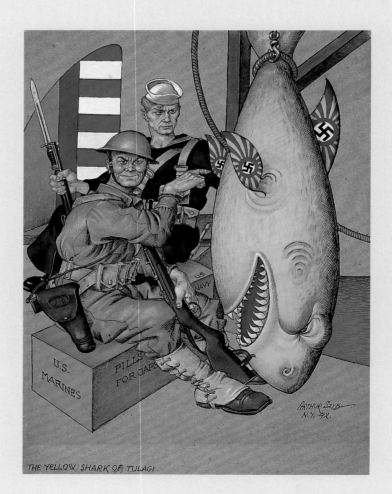

The Yellow Shark of Tulagi, 1942
Watercolor, gouache, pastel, and ink on board
USMC Historical Center, Washington Navy Yard, D.C.

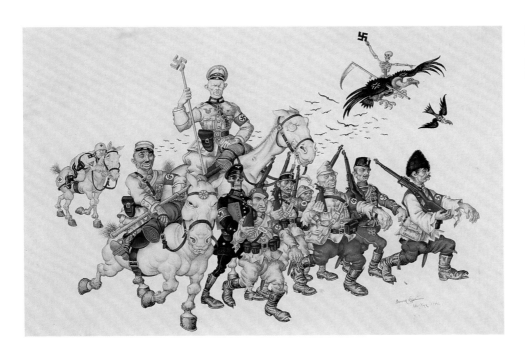

The New Orderlies, 1941
Watercolor, gouache, pastel, and
graphite on paper
Gluckselig Family Collection, New York

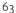

tration into North and South America and the dangers of internal subversion.
Szyk's prodigious output was daily fare for an American public following the
events of the war—Vichy, the invasion of North Africa, Stalingrad, the battle for
the Solomon Islands, D-Day, the liberation of Paris, the Nazi collapse, and the
destruction of Japan.

Throughout the war, Szyk's political art found numerous other outlets. Exhi-
bitions were mounted in galleries and museums across the country, including the
Museum of Science and Industry in New York City, San Francisco's Palace of the
Legion of Honor, the Philadelphia Art Alliance, the Whyte Gallery in Washington,
D.C., and the Telfair Academy in Savannah, Georgia. After a successful exhibition
at Mitchell Field, New York, the base commander dubbed Szyk "Citizen Soldier of
The Free World"; the artist thereafter took exhibitions to West Point, Annapolis,
Fort Dix, and other military installations. The United Service Organizations
(USO) displayed Szyk poster prints at 500 U.S. Army recreation centers, and a
magazine survey reported that his caricatures were as popular as pin-ups of
actress Betty Grable for overseas-bound troops. Referring to himself as Roosevelt's
"soldier in art," Szyk's caricatures also appeared in corporate advertising for
General Motors, Philco, U.S. Steel, North American Aviation, Coca-Cola, and
Casco; patriotic ads for U.S. Treasury War Bonds; and stamp series issued to raise
funds for such causes as the British American Ambulance Corps, Polish War
Relief, and Bundles for Britain.

Szyk's caricatures perfectly reflected the prevailing moods and attitudes of
America at war. In keeping with the goals of the country's official propaganda
agency, the Office of War Information (OWI), he trumpeted the justness of the
Allied cause in the struggle against fascism, and promoted Roosevelt's Four
Freedoms—the freedom of speech and expression, freedom to worship God in
one's own way, freedom from want, and freedom from fear—as the proper ideals
for a future democratic world.[13] Ironically, Szyk's savage portrayals of the Japanese

63

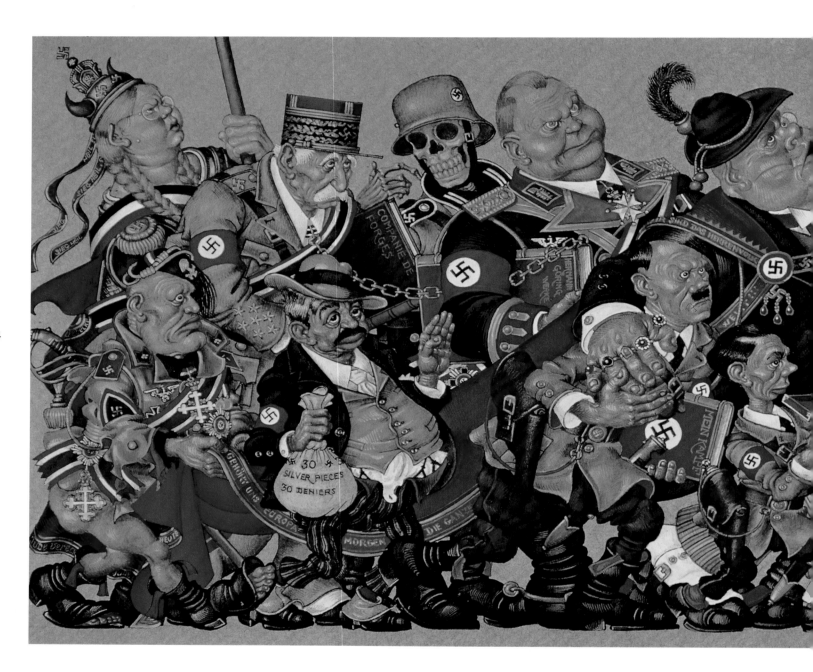

Satan Leads the Ball, 1942
Location of original artwork unknown
Photo: *Irvin Ungar through the Arthur Szyk Society*

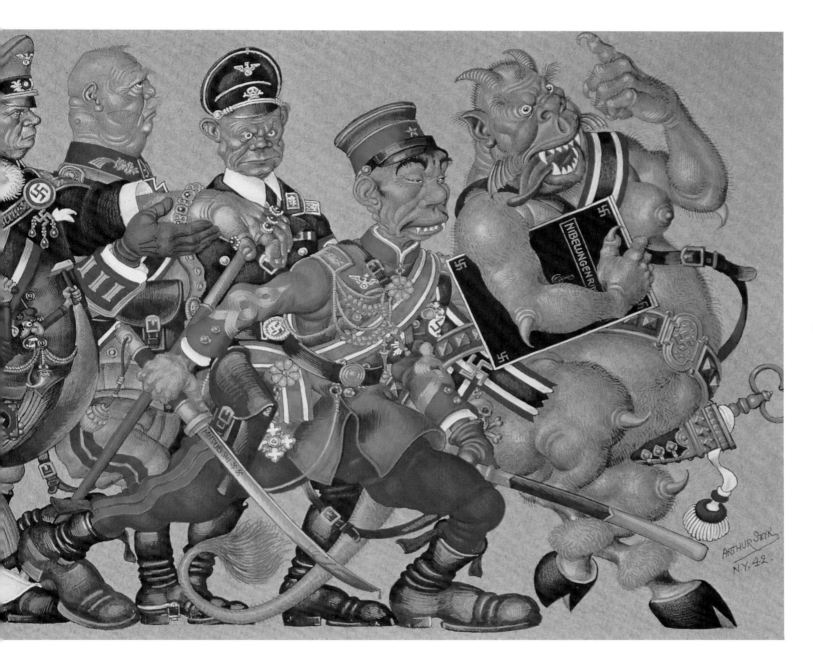

as inhuman beasts betrayed a racism that characterized the American view of the brutal Pacific War and the stereotyping found in the work of many Allied cartoonists.[14] Little in the artist's background suggests that he harbored a long-seething hatred of Japan; indeed, his caricatures of its leaders began appearing only in 1940 and 1941, when that country joined the Axis alliance. Until Pearl Harbor, the Japanese played a secondary role in Szyk's cartoons, much like the Fascist Italians. He emphasized their militarism and often portrayed them with swastikas and Iron Crosses to reinforce the ties to Nazi Germany, yet they appeared to be less threatening than Hitler. This changed dramatically after the Japanese sneak attack on the United States in December 1941. Though they never supplanted the Germans as his key enemy during the war, the Japanese increasingly were depicted as sinister, treacherous, and after 1942, as ape-like creatures or as bats, suggesting a less-than-human nature.

Like other wartime cartoonists, Szyk ridiculed, lambasted, and dehumanized the enemy. He created stock figures representing national character types, whether Allied friend or Axis foe, that often displayed exaggerated or distorted physical features. In his depictions of Göring, for instance, Szyk lampooned the German air force leader's covetousness for titles, uniforms, and stolen property as well as his expanding girth. He pictured Italian Fascist leader Benito Mussolini as a posturing fool whose imperial pretensions were out of keeping with his army's poor performance in the field. Szyk's many images of Hitler range from the comic to the terrifying. He made Goebbels, Germany's propaganda minister, the master of deceit who manipulates the news to split the Allies and to glorify the less-than-glorious deeds of the Third Reich. He caricatured Henri Pétain and Pierre Laval, France's collaborationist leaders, as obedient lapdogs to Hitler and Judases to their country, down to their bags replete with silver. His renderings of the Germans ran from the stock Prussian military officer with his monocle and severe demeanor, to the fat obedient *Bürger*, to the brutal SS man. As he freely admitted in 1942, "In my cartoons I try to accentuate all the vileness, villainy, and bestiality of the enemy."[15]

Szyk also waged personal wars with his cartoons, sometimes using them as a vehicle for his less-than-mainstream opinions. Among these was his view on race relations in the United States. He featured African American soldiers in several of his works, highlighting their contribution to the Allied war effort. To be sure, American propagandists wanted to show a country united against a common enemy, and they circulated carefully selected images of blacks and whites working together.[16] Szyk, however, went further than most, pointedly commenting on racism in the United States. In 1942, for instance, he responded to a journalist who asked him about his postwar plans: "Only time will tell what my new mission will be," he replied. "It may be complete Negro enfranchisement and social equality. Who knows? That is a subject dear to my heart." During the height of the war, when the U.S. armed forces still maintained racially segregated units, Szyk showed African American soldiers with white GIs (Jews as well as Christians) as a model of ethnic harmony. In 1944, he created a drawing of two American

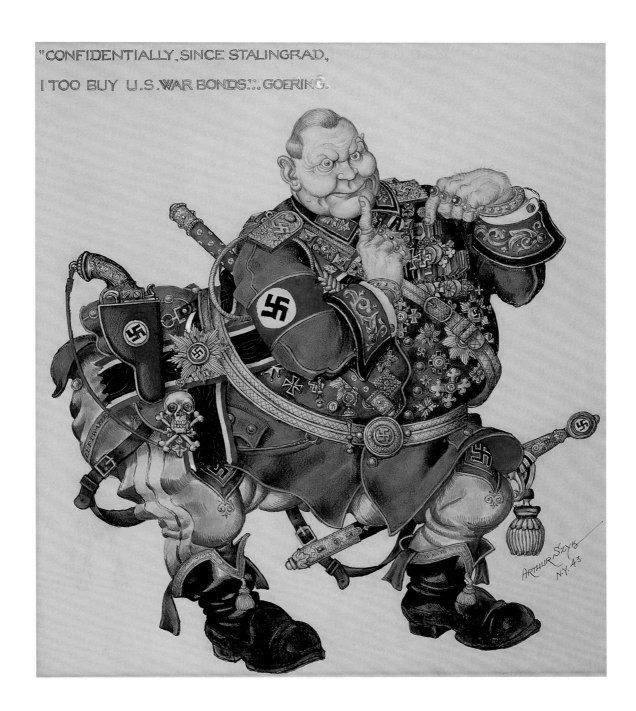

Confidentially, since Stalingrad, I Too Buy U.S. War Bonds!, 1943
Gouache, watercolor, graphite, pastel, and ink on paper
U.S. Naval Academy Museum, Annapolis

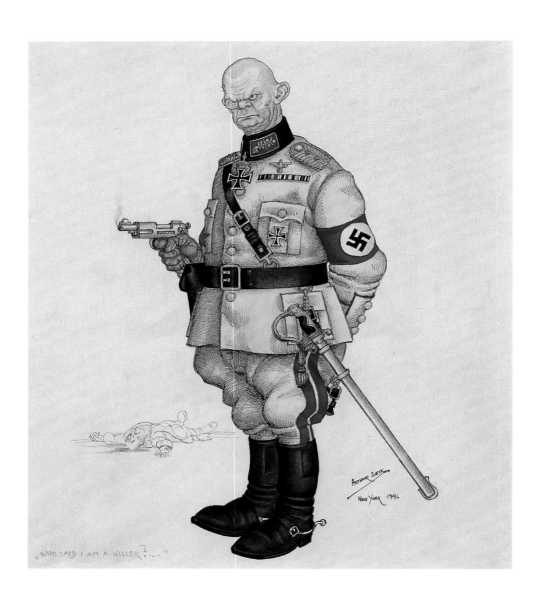

Who Said I Am a Killer?, 1941

Watercolor, gouache, graphite, pen, and ink on paper

USHMM Collection, Gift of Alexandra and Joseph Braciejowski

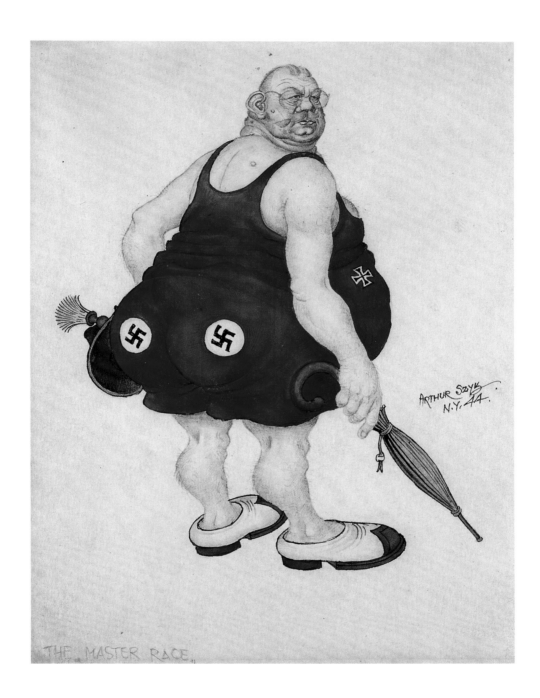

The Master Race, 1944
Ink, graphite, and colored pencil on paper
USHMM Collection, Gift of Alexandra and Joseph Braciejowski

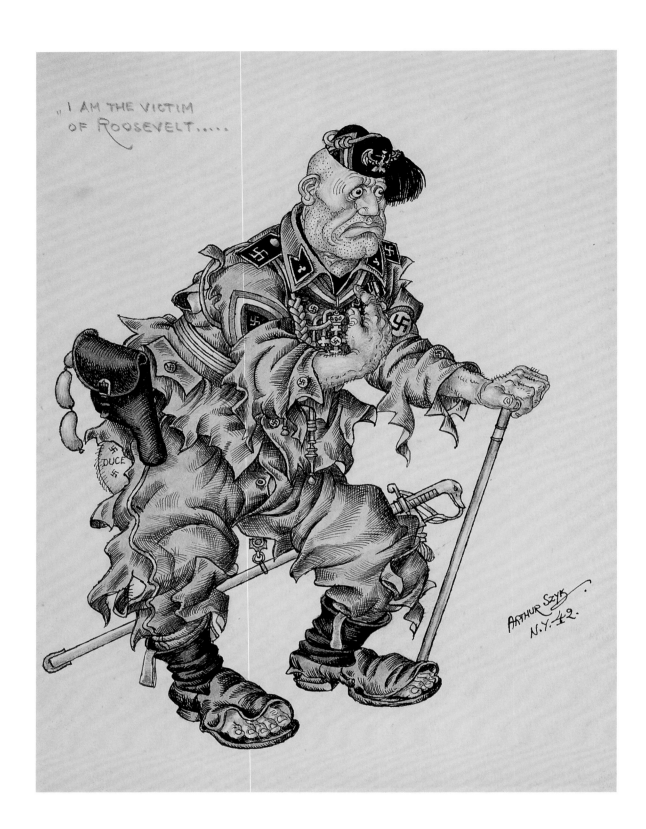

70

I Am the Victim of Roosevelt, 1942
Pen and pencil on paper
Philip and Ruth Holmes, New Jersey

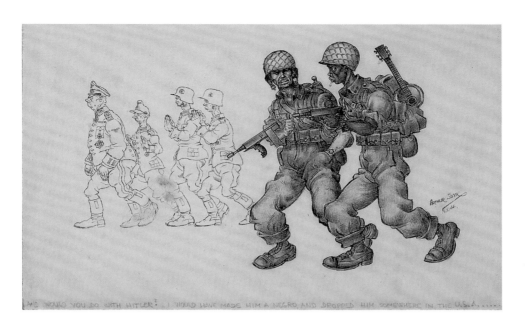

And [What] Would You Do with Hitler?, 1944
Graphite and ink on paper
Anthony J. Mourek, Chicago

soldiers talking while guarding a group of German prisoners. The white soldier asks, "What would you do with Hitler?" The black GI responds, "I would have made him a Negro and dropped him somewhere in the USA."[17]

The artist's other personal wars arose from his fervent interest in events on the European Eastern Front, in both the Soviet Union and Poland. Over the course of the war, his opinions radically changed toward both the USSR and the Polish government-in-exile. From 1939 through 1941, the period of the Nazi-Soviet non-aggression pact, Szyk tended to portray the Nazi as either an inflated buffoon or the personification of evil, and his Russian counterpart as a bloodthirsty Cossack. After all, the Soviets had invaded, occupied, and seized Polish territory, and they had taken over the Baltic countries of Estonia, Latvia, and Lithuania. Even after the June 1941 German invasion of the Soviet Union, Szyk sustained the parody of the untrustworthy "Asiatic" Soviet. But in December 1941, after the United States joined forces with Stalin against Hitler, the artist's Bolshevik Cossacks abruptly changed into heroic Russian soldiers and partisans. This *volte-face* can certainly be explained by the Soviet Union's valiant resistance to the Nazi onslaught, which won Szyk's admiration. The gallant image remained, through the Red Army's capture of Warsaw in January 1945 and the installation of a Soviet-sponsored Polish regime, to which Szyk threw his support.

Szyk's attitude toward the Polish government-in-exile fundamentally changed in 1943. That year, relations between it and the Soviets broke off as a result of the controversy surrounding Nazi Germany's publicity campaign about the Soviet massacre in 1940 of more than 4,000 Polish officers in the Katyn Forest near Smolensk, USSR. At the same time new strains emerged in the relations between Jewish organizations and the Polish government-in-exile, which would worsen over the course of the next year. In this tense atmosphere, Polish and Soviet officials both sought to win over American Jewish public opinion.

Before mid-1943, Szyk was a loyal supporter of the Polish government in London. His artwork focused public attention on Nazi brutalities against both

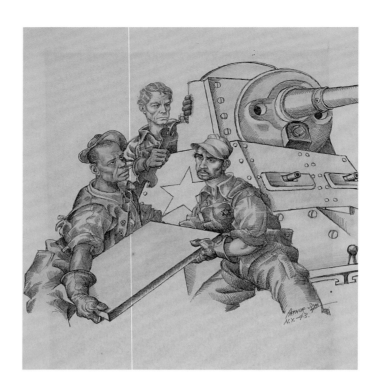

Untitled, 1943
Graphite and ink on board
Irvin Ungar through the Arthur Szyk Society

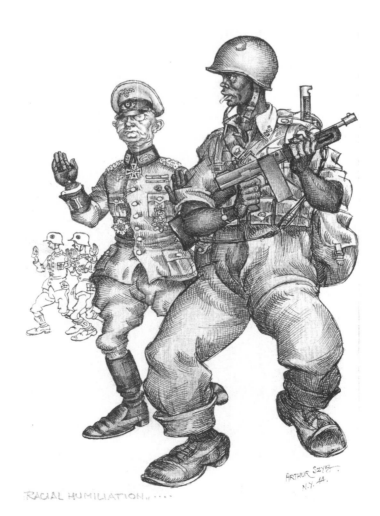

Racial Humiliation, 1944
Pen and ink on paper
Photo: *Wm. Hallam Webber, Maryland*

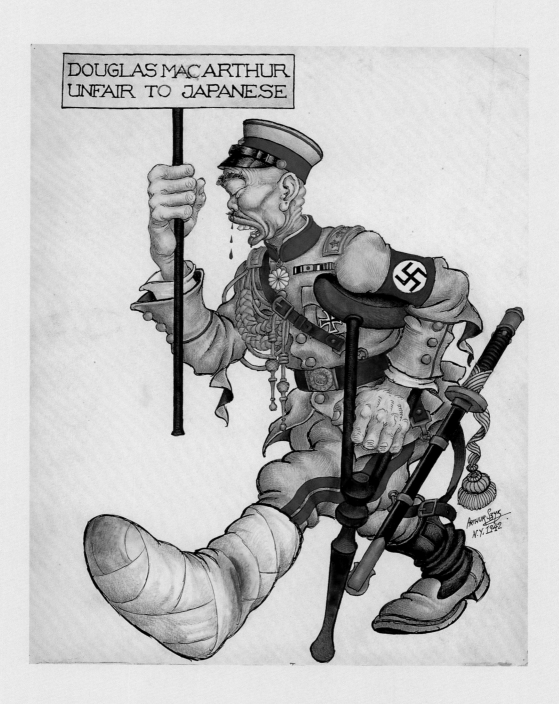

Douglas MacArthur Unfair to Japanese, 1942

Watercolor, gouache, pastel, colored pencil, graphite, and ink on paper

U.S. Naval Academy Museum, Annapolis

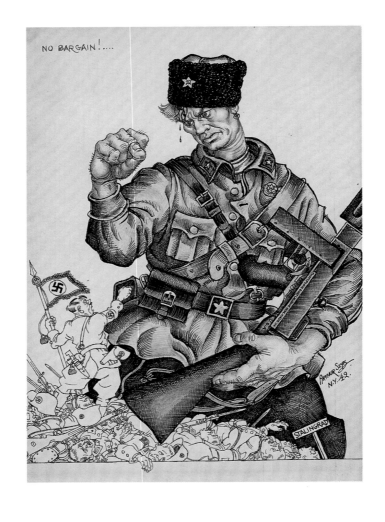

 No Bargain!, 1942
Graphite and ink on paper
Alexandra Braciejowski, Florida

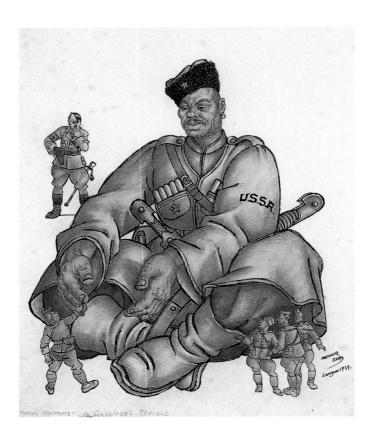

**"Mutual Assistance,"
or Gulliver's Travels,** 1939
Watercolor and gouache on paper
Heritage Bookshop, Los Angeles

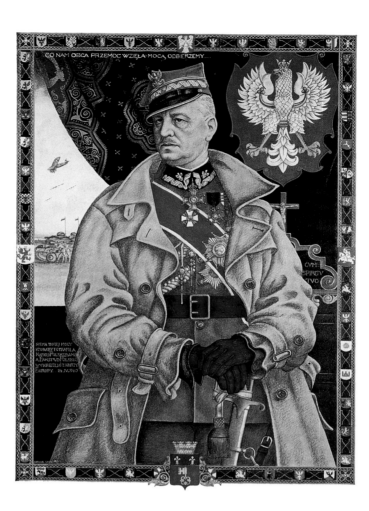

Władysław Sikorski, 1940
Print
The Kosciuszko Foundation, New York

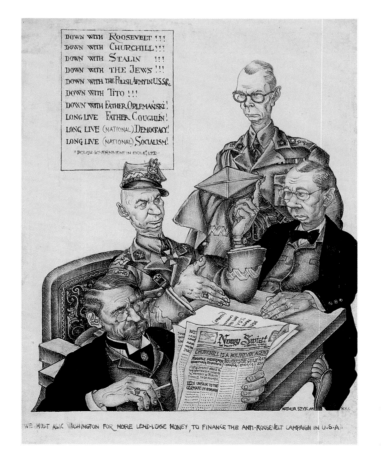

We Must Ask Washington..., 1944
Watercolor, pastel, graphite, and ink
on paper
Alexandra Braciejowski, Florida

Poles and Jews, and he used it to raise funds for relief for the victims. He also considered himself a loyal friend of Władysław Sikorski, the leader of the Polish government-in-exile and one of the architects of Polish-Soviet reconciliation, who died in a plane crash in July 1943. In the spring of that year, however, Szyk and his friend Tuwim joined a small group of pro-Soviet Polish Americans headed by University of Chicago economist Oscar Lange that publicly criticized the Polish representatives in London for trying to upset the Allied coalition by sowing distrust of the Soviets. By mid-1944, Szyk was denouncing the Polish government-in-exile as both antisemitic and fascist. His loyalties to Poland remained the same, but his allegiance to its leaders had shifted. Having become active in political campaigns aimed at rescue, he now probably believed that the Soviets and their Polish surrogates offered the best chance to protect the country's Jews.

Although Szyk savaged a host of individuals and countries during the war, he consistently expressed his greatest animosity toward Germany. Rooted in World War I and its aftermath, when he and Tuwim ridiculed Germany's democratic "revolution" as a sham concocted by the military to preserve its power, Szyk's negative feelings about Germany deepened after the Nazi takeover. In a letter to the poet, written in November 1940, Szyk outlined some of these sentiments:

76

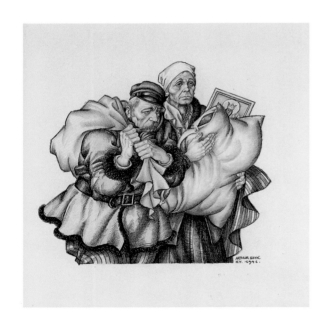

Polish Exiles, 1941
Pen and ink on paper
The Kosciuszko Foundation, New York

I am too preoccupied with our current struggle, the biggest in the history of humanity, our dream to come true, our crusade against the Germans. My hatred towards them, as you well know, was, is and always will be my credo.

I have lots of appreciation for Hitler. He has helped us enormously! None of the other Krauts would be able to awaken this spontaneous, basic hatred as he did in the English nation; he did it. Our own efforts, from the beginning of the war were in vain—but he did it. His slogan "Gewissen ist eine Jüdische Erfindung" [Conscience is a Jewish invention]. What a magnificent symbol "des Deutschthums" [of Germanness].

Their war is screwed—nothing will save them. They have lost the war, because the English will not let them out alive. Yes, I foresee a "Democratic Revolution" (second edition of our "Revolution"). As we both feel, the plans and slogans for the revolution must be prepared in the files of the Military Command. I am sure that a sensational appeal towards the Jews will be made, in short all weapons will be used, but all in vain. There is only one thing I pray to God for: may the hearts of our people remain brave and strong during this long period of suffering; may their hands never hesitate to liquidate the "Herrenvolk" [the master race]. I do all I can in my own field.[18]

Though the war did not end as Szyk predicted—as a repetition of World War I with the German army agreeing to an armistice—he feared that the sources of German militarism would not only survive intact but set the stage for the next war. In his mind, the solution to the "German problem" had to encompass more

than just the destruction of Hitler and the Nazi party. The centuries-old German militarism had become embedded in the country's culture, and it needed to be rooted out. "Hitler was Germany without a mask," he once remarked.[19]

Perhaps no other works illustrate Szyk's notion of continuity in German history better than his brilliantly detailed series *The Niebelungen*. As a group, these images do not constitute a narrative cycle but rather a thematic one. What ties almost all of them together are the visual or musical allusions to the four-opera cycle *Der Ring des Nibelungen*, by nineteenth-century German composer Richard Wagner. That Szyk would have targeted Wagner is unsurprising. Hitler was a lifelong devotee of Wagner's music, and no German composer was more identified, rightly or wrongly, with the Third Reich than Wagner. His ardent nationalism and antisemitism seemed to make him an ideal precursor to the Nazis.

In his portrait of Wagner, Szyk placed the composer at the piano, unleashing Wotan, the king of the Germanic gods, and with him the forces of war and destruction. *Götterdämmerung* (Twilight of the Gods)—a reference to the final opera in the *Ring* cycle—depicts the destruction of the German army in the frigid snows of the Soviet Union. In the *Ride of the Valkyries*, he portrayed the warrior-daughters of Wotan as bomb-hurling Nazis.

Szyk caricatures Wotan's palace, Valhalla, as a German beer hall, where the one-eyed divinity drinks with "heroes" of Germany's imperial past, while Hitler, Mussolini, Göring, and Goebbels bring in food and libations. In the background, opposite bodies hanging from the gallows in a cemetery, is the aged French collaborator Pétain preparing a meal for the guests. On the wall is a quote often cited by Szyk and attributed to Hitler: "Conscience is a Jewish invention." To emphasize the antisemitic tradition in German history, the god Wotan sits with one foot on the body of a Jew and the other on a volume of poetry by nineteenth-century German Jewish author Heinrich Heine. Each of the "heroes" wears a swastika to suggest a continuity of German antisemitism throughout the ages.

Szyk drew upon the imagery and style of the early-sixteenth-century German artist Albrecht Dürer for his *Walpurgis Night*. Though included as part of *The Niebelungen* series, the title does not refer to any scene in the *Ring* cycle or to the medieval German saga *Song of the Nibelungs*, upon which Wagner loosely based his operas. Instead, it comes from the German tale of the witches' Sabbath and the unleashing of demonic spirits, best known from Goethe's early-nineteenth-century epic *Faust*. To create the image, Szyk seems to have drawn heavily upon Dürer's woodcuts of the Apocalypse. Indeed, the figure of Hitler on horseback may be a reference to the rider on a pale horse—the symbol of Death—in the New Testament Book of Revelation (6:7–8):

And when he had opened the fourth seal, I heard the voice of the fourth beast say, Come and see. And I looked, and behold a pale horse: and his name that sat on him was Death, and Hell followed with him. And power was given unto them over the fourth part of the earth, to kill with sword, and with hunger, and with death, and with the beasts of the earth.

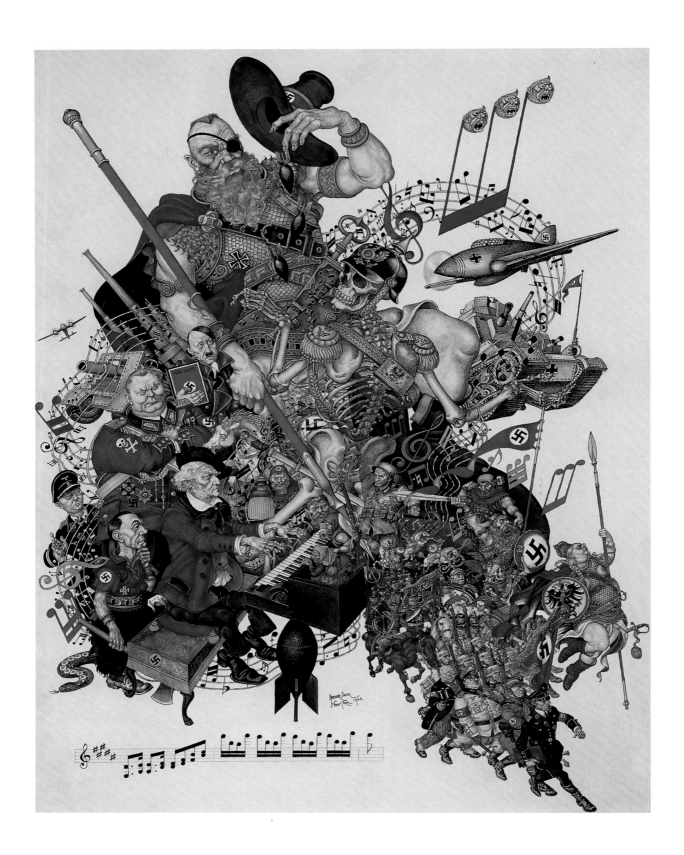

Wagner, 1942
Watercolor and gouache on paper
In Memory of Clarence H. Low

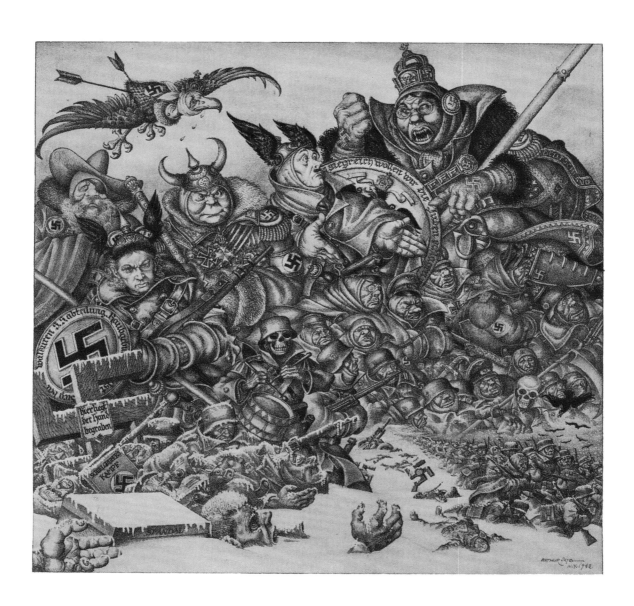

Götterdämmerung, 1942
Location of original artwork unknown
Photo from *Ink and Blood*, 1946
USHMM Collection, Gift of Pete Philipps

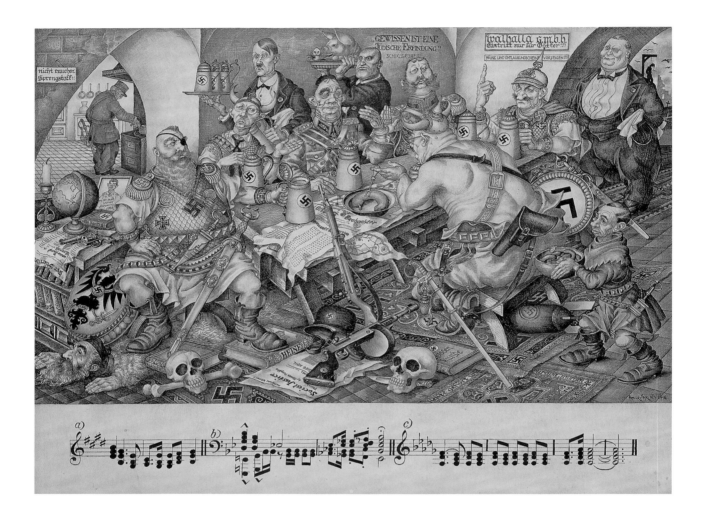

Valhalla, 1942
Pen and ink on paper
Rinjiro Sodei, Japan

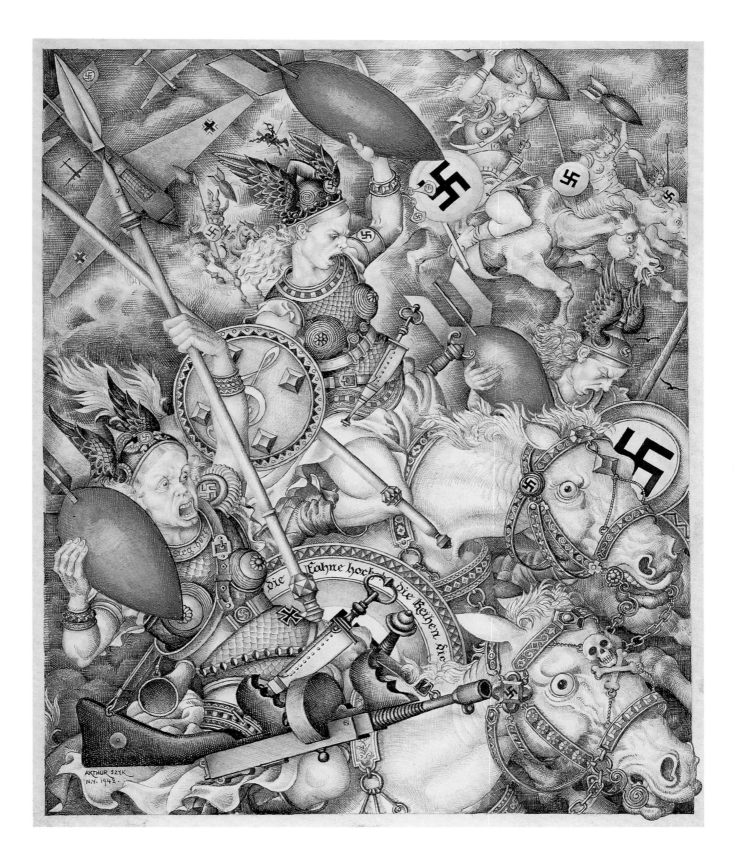

Ride of the Valkyries, 1942
Gouache, graphite, and ink on paper
Irvin Ungar through the Arthur Szyk Society

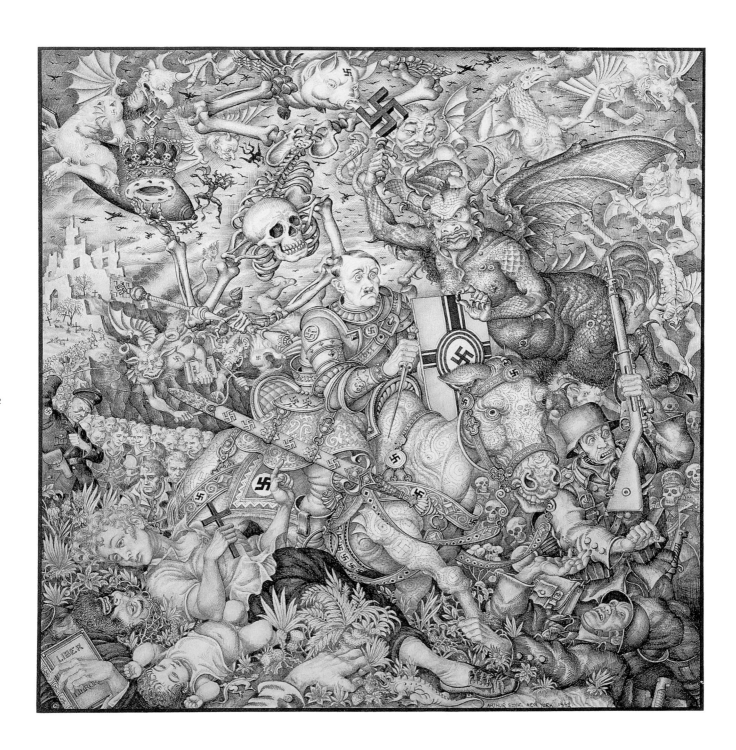

82

Walpurgis Night, 1942
Colored pencil, graphite, and ink on paper
USHMM Collection, Gift of Alexandra and Joseph Braciejowski

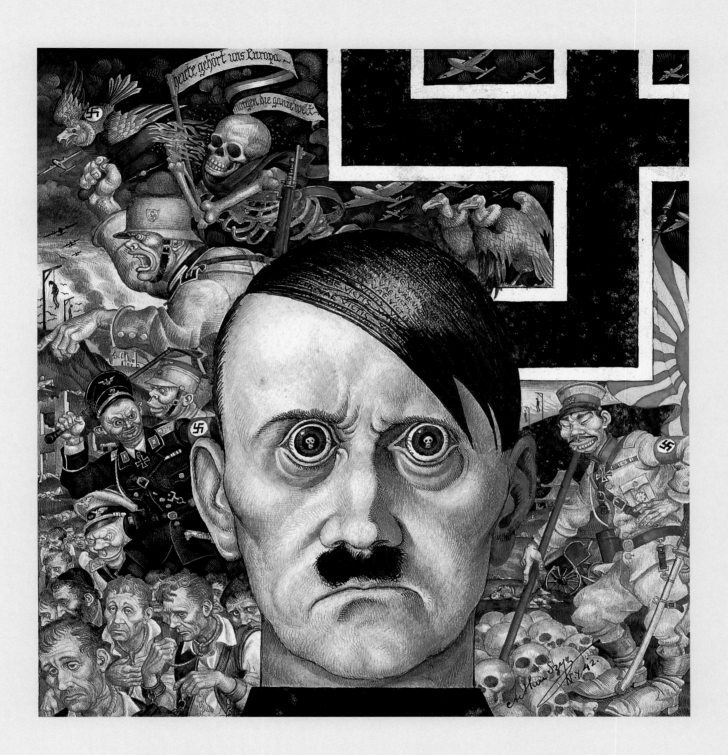

Anti-Christ, 1942
Watercolor and gouache on paper
Rinjiro Sodei, Japan

There is much in Szyk's image that seems to refer to this vision. The figure of Hitler (Death) on horseback, wearing a sword, heads a force of demonic beings and German troops into battle. All around them are scenes of death and destruction, represented by the corpses of a Jew, a Christian, a baby, and German soldiers. In the background are destroyed buildings and graves. Following Hitler is a group of enslaved men being driven into slaughter by a whip-wielding SS officer. This is an apocalyptic image of Death/Hitler leading Europe into destruction.

That a Jewish artist would choose an episode from a Christian text to illustrate a political message may seem surprising, but others did so as well in the 1940s. Marc Chagall and Abraham Rattner, for example, found parallels between the destruction of Europe's Jews and the story of Jesus' torment and crucifixion.[20] Indeed, Szyk entitled one of his most terrifying images of Hitler *Anti-Christ*. It shows the German leader, with skulls in his eyes, looking squarely into the face of the viewer. All around him are signs of destruction, slavery, and death. In his hair are the Latin words *Vae victis*, "Woe to the vanquished."

After the German and Japanese surrenders, Szyk published in 1946 a retrospective of his wartime political satires under the title *Ink and Blood*. The images, gathered into several themes, include *The Niebelungen* series and *Krauts through the Ages*. The noted American author Struthers Burt described the text as a

PEACE-BOOK; *a book for the parlous years that follow upon war, during which the seeds of war are either stamped out by the common sense and good will of men, or else allowed to take root and grow, not because of the blind stubbornness of the few warrior peoples left, but because of the blind carelessness of the peace loving nations.*[21]

Fittingly, the book ends with Szyk's "last word" on the "German question": an image entitled *I Need Peace Now! I Must Prepare for the Third Round!* First rendered in late 1944 and published in 1945 when V-1 rockets—the buzz bombs—were slamming into English cities, the painting shows a worn-out vulture representing the *Wehrmacht*, the German armed forces, with Goebbels, Göring, and SS leader Heinrich Himmler egging him on to do further battle. Unable to continue, the beaten bird pleads for a temporary respite so that he can gear up for the next war. In the background stands the portly figure of Germania, the national symbol of Germany, impatiently waiting for the military to recover. On the swastika-decorated pedestal are a skull, a model of the buzz bomb, and plans for future secret weapons to begin World War III. For Szyk, "Amalek" was an enduring threat against which one had to continually guard.

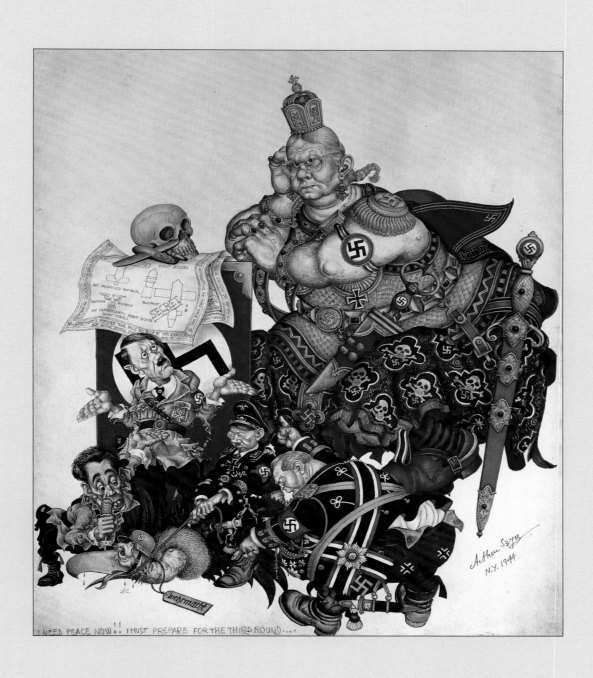

I Need Peace Now! I Must Prepare for the Third Round!, 1944

Location of original artwork unknown

Photo: *Irvin Ungar through the Arthur Szyk Society*

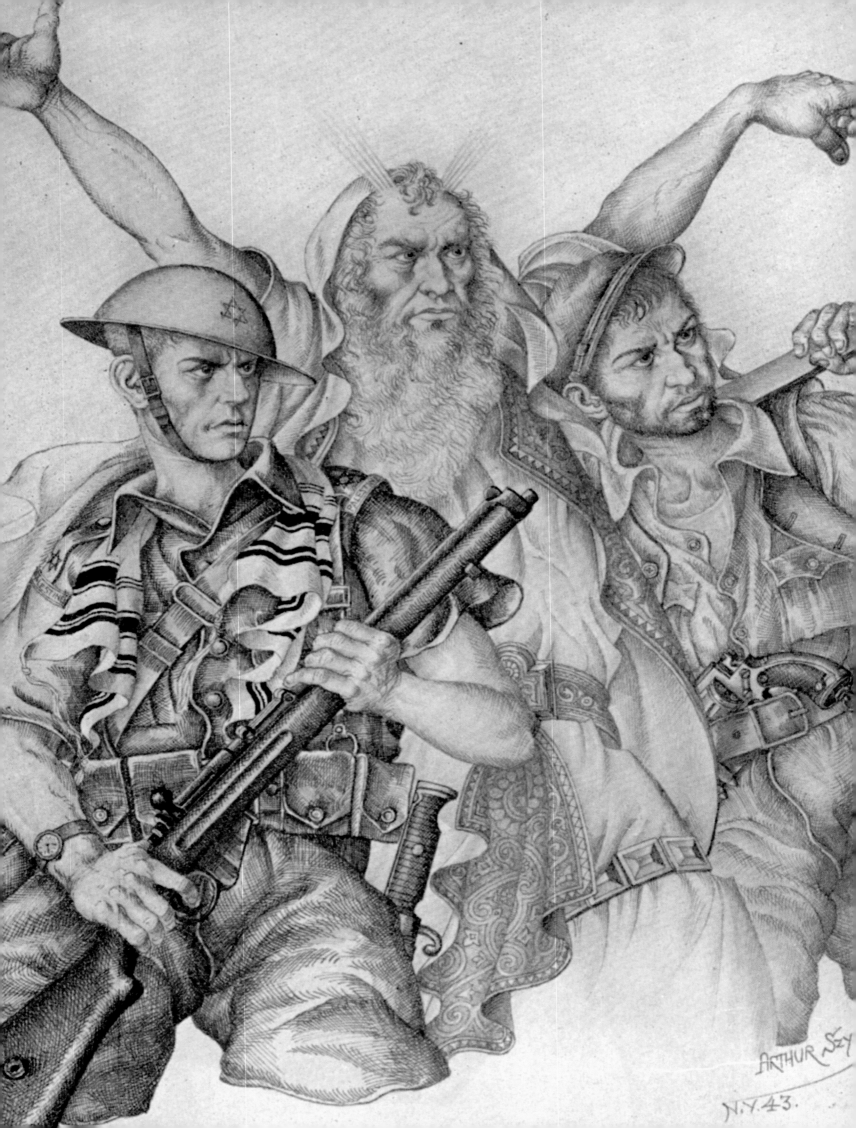

ACTION — NOT PITY

Few artists did as much as Arthur Szyk to make the American public aware of the horrors of Nazi antisemitism and the tragedy of the Holocaust. Szyk's goal was to call attention to the problems of European Jewry, not just to evoke sympathy for the victims but to wage war on their behalf, to demand "action—not pity."[1] His images, especially after 1942, were aimed at mobilizing American public opinion, both Jewish and non-Jewish, in order to win crucial popular and political support for Jewish rescue during the Holocaust and, after the defeat of Nazi Germany in 1945, for the creation and survival of a Jewish state in Palestine.

In many ways, Szyk's Holocaust imagery was unique. In contrast to a number of other Jewish artists of the 1940s who also were dramatically affected by the news of Nazi mass murder in Europe (Marc Chagall, Mark Rothko, Jacques Lipchitz), he did not retreat into the world of symbolism or abstraction. He channeled his anger, pain, and frustration into works that directly confronted the viewer. Unlike other artists, Szyk did not shy away from illustrating violence.[2] Though he did not draw gas chambers or shootings, his works included evidence of mass murder with piles of skulls and bones or the bodies of the dead or dying. He delivered his messages quickly and with clarity.

Upon Hitler's accession to power in January 1933, Szyk immediately recognized the threat the Nazis represented to the Jews and to European civilization. At the opening of his *Statute of Kalisz* traveling exhibition in Warsaw in April 1933, Szyk passionately discussed his art and the "Jewish martyrs in Germany" with a journalist. He remarked, "We are witnessing events of immense historical significance. . . . The persecution of Israel in Germany is opening up a new chapter in world history." Among Szyk's political cartoons of the 1930s were works intended

Modern Moses, 1943
Mechanical print (detail)
Irvin Ungar through the Arthur Szyk Society

to lay bare the resurgence of antisemitism in Germany and Poland. In April 1933, he drew an image of a tortured German Jew being forced by Storm Trooper thugs to sign a statement denouncing foreign anti-Nazi criticism as "atrocity propaganda." The cartoon, dedicated to his co-religionists in Germany, seems to be based on several contemporary events, including the forced public statements by prominent German Jews requesting Jews abroad to end their campaigns against Germany, and perhaps the beating and robbing of Rabbi Jonas Fränkel by Storm Troopers who later tried to force him at gunpoint to certify in writing that he had not been brutalized by the Nazis.[3] Alarmed at the rise of antisemitism in Poland after 1935, Szyk had several of his drawings published in Polish and Jewish newspapers to alert the public to the sufferings of Jews in his native land.

The outbreak of World War II profoundly affected Arthur Szyk and his work. Though too old to serve in the military, he saw himself as a soldier in the crusade against the Nazi enemy. Alerting the world to Nazi crimes and urging action to stop them became his primary mission. In 1939 and 1940, Szyk produced a series of images depicting the valiant resistance of the Polish citizenry to the German onslaught, the ugly nature of the German occupation, the desperate plight of refugees fleeing the violence, and the ruthless territorial ambitions of Nazi Germany and the Soviet Union.

Szyk understood, as few Allied officials did, that the Nazi terror against the Jews was fundamentally different from the persecution of other groups. Jews were being singled out not because they were citizens of occupied countries or for what they did, but simply because they were Jews. In his wartime imagery, Szyk depicted the rapid escalation of Nazi persecution, from segregation through enforced wearing of special markings to mass extermination, and showed that all Jews in German-occupied Europe were targeted regardless of age or gender.

In his book *The War and the Jew*, Revisionist Zionist leader Vladimir Jabotinsky cited Szyk's view in his own assessment of the "Jewish problem":

In this war (so it seems at the time of writing), it is not desired that the Jews should be "on the map": neither as active allies, nor as fellow sufferers, nor as the subject-matter of any special Allied demands or war aims.

Arthur Szyk, the gifted miniaturist who recently exhibited in London his brilliant and terrible drawings of tortured Poles and Jews under the German invader, has also a genius for finding the mot juste. To describe the attitude of the majority of the Allied statesmen and the greater part of Allied Press to this "Jewish" aspect of the war, he uses the word pornography.

"They treat us," he says, "as a pornographical subject. Pornography covers a most important department of life and nature; nobody denies it, but you cannot discuss it in polite society— it is not done."[4]

Jabotinsky and Szyk both recognized that Nazi antisemitism was unique among the other varieties of anti-Jewish hatred. Where Szyk had referred to it as "antisemitism of the exterminatory brand," Jabotinsky charged that the Nazis were pursuing "the deliberate policy of Jewish extermination . . . in the occupied

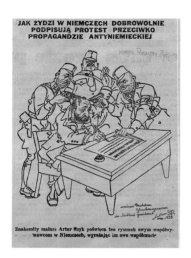

The Jews in Germany voluntarily sign a protest letter against anti-German propaganda.
Kurjer Poranny, April 1933
YIVO Institute for Jewish Research, New York

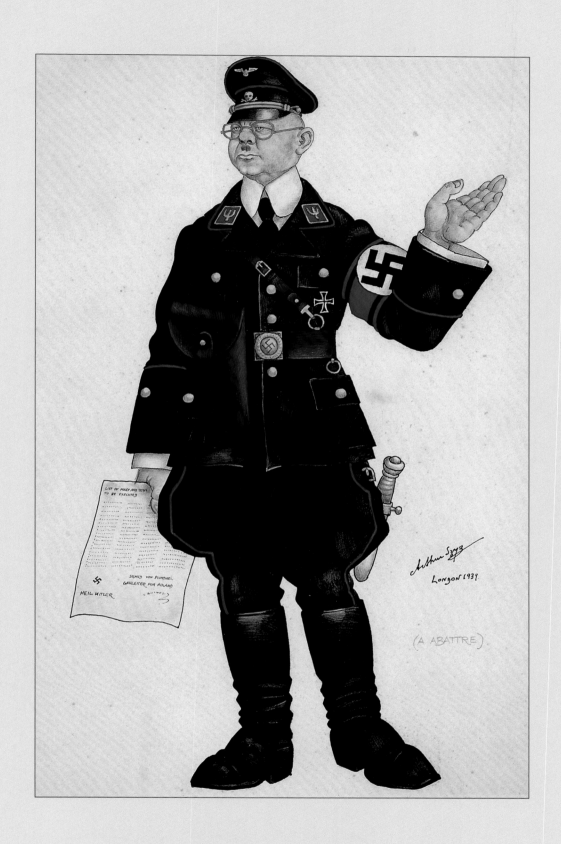

À Abattre (To Be Slaughtered), 1939
Gouache, pastel, graphite, and ink on paper
USHMM Collection, Gift of Mr. F. Peter Rose, New York

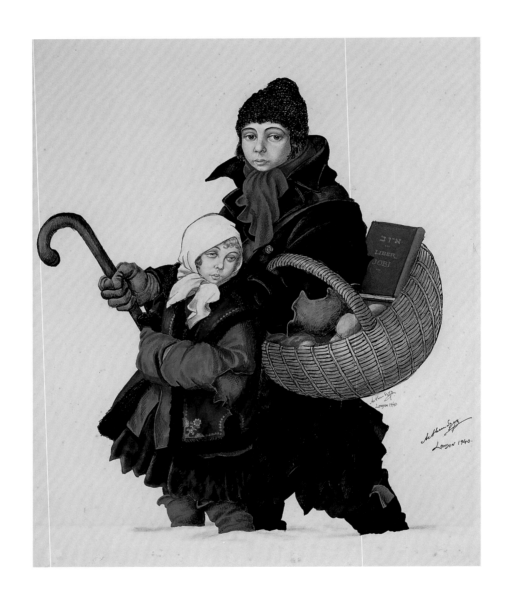

Young Refugees, 1940
Watercolor and gouache on paper
Moriah Galleries, New York

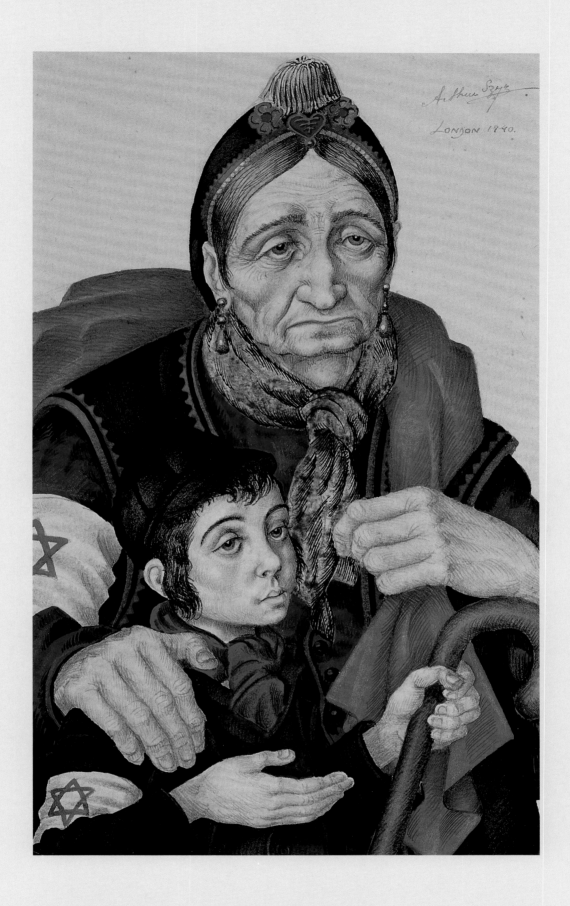

Untitled, 1940
Gouache, pastel, graphite, pen, and ink on paper
USHMM Collection, Gift of Leo Solet

92

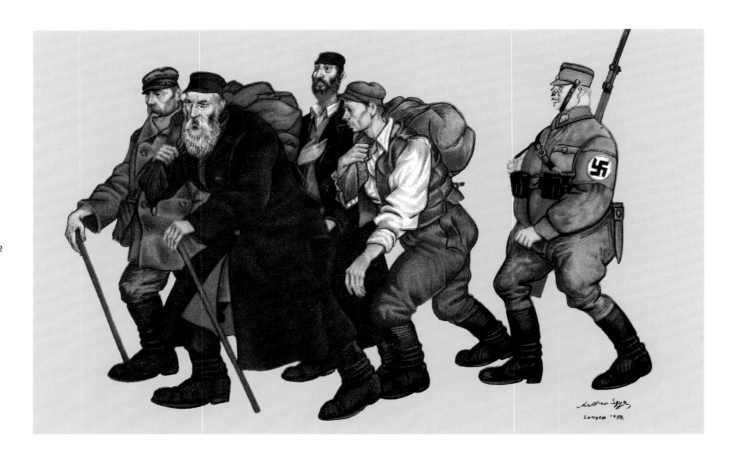

Prisoners of War, 1939

Print

Mass-Observation Archive, University of Sussex, Brighton

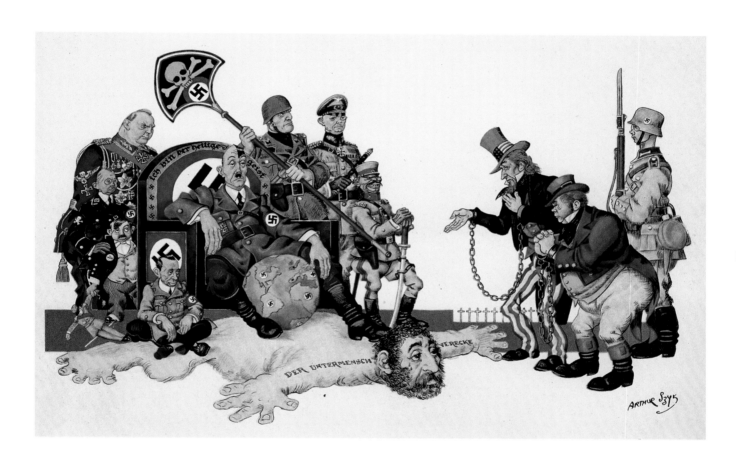

A Madman's Dream, 1940
From *The New Order,* 1941
Mechanical print
Philip House, Pennsylvania

territories."[5] Both men wanted to break what they saw as an Allied "conspiracy of silence" on Jewish suffering.

Jabotinsky's death in August 1940 was more than the loss of a friend to Szyk; he saw it as a tremendous blow to the Jewish people. On the second anniversary of the Revisionist Zionist leader's death, he remarked:

I will always consider the deceased as the greatest leader who ever was given to the Jewish people, a knight without fear and reproach, a phenomenon seldom paralleled in the history of the Jewish national movement.

I consider his untimely death an irreparable loss for world Jewry. In a most tragic period of its history it was left without its leader.[6]

In the years after Jabotinsky's death, Szyk used his pen to promote the "Jewish war demands" that the Revisionist leader had articulated: a Jewish army to fight on all fronts, an officially recognized Jewish presence on all international bodies dealing with issues of migration or reconstruction and a seat at the future peace conference, and Allied recognition that the creation of a Jewish state and an international covenant guaranteeing civil equality were part of their war aims.[7]

Szyk's wartime activism on behalf of Europe's Jews had begun outside the art studio shortly after the German and Soviet occupation of Poland in late 1939. Residing in Great Britain at the time, he and his wife Julia took on increasingly active roles in the Polish Jewish organizations there. She served as vice-chairman of the Ladies Committee of the Polish Jewish Refugee Fund, while he was president of the Association of Jewish Polish Citizens in Great Britain. Formed in March 1940 and organized to "represent and defend the rights and interests of Polish Jews," the association pledged to work with Polish officials to rebuild a free and democratic Poland. As part of his duties, Szyk met with leading representatives of the Polish government-in-exile, and he pressed for aid for those stateless Polish Jews who had been deprived of their citizenship as a result of legislation in 1938.[8]

In 1940, relations between Jewish organizations and the Polish government-in-exile were strained. English, American, and Polish Jews were especially concerned about Polish officials who were members of antisemitic parties or who had promoted anti-Jewish policies in prewar Poland. Moreover, Jewish activists expected the London-based regime to formally renounce the earlier advocacy for the mass emigration of the country's Jews and to clarify its position on Jewish rights in postwar Poland.[9]

For their part, Polish officials desired Jewish support for their cause and found willing allies in the Revisionist Zionists and Arthur Szyk. Representatives of the Polish government-in-exile provided various sorts of aid to the Revisionists, ranging from introductions to leading figures in the United States and Great Britain, to visas for travel to America, to financial support for their propaganda activities. The Revisionist Zionists looked to the Polish government-in-exile to support their bid to create a Jewish army.[10] Seen in this light, Szyk's offer to push

94

Vladimir Jabotinsky, ca. 1917
Signed by Jabotinsky to Arthur Szyk in 1928
Alexandra Braciejowski, Florida

the Polish cause in American Jewish circles through his exhibitions must have been most welcome. After all, in the early 1930s, his *Statute of Kalisz* had presented a positive image of Polish-Jewish relations to European and American audiences.

As the war escalated and the Holocaust grew more deadly, Szyk—a believer in the heroism of the Jewish people—openly supported the creation of a Jewish army to fight the Nazis and to aid suffering co-religionists in Europe. The idea was first publicly voiced by Jabotinsky in 1939, but it had strong supporters in the mainstream Zionist community as well. Leading members of the World Zionist Organization and the Jewish Agency, such as Chaim Weizmann, Nahum Goldmann, Moshe Shertok, and David Ben-Gurion, met with British officials to press for the creation of distinct Jewish units in the British army. These negotiations remained strictly confidential until 1941. In America, the United Palestine Appeal, a fund-raising organization for the Jewish Agency, urged Jewish organizations in the United States to write letters to members of the British cabinet in support of Palestinian Jews' right to bear arms.[11]

Szyk's first image for a Jewish army appeared on the cover of the United Palestine Appeal's 1941 *Yearbook*. It shows a Jewish soldier from Palestine armed with a British rifle, wearing a Star of David shoulder patch and giving the "thumbs-up" sign. The ornate Star of David at the upper left is surrounded by the lions of Judah, with a V-for-victory sign in the middle. Inscribed in Hebrew is Roman-era Rabbi Hillel's famous adage, "If I am not for myself, who will be for me?" This phrase appears often in Szyk's work and can be read as an injunction both to the individual as well as to the Jewish people. To the right of the Jewish fighter is a group of *halutzim* (Zionist pioneers) heading off to the fields, one of whom is raising his shovel in salute to the Jewish fighter. To the left is a dejected-looking eastern European Jewish family that bears the chains of enslavement. The youngest son, however, points to the Jewish soldier with hope. Szyk's meaning is quite clear: a Jewish army not only will defend Palestine and its Jewish inhabitants, but will aid in freeing the persecuted Jews of Europe.

Several months after he completed the *Yearbook* cover, Szyk joined the Committee for a Jewish Army, an organization created in the United States by Peter H. Bergson (né Hillel Kook) and a few members of the Irgun Zvai Leumi, the Revisionist Zionist

United Palestine Appeal
Yearbook, 1941
Dr. Samuel Halperin, Washington, D.C.

95

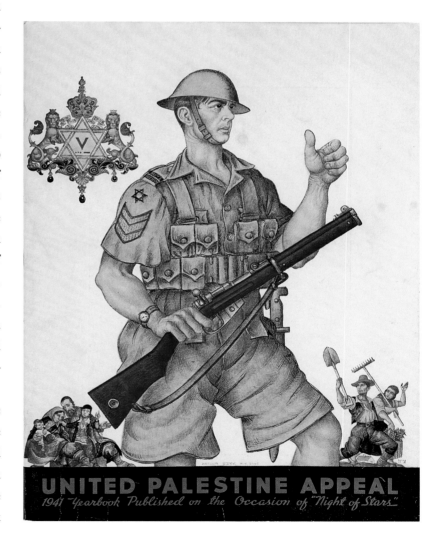

paramilitary group in Palestine. Bergson, a skilled organizer and lobbyist, was the highest-ranking member of the Irgun delegation in the United States. Shortly after he arrived in New York in July 1940, he took over the leadership of the American Friends of a Jewish Palestine, an organization that initially was dedicated to raising funds for the Irgun and "illegal" immigration, and he redirected its energies toward building support for a Jewish army. On December 3, 1941—just days before the Japanese attack on Pearl Harbor—Bergson and his colleagues established the Committee for a Jewish Army, adopting Jabotinsky's dream of creating a 200,000-man Jewish army from volunteers in Palestine and elsewhere. (In 1942, the group altered its name to the Committee for a Jewish Army of Stateless and Palestinian Jews in order to make it clear that such a military force would not recruit American Jews of military age, who by then were subject to conscription into the U.S. armed forces.) Within a year, Bergson succeeded in winning the backing of many prominent Americans, Jews and non-Jews, and had begun to establish firm grassroots support in a number of cities.

The circumstances under which Szyk became a member of the committee are not clear. He probably joined in late January or early February 1942; his name first appeared on their February 10 advertisement. His sympathies for a Jewish army and Revisionist Zionism certainly predated the committee, yet it is uncertain when he first made contact with Bergson or the other members of the group. He knew the committee's chairman, Pierre van Paassen, a Dutch-born liberal journalist and Christian Zionist, from his days in Paris in the 1920s. Though van Paassen eventually left the organization and engaged in a bitter feud with the Bergsonites, Szyk remained a trusted member of the committee and its various offshoots for some eight years, during which he became their chief artistic collaborator and contributed greatly to the success of their provocative press campaigns.

The popularity of the "Bergson Boys" coincided with increased Jewish fears over the situation in Palestine. In 1941 and 1942, Jews both in Palestine and the United States feared that an Axis invasion, perhaps in tandem with an Arab revolt, was imminent. A pro-Nazi coup had taken place in Iraq, the French forces in neighboring Syria had declared their loyalty to Vichy France, the exiled Grand Mufti Amin el-Husseini of Jerusalem openly called for an Arab Legion to aid Nazi Germany and Fascist Italy, and German forces under Field Marshal Erwin Rommel were making rapid advances in North Africa. Coupled with these events were the absence of a large British military presence in Palestine to counter any threat and Britain's unwillingness to create a separate Jewish army.[12] Adding to these fears was the spreading news about the Nazi mass murder of the Jews.

In July 1942, Szyk publicly presented to the committee an enlarged version of his 1936 work *Trumpeldor's Defense of Tel Hai* (or *Death of a Jewish Hero—Joseph Trumpeldor*), renamed *The Modern Maccabees*. The new title, probably coined by the committee, emphasized the continuity of a Jewish military tradition to the modern era from the ancient Hebrew warriors who battled the forces of the Hellenistic ruler Antiochus IV. Already in 1940, the committee's forerunner,

Peter H. Bergson (Hillel Kook),
ca. 1940
Photo: *Nili Kook, Israel, courtesy of the Newseum*

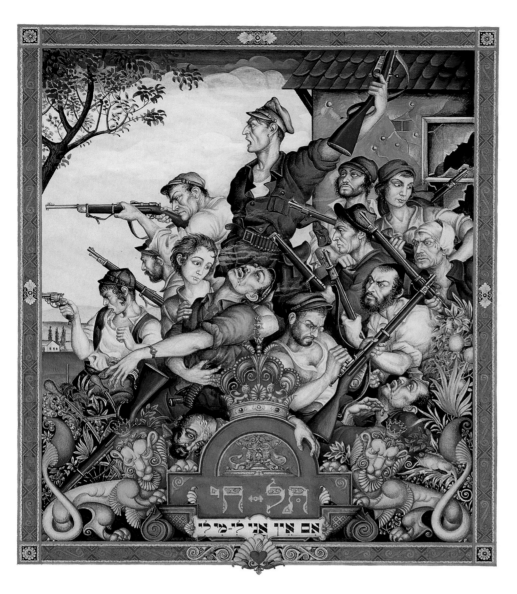

Trumpeldor's Defense of Tel Hai, 1936
Watercolor and gouache on paper
Sussi Collection, Chicago

the American Friends of a Jewish Palestine, had used "modern Maccabees" to describe Jabotinsky, Trumpeldor, and the Jewish Legion soldiers in the First World War.

Szyk's image, which was to appear under various names during the war, portrays the one-armed Russian Jewish Zionist Joseph Trumpeldor leading his forces in defense of the Galilean settlement of Tel Hai against Arab marauders in 1920. Although it is unclear what originally motivated Szyk to create the piece, the Arab revolt of 1936 may have been a major influence. Jabotinsky supplied him with information and a photograph of Trumpeldor. Already in the 1920s, Trumpeldor had become perhaps the most prominent martyr in Zionist mythology, symbolizing Jewish courage in the face of overwhelming military forces. During World War II, Zionist youths in the ghetto underground movements as well as Jews in Palestine found inspiration in Trumpeldor's example. The image was quite fitting for Bergson's Committee for a Jewish Army since Trumpeldor not only had served valiantly in the "Zion Mule Corps" during the Gallipoli campaign in World War I, but also had played an active role in pressing for the creation of Jewish units in the Entente armies. By resurrecting this event, Szyk was promoting

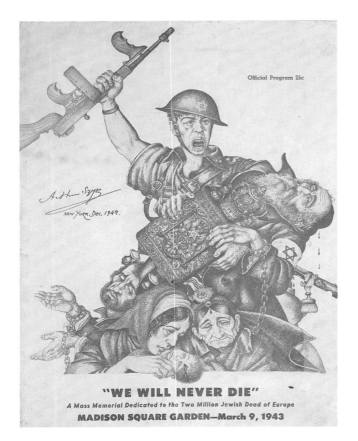

"WE WILL NEVER DIE"

A Mass Memorial Dedicated to the Two Million Jewish Dead of Europe

MADISON SQUARE GARDEN—March 9, 1943

98

Tears of Rage, 1942

From *We Will Never Die* program, 1943

Dr. Samuel Halperin, Washington, D.C.

an image of Jewish heroism—the "new Jew"—to serve as a model for a future Jewish army.[13]

In December 1942, Szyk created an icon for the Committee for a Jewish Army entitled *Tears of Rage*—an image of a Jewish soldier coming to the aid of his murdered and suffering fellow Jews in Europe. With his American-made submachine gun held above his head as a symbol of defiance and anger, the soldier supports a dying Jew who clutches firmly to his beloved Torah, the eternal source of strength in Judaism. In front of the two figures are a woman tenderly holding her murdered child, a mournful old woman, and a man pleading with outstretched hands. Throughout the image are the signs of the perpetrators: a swastika-emblazoned bayonet buried in the old man's back, and the swastika-stamped manacles that hold the Jews in bondage. The artist dedicated the piece "To those of my people who fight for the right to die with their boots on—my pride, my love, my devotion."

In this single drawing, Szyk conveyed the ideas that Jews, regardless of gender or age, were singled out for death by the Nazis, and that a Jewish army was necessary to strike back at the hated enemy and avenge the murder of their brethren. This powerful image of Jewish militancy and heroism well complemented the committee's demand for "action—not pity."[14] This was, as one sympathetic writer commented, "the drawing that revolutionized an attitude," adding:

One of Arthur Szyk's masterpieces, this drawing of the Fighting Jew of Palestine, fighter for freedom and avenger of his brethren's innocent blood, has been the symbol of the demand for recognition by the battling descendants of the Maccabees and Bar Kochba.[15]

Szyk's *Tears of Rage* first appeared in the press in early December 1942 as part of a two-page spread that included the committee's "Proclamation on the Moral Rights of the Stateless and Palestinian Jews" along with the names of more than 1,000 prominent individuals who supported the cause. Szyk's image summarized in clear, succinct, and plain terms the goals of the Bergson committee; one did not have to read the often-lengthy accompanying advertisement text to understand the point of the campaign.

Only days before the publication of the Bergson advertisement, Americans had received the first verified reports of the Nazi genocide against the Jews. In a press conference in Washington on November 24, Rabbi Stephen S. Wise, president of the World Jewish Congress, announced that the State Department had confirmed information that two million Jews had been killed by the Nazis as part of a systematic campaign of extermination. As historian David S. Wyman points out:

November 24, 1942, marked a turning point in Holocaust history. From then on, the news of Hitler's plan to annihilate the Jews was available to everyone in the democratic world who cared to know. But those not especially concerned were hardly confronted with the problem, because the news media gave it little prominence.[16]

When Bergson read the *Washington Post* on November 25, he immediately called Assistant Secretary of State Adolf A. Berle, Jr., to schedule an appointment. Berle corroborated the accuracy of Wise's statements. When asked by Bergson what he intended to do about it, Berle replied: "What can we do?" Following the meeting, Bergson summoned members of the committee's executive board. They all agreed that rescuing the remnant of Europe's Jews should be given highest priority.[17]

The news of Nazi genocide shocked American Jews. December 2, 1942, was declared a Day of Mourning and Prayer. Six days later, Wise and several other Jewish leaders met with President Roosevelt to discuss the tragic events. It was the first and last meeting that Roosevelt ever granted Jewish leaders to discuss the Holocaust.[18]

In the months that followed, the Bergsonites waged an even more aggressive campaign to rouse the American public and goad the government into action. Reflecting on their press promotions, Yitshaq Ben-Ami, one of the key members of the Irgun delegation in the United States, wrote:

It was without precedent among Jews to campaign on such a large scale of public agitation. When we brought into the open the subject of a Jewish army, the reports about the Nazi attacks on Jews were hidden away as small news items in the back pages with the religious news, next to the obituaries, as if Hitler himself had chosen the location.[19]

Łódź Yizkor Book, 1943
USHMM Library, Rare Memorial Books

Szyk too was deeply affected by Wise's announcement; it confirmed his earlier suspicions that Nazi antisemitism was an "exterminatory brand." From 1942 onward, his Holocaust imagery, like Bergson's campaigns, became more aggressive. His artwork helped take the news of Nazi genocide against the Jews out of the back pages. That year, he drew an image of Hitler ranting and raving before a crowd of Nazi leaders at the Berlin Sportpalast. On the floor, under his foot, is a skull marked *Jude* (Jew) with a bullet hole in it. Szyk seems to have been referring to Hitler's speech of September 30, 1942, in which he repeated his 1939 "prophecy" to carry out the annihilation of the Jewish "race" if it succeeded in plunging the world into war.[20]

There can be little doubt that the reports of Nazi mass murder were especially upsetting to Szyk because his mother and brother had remained in Poland. In 1943, he created the frontispiece image for a memorial book for the Jews of Łódź. Later that year, he drew *We're Running Short of Jews*, in which Hitler, Göring, Goebbels, and Himmler sit around a table while the SS Reichsführer points to a large document that reads: "Gestapo reports 2,000,000 Jews executed. Heil Hitler." Szyk dedicated the image "To the memory of my darling mother, murdered by the

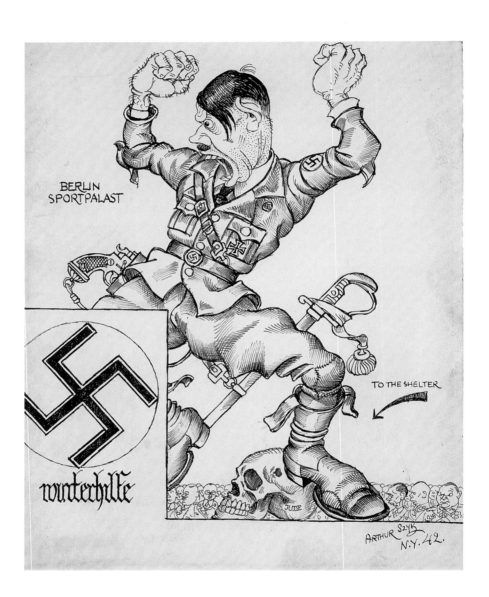

Berlin Sportpalast: To the Shelter, 1942
Graphite and ink on paper
Irvin Ungar through the Arthur Szyk Society

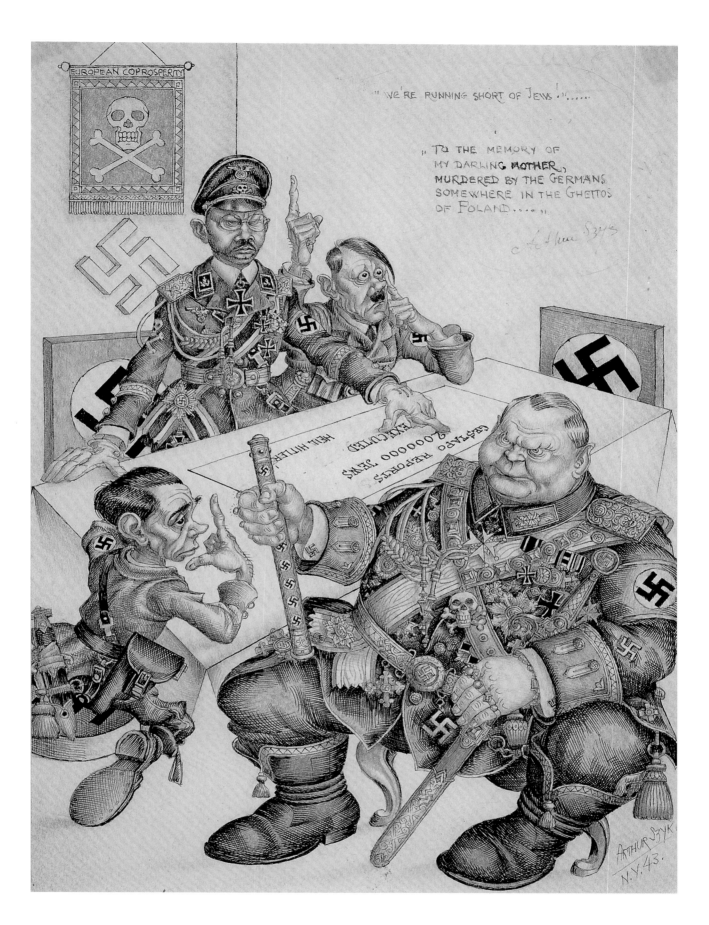

We're Running Short of Jews, 1943

Pen and ink on paper

Gluckselig Family Collection, New York

creation of a 200,000-member Jewish army that would form "suicide squads" to engage in commando raids in Germany and use Jewish pilots to bomb German cities in reprisal, and convene an "inter-governmental commission of military experts to determine a realistic plan of action to stop the wholesale slaughter of European Jewry." The Bergsonites also urged Great Britain to open Palestine as a refuge for the endangered Jewish populations in Romania, Bulgaria, Hungary, and other countries.[23]

In July 1943, the committee convened its own commission of experts at the Hotel Commodore in New York City. Appropriately named the Emergency Conference to Save the Jewish People of Europe, the attendees included former president Herbert Hoover; media mogul William Randolph Hearst; congressmen Samuel Dickstein, Emanuel Celler, and Will Rogers, Jr.; and celebrated authors like Writers' War Board chief Rex Stout, columnist Dorothy Parker, and Nobel Prize–winner Sigrid Undset. Arthur Szyk was chosen to be one of the experts on a panel devoted to public opinion. Following the five-day meeting, the conference issued its findings and drafted a series of resolutions on rescue. While acknowledging that non-Jews in Axis-occupied countries "undergo unbelievable sufferings, enslavement, semi-starvation and death," the report concluded that the "Jews alone have been singled out for mass destruction as a people." Among its recommendations were the creation of an official government agency in the United States specifically tasked with saving the Jews of Europe; grants by the United Nations of temporary asylum, especially in Palestine, for Jewish refugees fleeing Axis countries; and military reprisals against the Axis powers for anti-Jewish atrocities.[24] The conference evolved into yet another Bergson organization, the Emergency Committee to Save the Jewish People of Europe.

Like his colleagues on these committees, Szyk was infuriated at British restrictions on immigration to Palestine, and he used his artwork to condemn it. In *The White Paper* (1943), he portrayed the policy document as a large snake about to be killed by a Jewish soldier. In the background are flames and smoke arising from a destroyed Europe, Jews hanging on gallows and lying dead in cemeteries, and masses of terrified Jews fleeing the destruction. Their path to safety and freedom, however, is blocked by the locked gates of Palestine. At the bottom of the image are tombstones representing locations where Jews died, either in the Allied armies (Tobruk, Libya, Syria, and Bir-Hakeim) or in the ghettos. On the ground lies the Balfour

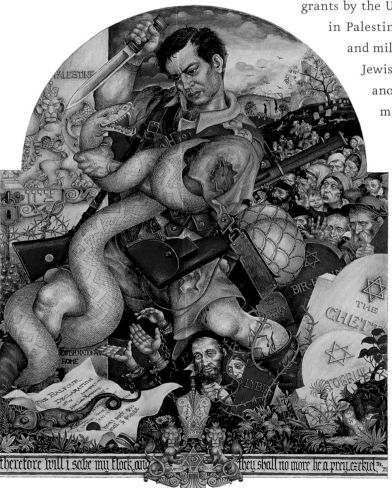

The White Paper, 1943
Watercolor, gouache, and ink on paper
Warren D. Starr, New York

104

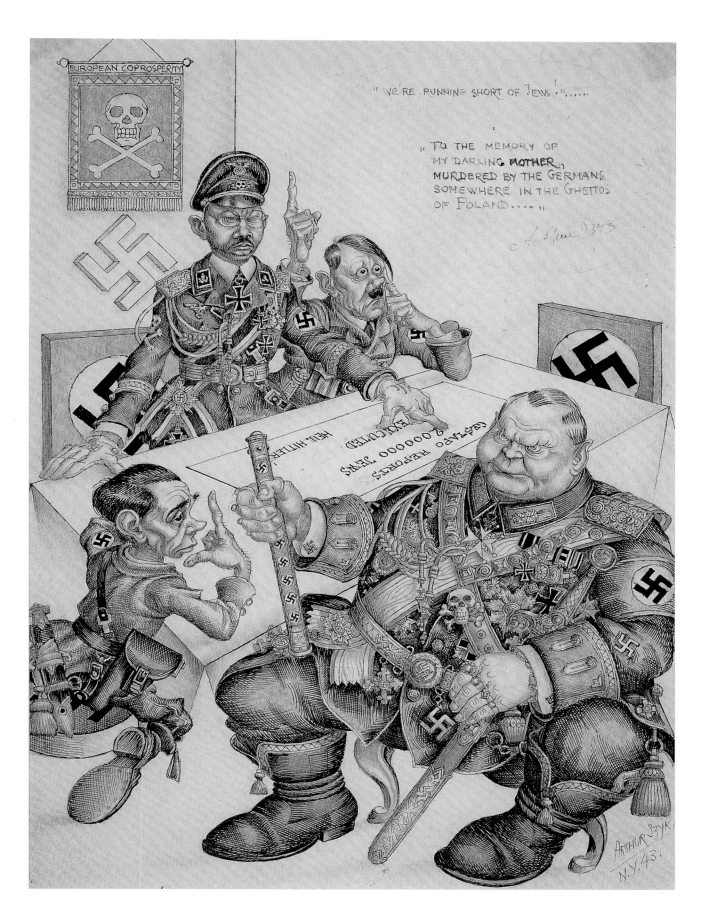

We're Running Short of Jews, 1943

Pen and ink on paper

Glückselig Family Collection, New York

102

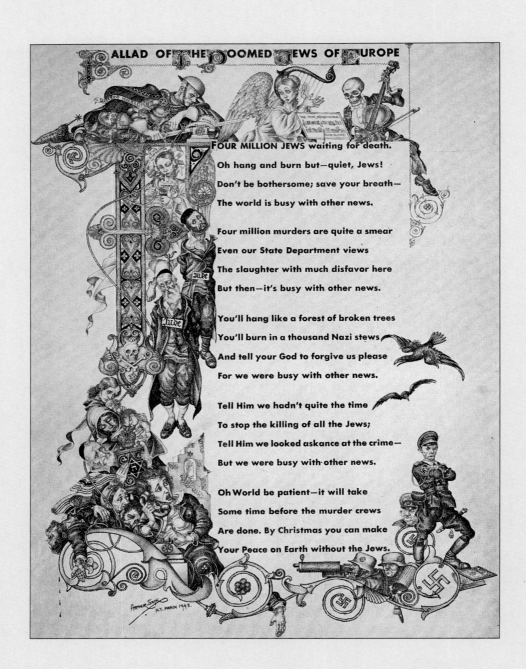

Ballad of the Doomed Jews of Europe, 1943
Print
Dr. Samuel Halperin, Washington, D.C.

Germans somewhere in the ghettos of Poland. . . " Unbeknownst to him, his mother had been deported from the Łódź ghetto to the Chełmno killing center in September 1942, when the Nazis ordered a roundup of young children and the elderly in the ghetto. In late March 1943, his brother Bernard perished.[21] On July 20, 1943, the work appeared in *PM* as *We Are Running Out of Jews*.

The Bergson Boys launched a series of bold actions in 1943 to mobilize popular support for the cause of rescue. Using Szyk's *Tears of Rage* as its focal point, the Committee for a Jewish Army of Stateless and Palestinian Jews filled American newspapers with full-page advertisements reiterating its proclamation of Jewish rights and proposing rescue schemes. The media blitz coincided with its staging of Hollywood screenwriter Ben Hecht's pageant *We Will Never Die*, a "mass memorial dedicated to the two million Jewish dead of Europe" that harnessed the talents of German Jewish composer Kurt Weill, theatrical producer Billy Rose, playwright and director Moss Hart, and actors Edward G. Robinson, Paul Muni, and Sylvia Sidney. At its opening at New York City's Madison Square Garden on March 9, 1943, the drama caused a sensation, bringing in more than 40,000 spectators and gaining wide media attention. After this success, the show played in Washington, D.C. (April 12), Philadelphia (April 22), Chicago (May 19), Boston (June 6), and Hollywood (July 21).[22] Although he had no role in the pageant, Szyk's *Tears of Rage* appeared on the cover of the official programs for all but the Hollywood presentation.

The same month that the show opened in New York, Szyk and Hecht collaborated on a biting indictment of Allied inaction. In *Ballad of the Doomed Jews of Europe*, Szyk's artwork frames Hecht's caustic verse, which begins

103

Four million Jews waiting for death.
Oh hang and burn but—quiet, Jews!
Don't be bothersome; save your breath—
The world is busy with other news.

Four million murders are quite a smear
Even our State Department views
The slaughter with much disfavor here
But then—it's busy with other news.

Szyk's illustration has Nazi troops preparing to machine-gun a group of Jews, one of whom desperately puts in a call for help to the United Nations. The telephone line intertwines itself between the bodies of dead and still-living Jews to reach an angelic operator, who informs the caller, "Sorry, they don't answer." Above, a United Nations soldier, sword in hand, watches the phone ring while an angel with a harp and Death, a skeleton playing the cello, perform "The Four Freedoms (Restricted)."

To save the remaining Jews of Europe, Bergson's committee proposed that the United Nations consider that "the cessation of atrocities against the Jews are an immediate aim of [the UN's] military and political operations," approve the

creation of a 200,000-member Jewish army that would form "suicide squads" to engage in commando raids in Germany and use Jewish pilots to bomb German cities in reprisal, and convene an "inter-governmental commission of military experts to determine a realistic plan of action to stop the wholesale slaughter of European Jewry." The Bergsonites also urged Great Britain to open Palestine as a refuge for the endangered Jewish populations in Romania, Bulgaria, Hungary, and other countries.[23]

In July 1943, the committee convened its own commission of experts at the Hotel Commodore in New York City. Appropriately named the Emergency Conference to Save the Jewish People of Europe, the attendees included former president Herbert Hoover; media mogul William Randolph Hearst; congressmen Samuel Dickstein, Emanuel Celler, and Will Rogers, Jr.; and celebrated authors like Writers' War Board chief Rex Stout, columnist Dorothy Parker, and Nobel Prize–winner Sigrid Undset. Arthur Szyk was chosen to be one of the experts on a panel devoted to public opinion. Following the five-day meeting, the conference issued its findings and drafted a series of resolutions on rescue. While acknowledging that non-Jews in Axis-occupied countries "undergo unbelievable sufferings, enslavement, semi-starvation and death," the report concluded that the "Jews alone have been singled out for mass destruction as a people." Among its recommendations were the creation of an official government agency in the United States specifically tasked with saving the Jews of Europe; grants by the United Nations of temporary asylum, especially in Palestine, for Jewish refugees fleeing Axis countries; and military reprisals against the Axis powers for anti-Jewish atrocities.[24] The conference evolved into yet another Bergson organization, the Emergency Committee to Save the Jewish People of Europe.

Like his colleagues on these committees, Szyk was infuriated at British restrictions on immigration to Palestine, and he used his artwork to condemn it. In *The White Paper* (1943), he portrayed the policy document as a large snake about to be killed by a Jewish soldier. In the background are flames and smoke arising from a destroyed Europe, Jews hanging on gallows and lying dead in cemeteries, and masses of terrified Jews fleeing the destruction. Their path to safety and freedom, however, is blocked by the locked gates of Palestine. At the bottom of the image are tombstones representing locations where Jews died, either in the Allied armies (Tobruk, Libya, Syria, and Bir-Hakeim) or in the ghettos. On the ground lies the Balfour

The White Paper, 1943
Watercolor, gouache, and ink on paper
Warren D. Starr, New York

104

Declaration, the official statement signed in 1917 by British Foreign Secretary Arthur James Balfour that declared his country's support for a Jewish national home in Palestine. Its placement in the painting symbolizes Britain's betrayal of its promise to the Jewish people. All the while, a Nazi serpent watches the action. Inscribed below is a passage from Ezekiel (34:22): "Therefore will I save my flock, and they shall no more be a prey."

Szyk's message is clear. The White Paper is an obstacle to rescue that must be destroyed. The tombstones symbolize the human cost paid by the Jewish people during the war—a compelling reason in itself for a national homeland. The biblical passage, generally interpreted as God's promise to protect his people, here also could be viewed as the Jewish soldier's commitment to rescue his people.

At the time Szyk created *The White Paper*, it was not just the "Bergson Boys" who were attacking British policy and demanding that the gates of Palestine be opened. American Zionists, whose relatively few adherents had dramatically increased with the escalation of Nazi brutalities against the Jews, viewed rescue and the creation of a Jewish state in Palestine as being intertwined. Though fervently Zionist, the Bergsonites feared that linking the two items would doom any rescue effort to failure. They believed that saving Europe's Jews took priority and pressed for the creation of temporary havens in Palestine instead of immediate statehood.[25] The British government, however, since 1939 had refused to discuss the future of Palestine or to revoke the White Paper, and in the United States, the Roosevelt administration was reluctant to disrupt the wartime alliance over Middle East politics. Not surprisingly, such positions fueled anger. In Palestine itself, the Irgun, now under the command of Menachem Begin, began its preparations to revolt against British rule.[26]

For the remainder of the war, Szyk and the Bergsonites continued to hammer away at British policy. In October 1943, for instance, they asserted that "hundreds of thousands could escape from the Balkan countries to Palestine if the discriminatory immigration restrictions of the White Paper are lifted and the Jews are freely admitted to their own homeland."[27] On March 31, 1944, the date specified in the White Paper after which no further Jewish immigration would be permitted without the acquiescence of the country's Arabs, *PM* published a full-page version of Szyk's editorial cartoon *Palestine Restricted*.[28] Depicted are a group of Jews trapped between a deadly Nazi vulture and the closed gates of Palestine, padlocked by the White Paper.

In the spring of 1943, amid all these discussions concerning rescue and Palestine, the world received the first news of the Warsaw ghetto uprising. Like other Jews, Szyk welcomed the reports. They confirmed his long-held belief that the Jews were a heroic people. For the artist, the ghetto revolt against the Nazi enemy symbolized the continuity of Jewish heroism from ancient times to the present and discredited the common antisemitic allegation that Jews avoided combat. They were the "modern Maccabees."

Szyk created the first of his two portrayals of the Warsaw ghetto uprising in 1943. Entitled *The Repulsed Attack*, the drawing includes Jewish fighters wearing

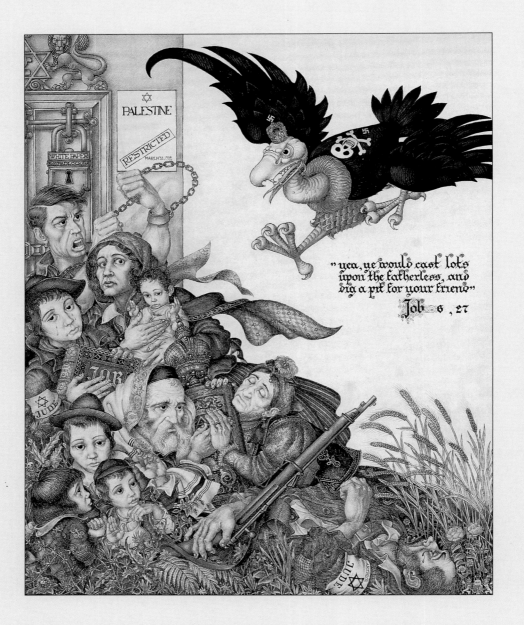

Palestine Restricted, 1944

Watercolor, gouache, pastel, graphite, and ink on board

Joanna and Daniel Rose, New York

Star of David armbands, battling the German invaders in the ghetto ruins. The heroes are a diverse lot, including a young boy, one man in a Polish uniform, and a second man dressed in a three-piece suit. Little accurate information circulated at the time about the leadership of the revolt, yet the dignified man in the suit bears a resemblance to David Wdowinski, the Revisionist Zionist who led an underground group in the uprising. Certainly some of the Bergsonites who had been in Poland before the war—and perhaps even Szyk—would have known Wdowinski. After the war, the artist and the ghetto fighter became friends, joining together in common support for the Irgun.

In April 1945, the second anniversary of the uprising, Szyk created yet another tribute to the fighters, *The Battle of the Warsaw Ghetto*. He again showed the diversity of the fighters, including a woman firing from the battlements and an aged man bearing the Torah. In contrast to *The Repulsed Attack*, the Jewish heroes are now seen fighting under the Zionist flag, a point that would not have been lost on his audience. Szyk's image is one of defiance: the Jewish fighters, having killed an SS officer, hold aloft his order from Himmler to murder all the Jews of the ghetto. The painting bears the dedication "Samson in the ghetto," a clear reference to Judges 16:30 that tells of a blinded Jewish hero who pulled down the pillars supporting his enemy's palace, killing himself and his people's oppressors while crying out, "Let me die with the Philistines!" Surrounding the entire image is Szyk's curse upon the Germans: "To the sons of Cain, be ye doomed forever and ever amen."

Szyk's representations of the fighting Jew did not end with his works about the Warsaw ghetto uprising. Beginning in 1943, he also paid tribute to the heroism of the Soviet Jewish partisans. It was probably at this time that he joined the American Committee of Jewish Writers, Artists, and Scientists, a Soviet front organization formed in 1941 ostensibly to foster Jewish art and culture and to combat antisemitism, racism, and discrimination. What or who influenced Szyk's decision to join is not clear, but during the war, this organization attracted many prominent Jews, including Marc Chagall, Albert Einstein, Arthur Miller, Lillian Hellman, Lion Feuchtwanger, and Sholem Asch, the noted Polish Jewish author whom Szyk had known in Paris.

During the spring and summer of 1943, the Soviet Union conducted a major public relations campaign in North America with a speaking tour by two key members of the Jewish Anti-Fascist Committee in Moscow, actor Solomon Mikhoels and writer Itzik Feffer. Their goal was to win support from a broad section of the Jewish community, and in this they were quite successful. A National Reception Committee for Mikhoels and Feffer, headed by Einstein, included representatives of major Jewish organizations such as Stephen S. Wise and Nahum Goldmann of the World Jewish Congress, Henry Monsky of B'nai B'rith, and Louis Levinthal of the Zionist Organization of America, as well as writers Asch, Hellman, and Feuchtwanger.[29] The committee chose Szyk to create the iconic image for the program *Jews Have Always Fought for Freedom*. His drawing shows a group of Soviet Jewish partisans superimposed on the image of a Jewish

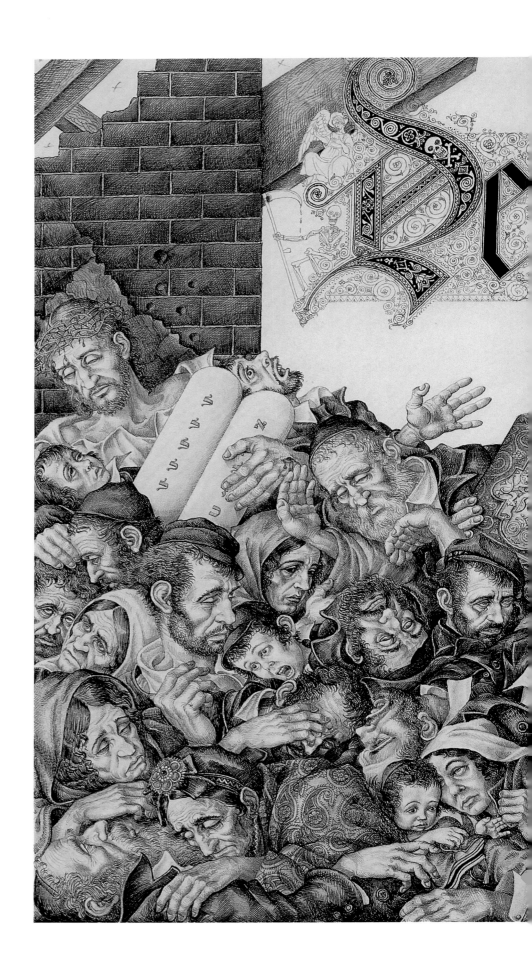

De Profundis, 1943
Graphite and ink on board
Irvin Ungar through the Arthur Szyk Society

Star of David armbands, battling the German invaders in the ghetto ruins. The heroes are a diverse lot, including a young boy, one man in a Polish uniform, and a second man dressed in a three-piece suit. Little accurate information circulated at the time about the leadership of the revolt, yet the dignified man in the suit bears a resemblance to David Wdowinski, the Revisionist Zionist who led an underground group in the uprising. Certainly some of the Bergsonites who had been in Poland before the war—and perhaps even Szyk—would have known Wdowinski. After the war, the artist and the ghetto fighter became friends, joining together in common support for the Irgun.

In April 1945, the second anniversary of the uprising, Szyk created yet another tribute to the fighters, *The Battle of the Warsaw Ghetto*. He again showed the diversity of the fighters, including a woman firing from the battlements and an aged man bearing the Torah. In contrast to *The Repulsed Attack*, the Jewish heroes are now seen fighting under the Zionist flag, a point that would not have been lost on his audience. Szyk's image is one of defiance: the Jewish fighters, having killed an SS officer, hold aloft his order from Himmler to murder all the Jews of the ghetto. The painting bears the dedication "Samson in the ghetto," a clear reference to Judges 16:30 that tells of a blinded Jewish hero who pulled down the pillars supporting his enemy's palace, killing himself and his people's oppressors while crying out, "Let me die with the Philistines!" Surrounding the entire image is Szyk's curse upon the Germans: "To the sons of Cain, be ye doomed forever and ever amen."

Szyk's representations of the fighting Jew did not end with his works about the Warsaw ghetto uprising. Beginning in 1943, he also paid tribute to the heroism of the Soviet Jewish partisans. It was probably at this time that he joined the American Committee of Jewish Writers, Artists, and Scientists, a Soviet front organization formed in 1941 ostensibly to foster Jewish art and culture and to combat antisemitism, racism, and discrimination. What or who influenced Szyk's decision to join is not clear, but during the war, this organization attracted many prominent Jews, including Marc Chagall, Albert Einstein, Arthur Miller, Lillian Hellman, Lion Feuchtwanger, and Sholem Asch, the noted Polish Jewish author whom Szyk had known in Paris.

During the spring and summer of 1943, the Soviet Union conducted a major public relations campaign in North America with a speaking tour by two key members of the Jewish Anti-Fascist Committee in Moscow, actor Solomon Mikhoels and writer Itzik Feffer. Their goal was to win support from a broad section of the Jewish community, and in this they were quite successful. A National Reception Committee for Mikhoels and Feffer, headed by Einstein, included representatives of major Jewish organizations such as Stephen S. Wise and Nahum Goldmann of the World Jewish Congress, Henry Monsky of B'nai B'rith, and Louis Levinthal of the Zionist Organization of America, as well as writers Asch, Hellman, and Feuchtwanger.[29] The committee chose Szyk to create the iconic image for the program *Jews Have Always Fought for Freedom*. His drawing shows a group of Soviet Jewish partisans superimposed on the image of a Jewish

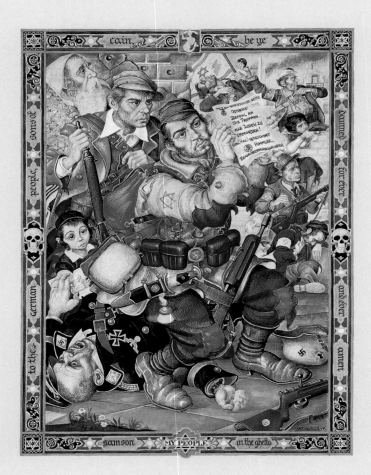

The Battle of the Warsaw Ghetto, 1945
Watercolor, gouache, and ink on board
Irvin Ungar through the Arthur Szyk Society

108

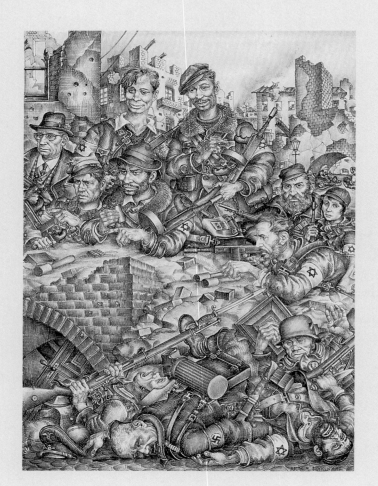

The Repulsed Attack

From *Songs of the Ghetto,* 1943
Graphite and ink on board
Irvin Ungar through the Arthur Szyk Society

warrior from ancient times and bears his dedication to "The Jewish guerillas, the sacred avengers of my people. . . ."

That Szyk was a member of this organization may seem somewhat surprising, given his ties to Revisionist Zionism. Yet in certain respects the pro-Soviet Jewish groups and the Bergsonites spoke a common idiom that appealed to the artist. Both emphasized the heroism of the Jewish people from ancient times to the present, called attention to the Nazi campaign of extermination, and championed the cause of rescue. As Mikhoels and Feffer wrote:

In the course of centuries, our Jewish people has suffered much from bitter enemies, the Hamans and the Amalachites. The precursors and ancestors of the present-day Fascists have tried more than once to destroy our people, to wipe it off the face of the earth. But our people lives and will continue to live.[30]

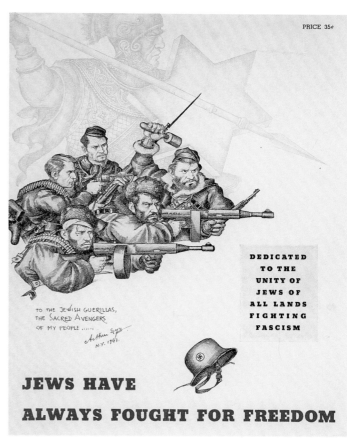

Jews Have Always Fought for Freedom, 1943
Wm. Hallam Webber, Maryland

The two Soviet spokesmen further claimed that the Red Army had rescued more than four million Jews from destruction. While the numbers are grossly exaggerated, at the time these words struck a responsive chord with the audience, particularly since the British and American governments seemed so reluctant to engage in any rescue activities.

Mikhoels and Feffer's use of biblical parallels to highlight the persecution of the Jews was not unique in the 1940s. Like other Jewish artists, Szyk repeatedly alluded to the Bible and Christian iconography in his Holocaust imagery. In 1943 he made use of several different allusions to biblical passages and even the figure of Jesus for his masterful *De Profundis*, a work that boldly dramatized the mass murder of Europe's Jews and raised the issue of the painful legacy of Christian antisemitism. Like fellow Jewish artists William Gropper and Ukrainian-born Ben-Zion, Szyk was drawn to Psalm 130: "Out of the depths have I called Thee, O Lord. Lord, hearken unto my voice; let Thine ears be attentive to the voice of my supplications."[31] On one level, the image, with its gripping picture of dead and dying Jews, is a pained cry for divine, or perhaps Allied, aid to end their tragic suffering. In the ornate letters above sits Job, the eternal symbol of unjust persecution throughout Jewish history, while the Grim Reaper with bloody scythe in hand rests below an angel.

The biblical passage "Cain, where is Abel thy brother?" (Genesis 4:9) is God's question to the murderous son of Adam. Dating back at least to late antiquity and continuing through the Middle Ages and after, Christian writers and artists frequently compared Cain to the Jews, as a people rejected and cursed by God. They likened the killing of Abel to the crucifixion of Jesus.[32] In *De Profundis*, Szyk

110

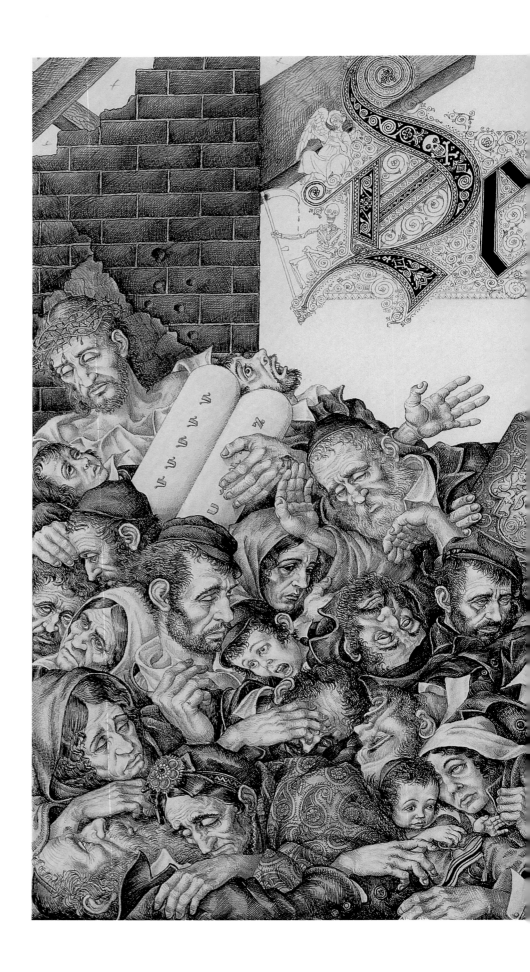

De Profundis, 1943
Graphite and ink on board
Irvin Ungar through the Arthur Szyk Society

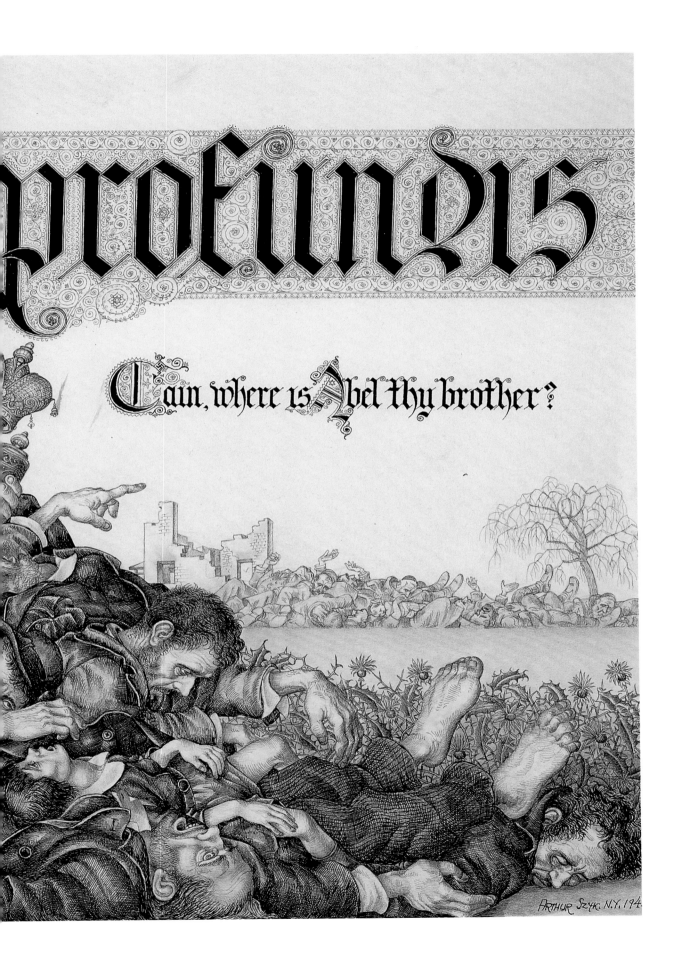

profundis

Cain, where is Abel thy brother?

ARTHUR SZYK. N.Y. 194

turns this analogy on its head, pointing the finger at the non-Jewish world. In *The Battle of the Warsaw Ghetto*, done some two years later, he compared Cain to the Germans, whom he viewed as being cursed among the nations. But in *De Profundis*, he clearly is placing responsibility more broadly on Christians.

That this was a particular message of the work is borne out in part by the fact that Szyk allowed *De Profundis* to be the poster image for the Textbook Commission chaired by the controversial left-wing editor of *The Protestant*, Kenneth Leslie. A colleague and friend of Pierre van Paassen, the onetime chairman of the Committee for a Jewish Army, Leslie was an ardent activist who created the commission for the expressed purpose of searching out and purging antisemitic statements from American textbooks, religious catechisms, and even Bibles. The commission constituted a key component of his "Smash Anti-Semitism" campaign, launched in 1943.[33] Leslie described *De Profundis* as "the living voice of the dead." He wrote: "Out of the depths they speak. . . . [No] man nor committee nor organized 'hush-hush' can stop them. . . . 2,000,000 sensitive human beings tortured, starved, butchered, in an orgy of hate reaped by Hitler but sown in the very soil of Christian civilization, *sown in the texts of intolerance.*" The text and image thus well complement each other, pleading to end the tragic legacy of antisemitism.

Szyk included Jesus and the symbolic Wandering Jew among the mass of dead and dying in *De Profundis*. Once again, the artist seems to be reinterpreting how audiences should view the two, investing them with new meaning. Since the late nineteenth century, Jewish artists had depicted both Jesus and the Wandering Jew in far different ways than had Christian iconographers or rabbinic authorities. Painters as diverse as Maurycy Gottlieb, the gifted Polish Jew who died at age 23, and Chagall reclaimed Jesus for the Jews, seeing him not as the messiah but as a representative of his people who maintained Mosaic traditions.[34] Szyk's Jesus, shown holding the tablets bearing the Ten Commandments, certainly fits into this tradition. Yet the artist also wanted to remind his audience that Jesus was a Jew whom the Nazis would have murdered just like the two Jews he holds. He wears the crown of thorns and bears the marks of the cross on his hands, the traditional symbols of his torture and death.

The figure of Jesus reappeared in 1944 in one of Szyk's cartoons for *PM*. In this instance, he stands before a court of Nazi leaders, with Hitler representing Pontius Pilate. Goebbels, as prosecutor, charges the defendant with preaching "the brotherhood of man" and denying "there is a master race." Himmler stands next to Jesus, pointing to the passage from the Sermon on the Mount (Matthew 5:7): "Blessed are the merciful." Jesus, wearing the crown of thorns and bound by ropes, represents both the persecution of the Jews and the antithesis of Nazi values.

In January 1944, the provocative campaigns of the Emergency Committee to Save the Jewish People of Europe and Bergson's lobbying efforts on Capitol Hill achieved a significant measure of success. President Roosevelt established the War Refugee Board (WRB), a governmental agency whose expressed purpose was to aid rescue efforts in Europe. Although it began its activities only late in the

war, after most of the Jews in Nazi hands had been killed, the organization helped to save tens of thousands of Jewish lives.[35]

Bergson's activities, however, had garnered not just support but animosity and hatred. From the inception of their work in the United States in 1940, the Bergson-supported Irgunists encountered resistance and bitterness from many of the mainstream Jewish organizations. The roots of this antagonism dated at least to 1935, when Jabotinsky withdrew from the World Zionist Organization to create the New Zionist Organization. To some, the militancy of Jabotinsky's group, coupled with the adoration of its leader and the creation of the Irgun as its paramilitary wing, seemed to smack of fascism.[36] Stephen S. Wise, for example, viewed the Irgun as a divisive organization that was "responsible to no one but itself."[37] Attempts to create a united front between the mainstream Jewish organizations and the Bergson group evaporated in this growing antagonism. By the end of 1944, the Irgunists had made some powerful enemies. Some, like Senator Harry S. Truman, charged the group with misusing his and others' names in advertisements of which they did not approve.[38] Assistant Secretary of State Breckinridge Long, angered at the Bergsonites' constant demands for action, urged the Justice Department to investigate the organization, and indeed, the Federal Bureau of Investigation began looking into its activities.[39] Even van Paassen publicly

Christmas, 1944
Watercolor and gouache on paper
Location of original artwork unknown
Photo: *Wm. Hallam Webber, Maryland*

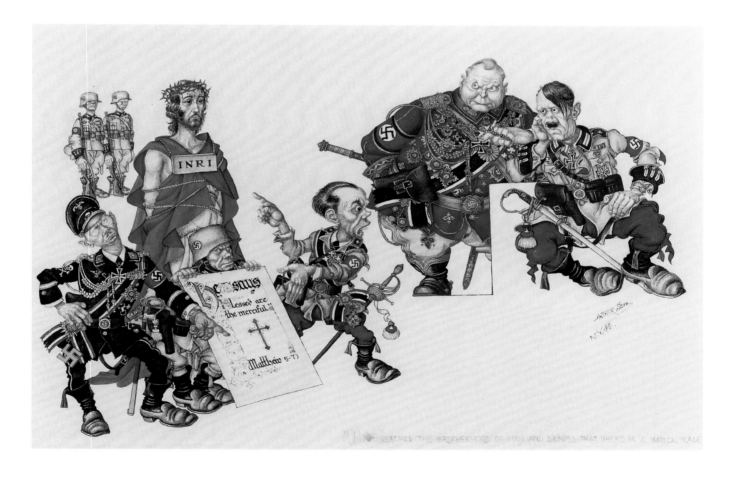

denounced his former colleagues in April of that year, accusing them of creating a series of front organizations to disguise their activities as members of the "fascist, terrorist Irgun."[40] In October, the *Washington Post* published a series of articles aimed at uncovering the true motives of the Bergson group. In spite of growing public criticism, Szyk remained a stalwart member of the group, defending their actions and attacking their opponents.

Even as the controversies raged around him, Bergson created two new organizations: the Hebrew Committee of National Liberation, which he envisioned to become the official representative body for Palestinian and stateless Jews, and the American League for a Free Palestine. With the war in Europe rapidly drawing to a close, the two organizations began a concerted campaign to demand United Nations recognition for the Jews as a nationality and to urge the Allies to confront the looming problem of what to do with the Jewish survivors whom the Nazis had taken from their homelands. Bergson and his colleagues accurately predicted, even before the large-scale establishment of displaced persons (DP) camps, that many Jews would not want to return to Eastern Europe, "to the horrible scenes of desolation, of murder and rape—to the refurbished ghettos in Europe's valley of death."[41]

To dramatize this issue, Szyk drew upon the figure of the Wandering Jew, Ahasuerus, the tragic symbol of his people in the Diaspora. In Christian iconography, Ahasuerus stands as a negative representation, for he was condemned to walk to the ends of the earth as punishment for mocking Jesus at the crucifixion. Only with the Second Coming would his suffering end. Beginning in the late nineteenth century, Jewish artists like Samuel Hirszenberg and Alfred Nossig began reinvesting the figure, the personification of the Jewish people, with new meaning. To the Łódź native Hirszenberg, Ahasuerus represented Jewish suffering at the hands of Christians, while Nossig portrayed him as a heroic figure who marches through time, carrying his Torah, the source of his people's strength and a sign of their continued survival.[42] That Szyk was aware of these new artistic developments seems probable. Hirszenberg's *The Wandering Jew* (1899) was reproduced in Jewish newspapers, posters, and postcards, and he may have seen the original while he was at the Bezalel Institute of Art in Jerusalem in 1914.[43]

The figure of the Wandering Jew appears in a number of Szyk's works from the 1940s, but nowhere with greater impact than in the piece entitled *Oh Ye Dry Bones, Hear the Word of the Lord* (Ezekiel 37:4). The work appeared on the cover of the Bergsonite journal *The Answer* in November 1944, circulated in Bergsonite petition drives, and was included in *Ink and Blood* (1946). The image shows the Wandering Jew passing through a massive graveyard filled with the skulls and bones of the Jewish dead. The perpetrators—Hitler, Göring, Goebbels, and Himmler—look on in disbelief. Throughout the drawing are tombstones marked with the Star of David that memorialize several sites where Jews were murdered in large numbers: Majdanek, Bialystok, Tremblinka (Treblinka), and Oswiecim (Auschwitz). Szyk seems to have modeled the piles of bones on photographs showing the post-liberation exhumations at Majdanek, the Nazi concentration camp that had been liberated in July 1944. Auschwitz was still operating when Szyk created this image.

114 **During their Bergson-sponsored march on Washington, 400 Orthodox rabbis assemble on the Capitol steps to demand U.S. aid for Europe's Jews.**
October 6, 1943
TimePix, New York

The drawing carries several potent messages. The Wandering Jew personifies the survival of the Jewish people and thereby denies the Nazis final victory in their program to exterminate the entire nation. But he is not a triumphant figure. Like Hirszenberg's, he symbolizes the tragedy of a homeless and persecuted people and serves as a painful reminder of the tortured relationship between Christians and Jews over the centuries. Szyk's goal was to give expression to the Bergsonites' demands for a Jewish state, the only means by which the wandering of the Jews could stop. The allusion to the passage from Ezekiel about breathing new life into the bones of the dead thus reinforces the Zionist message.

As part of its public relations campaign to focus attention on the future of the Jewish survivors, the American League for a Free Palestine created a full-page advertisement, *There Were 4 Sons*, that appeared in major daily newspapers. Addressing American Jews during the Passover holiday, the ad featured Szyk's drawings of the Four Sons. As in many other representations of this parable from the Haggadah, each son represents a different viewpoint or social attitude. In Szyk's version, the sons highlighted the disunity within the American Jewish community. The wicked son, an assimilated Jew, expresses alienation from his own people and demands that the survivors return to their former homes and forget all about a Jewish homeland. Szyk and his colleagues may very well have aimed this barb at the German-Jewish establishment in the United States, especially as represented by the (non-Zionist) American Jewish Committee. The indifferent or simple son does not want to challenge the status quo, fearful that spreading "atrocity stories about the torture and death in Majdenek [Majdanek], Treblinka and other death factories" will lead to a backlash of antisemitism against American Jews. The uninformed son, a member of the working class, asks questions that reveal he has failed to grasp the Bergson group's distinction between Hebrews and Jews and cannot understand the complaints about the British mandate in Palestine. In contrast, the wise son, portrayed as a soldier in the U.S. Army, only asks what he can do to ensure that the Jewish survivors will live free and safe from persecution and antisemitism. He is "a Moses who will lead a lost people out of the centuries-old wilderness."

A few weeks later, Szyk incorporated the figure of Jesus in another advertisement for the American League for a Free Palestine. Jesus is shown sitting outside Veteran's Hall in San

Oh Ye Dry Bones, Hear the Word of the Lord
The Answer cover, November 1944
Irvin Ungar through the Arthur Szyk Society

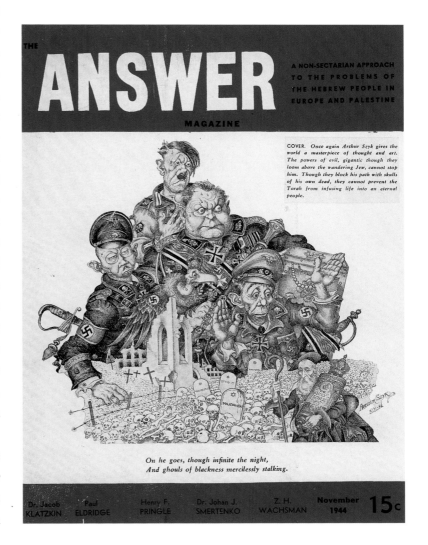

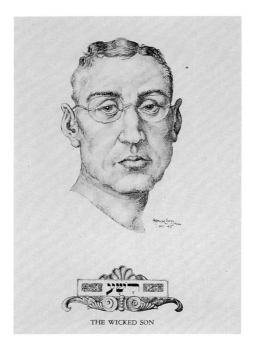

THE WICKED SON

The Wicked Son, 1945
Black and white mechanical print
Yeshiva University Museum, New York

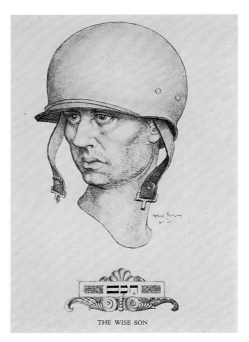

THE WISE SON

The Wise Son, 1945
Black and white mechanical print
Yeshiva University Museum, New York

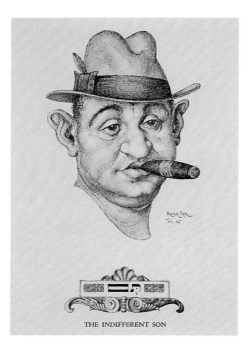

THE INDIFFERENT SON

The Indifferent Son, 1945
Black and white mechanical print
Yeshiva University Museum, New York

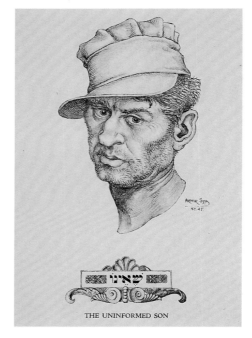

THE UNINFORMED SON

The Uninformed Son, 1945
Black and white mechanical print
Yeshiva University Museum, New York

Francisco, the site for the inaugural meeting of the United Nations, where he watches the procession of foreign delegates enter the building. Once again, Jesus represents the Jewish people, bearing the Star of David emblem on his cloak with the German words, *Der Juden König* (the King of the Jews). His words, "You who speak in My name—Where are My People?" refer to the official exclusion of a Jewish delegation from the proceedings, a decision that both Bergson and the mainstream Zionists independently sought to rectify. The image also alludes to the devastating Jewish losses suffered during the Holocaust: Jesus speaks for the "ghosts of their dead," demanding justice and equality.

The advertisement, published in the *New York Post* on May 14, 1945, just days after the war in Europe ended, targeted a Christian audience. It uses language that reinforces the traditional image of Jesus as an advocate for brotherhood and peace, yet is a reminder of Christianity's anti-Jewish past. "The Christian world," the advertisement states, "having long denied them a resting place, and condemned them to eternal wandering, must now enable the Hebrews of Europe to return to the country of their origin so that they may rebuild their national life in an atmosphere of completer freedom."

This advertisement came at a time when Zionist hopes and aspirations seemed to have been dashed by the failure of the Allies to adopt a strong position on a Jewish homeland in Palestine. At the Yalta Conference (February 7–12, 1945), the "Big Three"—Roosevelt, Stalin, and Churchill—did not address the issue, and just a few short weeks later, Roosevelt announced to Congress that he had learned more about Arabia, the Muslims, and the "Jewish problem" "by talking to [Arab king] Ibn Saud than I could have learned in the exchange of two or three dozen letters."[44] Jewish groups immediately expressed anger at these comments, which appeared to repudiate his earlier statements of support for Zionism.

With the end of the war in 1945, the Bergsonite American League for a Free Palestine and the Hebrew Committee of National Liberation turned their attention to the tens of thousands of Jews who were sitting in the DP camps in Europe, to an aggressive campaign to force the British to open Palestine, and to the creation of a state of Israel. Once again, Szyk lent his pen to the struggles, sympathetically portraying the refugees, castigating British policy, and extolling the heroism of the Irgun fighters.

Like other Jewish organizations, the Bergsonite committees were concerned about the plight of Jewish DPs in Europe. Earl G. Harrison, who had been dispatched by President Truman to the DP camps in Germany and Austria, sent a copy of his scathing report "in strictest confidence" to Bergson on September 10, 1945. In his report, Harrison had decried the American military's treatment of the Jewish DPs: "We appear to be treating the Jews as the Nazis treated them, except that we do not exterminate them." He further reported that the DPs urgently wanted to be evacuated from Germany and Austria to Palestine.[45] In October 1945, just

117

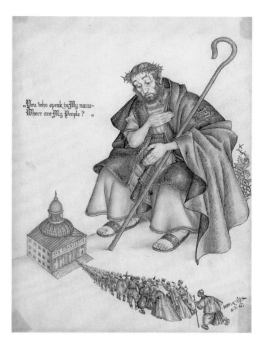

You Who Speak in My Name—
Where Are My People?, 1945
Graphite and ink on paper
USHMM Collection, Gift of Alexandra and
Joseph Braciejowski

weeks after Harrison's report was released to the press, the American League for a Free Palestine used it to demand the immediate end to the situation and the transfer of all willing "Hebrew survivors" to Palestine.

The following month, Szyk dramatized the conditions in the DP camps in his *Lullaby for Dying Children*. The image is of a Jewish survivor who holds his dying son behind the barbed-wire fence of a "concentration camp for 'the liberated.'" In the background, a British soldier stands guard. The son clutches a statement by Britain's Foreign Minister Ernest Bevin on Palestine, likely a reference to the newly elected Labour Party government's abandonment of its prior pledge to end the restrictionist immigration policies. Szyk's *Lullaby* appeared thereafter on the cover of *The Answer* and in full-page advertisements placed in newspapers by the American League for a Free Palestine.

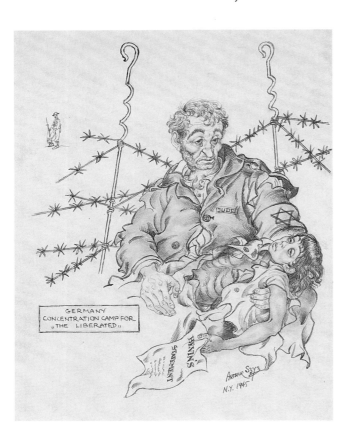

"A Lullaby for Dying Children...," 1945
Ink and graphite on paper
The Jewish Museum, New York,
Gift of Herman H. Rosenthal

As the number of Jewish DPs increased and Great Britain's intransigence on Palestine grew, the Bergsonites increased their attacks on British policy. In 1946, Szyk drew a group of Jewish DPs representing "the surviving Hebrews of Europe," who have climbed up a steep precipice (Palestine). There, they are confronted by the monstrous figure of John Bull—long a symbol of Great Britain—wielding a club and saying: "Just one step backwards—that's all I'm asking for. . . ." In the background is a representation of Europe filled with Jewish tombstones, over which vultures circle. As a counterweight to John Bull stands a Jewish soldier, symbolizing "the heroes of the Hebrew resistance forces in Palestine," with his submachine gun trained on the British monster.

Szyk's images of John Bull grew darker and more sinister as the struggle for a Jewish state in Palestine intensified. In 1948, he drew the English icon as a string-pulling conspirator who manipulated Arab leaders and others in order to preserve his crumbling empire and oil supplies. He even began to depict the British and some of the Arab leaders with swastikas, suggesting that they were aiming to complete what the Nazis had started. To be sure, Szyk earlier had attacked the Grand Mufti and Rashid Ali, the exiled former prime minister of Iraq, for their ties to the Axis powers during the war; the Grand Mufti appears often in the artist's cartoons on Palestine. Together, they represented the faces of the new enemy.

Following the end of the war, the Bergsonites rendered the struggle over Palestine in terms that Americans and Jews alike could understand. The demand for a Jewish state was likened to the American War of Independence against British tyranny: "It's 1776 in Palestine."[46] For his part, Szyk had already been convinced of the parallels in 1941, when he remarked to a journalist:

118

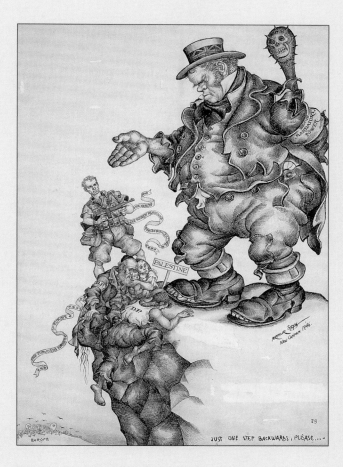

Just One Step Backwards, Please..., 1946
Pen and ink on paper
Yeshiva University Museum, New York

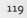

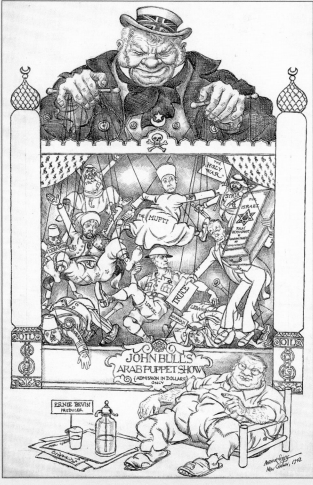

*John Bull's Arab Puppet Show
(Admission in Dollars Only),* 1948
Pen and ink on paper
Yeshiva University Museum, New York

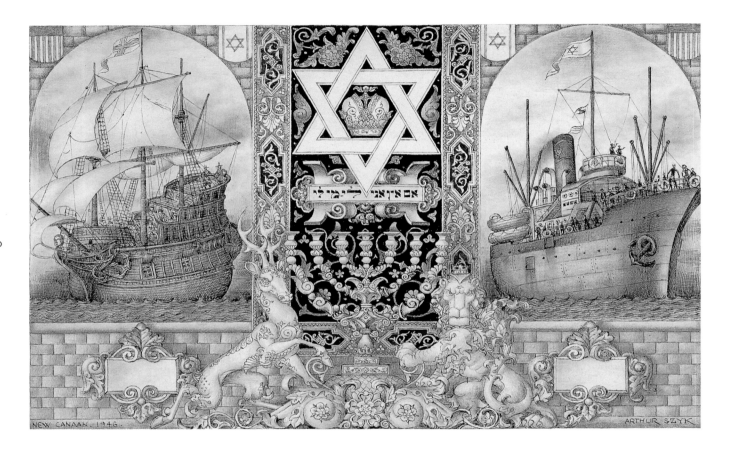

120

"Illegal" Ship and the *Mayflower*, 1946
Graphite and ink on board
Irvin Ungar through the Arthur Szyk Society

Palestine and the United States have a great deal in common. This country too was founded and built up as a result of persecution in Europe. Zionists must be more militant because no nation has ever attained its liberty except through blood and struggle.[47]

In the postwar years, Szyk completed several works that reflected this historical metaphor. In 1946, he created a drawing of two ships, the *Mayflower* and an "illegal" immigrant vessel bound for Palestine. The message underlying the imagery was clear: the Jewish refugees to Palestine were fleeing persecution, just like the Pilgrims in 1620. Moreover, both were victims of British tyranny; the Calvinists could not worship openly in England, and the "illegal" immigrants were denied entry into Palestine. Though it calls to mind the plight of the passengers on board the *Exodus 1947*, perhaps the most famous of the "illegal" immigration ships, Szyk's drawing was completed more than a year before that ill-fated voyage. On the back of the image, the artist wrote "Smyrna," referring to a ship that set sail from Romania for Palestine on May 7, 1946, but was intercepted and later boarded by the Royal Navy as it approached the Palestinian coast.[48]

At the same time he was pillorying British and Arab leaders, Szyk glorified the Irgun as the true fighting force in Palestine. Indeed, he probably served as the leading artistic propagandist in the United States for the paramilitary group. His images of the Revisionist Zionist fighters were part of the advertisements underwritten by the Hebrew Committee of National Liberation and the American League for a Free Palestine. The Irgun fighters were the symbols of the "new Jew," the proud descendants of the Maccabees, Bar Kochba, Berek Joselewicz, the Warsaw ghetto fighters, and the Soviet Jewish partisans. No doubt Szyk's drawings also served to counter the impression in some American Jewish and non-Jewish circles that the Irgun was a terrorist organization. Like Bergson and Hecht, Szyk depicted the armed struggle against the British and the Arabs in heroic terms. His Irgun soldiers are freedom fighters, and those who were hanged by the British are martyrs to the cause of Jewish liberty.

In 1948—the year the State of Israel was created—Szyk paid tribute to the Jewish soldiers who died fighting for their country's independence with *Baruch Dayan Emeth* (Blessed Be the Judge of Truth). Beneath the image of the dead fighter are the words of Thomas Jefferson: "The tree of liberty must be refreshed from time to time by the blood of patriots and tyrants . . ." Again, Szyk equated the armed struggle for a Jewish state with the creation of the United States.

After the founding of the State of Israel, Szyk devoted his energies to winning public support for the embattled new nation and attacking its enemies. He illustrated the Israeli Declaration of Independence with figures representing Jewish heroism in the ancient and modern eras. Flanking the text, an Israeli soldier with submachine gun and flag in hand defends his country's soil. Moses,

"German Measles...," 1948
Ink and graphite on paper
The Jewish Museum, New York,
Gift of Herman H. Rosenthal

121

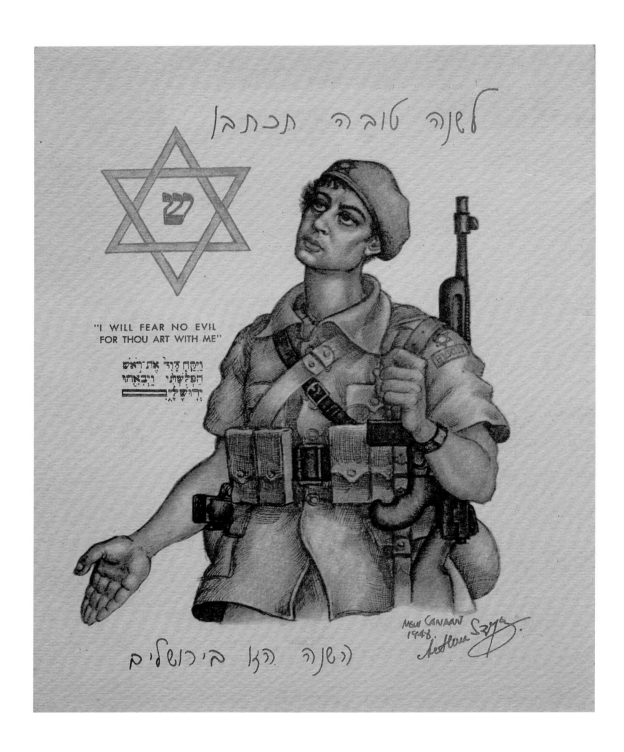

"I WILL FEAR NO EVIL
FOR THOU ART WITH ME"

Jewish New Year's card, "This year in Jerusalem," 1948
Print
Roslyn Winard, Maryland

בָּרוּךְ דַּיָּין אֱמֶת

THE TREE OF LIBERTY MUST BE REFRESHED FROM TIME TO TIME BY THE BLOOD OF PATRIOTS AND TYRANTS......

(THOMAS JEFFERSON)

Baruch Dayan Emeth
(Blessed Be the Judge of Truth), 1948
Pen and ink on paper
Yeshiva University Museum, New York

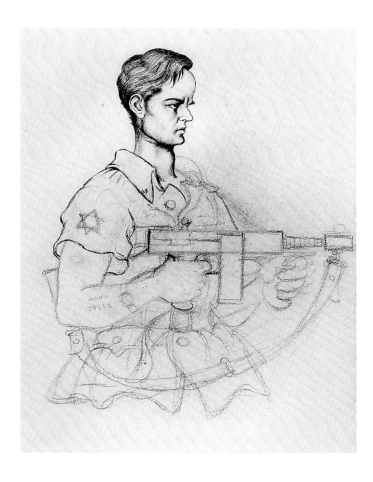

Jewish fighter in Palestine, n.d.
Graphite, colored pencil, and ink on board
*USHMM Collection, Gift of Alexandra and
Joseph Braciejowski*

Aaron, and Hur stand as symbols of triumph over Amalek, the hated eternal enemy of the Jews who continually appears generation after generation. Together the three figures also symbolize spiritual and temporal authority: Aaron holds the Torah, while Hur stands ready with his sword unsheathed. The creation of the new Jewish state fulfilled the ancient promise of a return to Zion. Ezekiel, the great prophet of exile, seems to be gently breathing new life into the remains of the Jewish heroes of the past in the Valley of Dry Bones while pointing to the Declaration as the fulfillment of his prophecy.

Before his death in 1951, Arthur Szyk had lived to see the defeat of the modern Amalekites and the return of the scattered remnants of the Jewish people to the land of Israel. He had played a role in both, by mobilizing British, Canadian, and American opinion against the Nazis and by engaging in a tireless campaign for a Jewish state in Palestine. Reflecting on his friend's many contributions to the various Jewish causes in the 1940s, Ben Hecht wrote:

His Hebrews under fire, under torture, exterminated in lime pits and bonfires did not change. They remained a people to be loved and admired. Their faces, fleeing from massacre now, were tense and still beautiful. There was never slovenly despair or hysterical agony in Szyk's dying Jews, but only courage and valor. If there was ever an artist who believed that an hour of valor was better than a lifetime of furtiveness and cringe, it was Szyk. Just as the Irgun produced the first fighting Jew since Bar Kochba, Szyk put him on paper for the first time. He died still drawing for the Jews.[49]

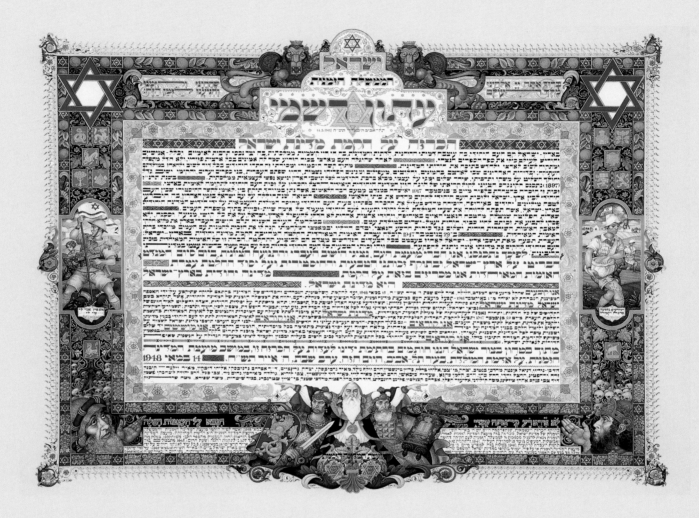

Declaration of Independence for the State of Israel, 1948

Mechanical print

Dr. Samuel Halperin, Washington, D.C.

126

Introduction

1. Max Hoffberg, "Portrait of an Artist-Warrior: Arthur Szyk, Cartoonist Who Is a Front-Line Fighter Against Hitlerism," *Detroit Jewish Chronicle and the Legal Chronicle*, 29 August 1941.

2. S. L. Shneiderman, *The Stormy Life and Work of Arthur Szyk* (in Yiddish) (Tel Aviv: I. L. Peretz Publishing House, 1980). I am indebted to Professor Ben Shneiderman for providing me with a partial translation of his father's book and to Tina Lunson for translating some of the author's articles from *Der Morgen Zshurnal* (The Jewish Morning Journal [New York]).

3. See the essays by Irvin Ungar, "Justice Illuminated: The Art of Arthur Szyk" and Joseph P. Ansell, "Arthur Szyk: Life and Work," in *Justice Illuminated: The Art of Arthur Szyk* (Berkeley and Burlingame, Cal.: Frog Ltd. and Historicana, 1999).

4. Joseph P. Ansell kindly shared his book manuscript as well as a draft of his article, "Arthur Szyk's Depiction of the 'New Jew': Art as a Weapon in the Campaign for an American Response to the Holocaust," *American Jewish History* 89, no. 1 (March 2001): 123–34.

5. Marek Szukalak, *Łódzkie rysunki Artura Szyka* (Łódz: Oficyna Bibliofilów, 1997); and Beate Jegier-Filipiak, "Artur Szyk (1894–1951)," *Biuletyn Zydowskiego Instytutu Historycznego w Polsce* 3, no. 151 (July–September 1989): 65–80.

6. H. K., "Szyk as Propagandist," *Jewish Chronicle* (London), 26 January 1940, 25.

7. Rachel Wischnitzer, "Jewish Art," in *The Jewish People: Past and Present*, ed. William Foxwell Albright et al., 4 vols. (New York: Jewish Encyclopedia Handbooks, Central Yiddish Culture Association, 1952), 3: 303. In some of her other writings on Jewish art, Wischnitzer also has tended to be rather dismissive of Szyk's work. In one study, she wrote: "Arthur Szyk was hailed as the rediscoverer of the technique of medieval illumination. He did not avoid a certain prettiness typical of most revivalisms," "Passover in Art," in *The Passover Anthology*, ed. Philip Goodman (Philadelphia: Jewish Publication Society of America, 1961), 321. Szyk's illustrations of the Book of Esther were given only passing mention in Wischnitzer's article "The Esther Story in Art" in *The Purim Anthology*, ed. Philip Goodman (Philadelphia: Jewish Publication Society of America, 1952), 243.

8. Edouard Roditi, "The Jewish Artist in the Modern World," in *Jewish Art: An Illustrated History*, ed. Cecil Roth (New York: McGraw-Hill Book Company, Inc., 1961), 796.

9. In Avram Kampf's *Jewish Experience in the Art of the Twentieth Century* (South Hadley, Mass.: Bergin & Garvey Publishers, Inc., 1984), Szyk is conspicuously absent from the text; even in recent studies of Jewish artists in Paris, he is largely ignored. See, for instance, Kenneth E. Silver and Romy Golan,

The Circle of Montparnasse: Jewish Artists in Paris 1905–1945 (New York: Universe Books, 1985); and Nadine Nieszawer, Marie Boyé, and Paul Fogel, *Peintres Juifs à Paris 1905–1939: École de Paris* (Paris: Denoël, 2000). In his major study of *haggadot*, Yosef Hayim Yerushalmi mentions the artist only in passing: *Haggadah and History: A Panorama in Facsimile of Five Centuries of the Printed Haggadah from the Collections of Harvard University and the Jewish Theological Seminary of America* (Philadelphia: Jewish Publication Society of America, 1975), 49; likewise, Haya Friedberg refers to Szyk only once in a footnote to her fascinating article, "The Unwritten Message—Visual Commentary in Twentieth-Century Haggadah Illustration," *Jewish Art* 16/17 (1990/1991): 159, n. 9. Even Cecil Roth, with whom Szyk collaborated on *The Haggadah*, only mentions the artist in passing in his "The Illustrated Haggadah," *Studies in Bibliography and Booklore* 7 (1965): 37–55. Matthew Baigell's important studies of Jewish artists in America and the Holocaust have paid little attention to Szyk. There is one lone reference to "Arthur Szyck" in his article "Jewish Artists in New York during the Holocaust Years," Monna and Otto Weinmann Lecture Series (Washington, D.C.: United States Holocaust Memorial Museum, 16 May 2001); see also his *Jewish-American Artists and the Holocaust* (New Brunswick, N.J.: Rutgers University Press, 1997). Ziva Amishai-Maisels, in her monumental monograph *Depiction and Interpretation: The Influence of the Holocaust on the Visual Arts* (Oxford: Pergamon Press, 1993), makes a few references to Szyk's work, but only in the endnotes.

10. During the war years, Szyk's images reached millions of American readers through mass publications. *Collier's* had a circulation of almost 3 million subscribers, *Liberty* almost 2 million, *Time* some 800,000 in 1941 and 1942, and *Esquire* more than 500,000. Newspapers, such as the *Chicago Sun* and *New York Post* each reached more than 200,000 daily subscribers. *N. W. Ayer & Son's Directory of Newspapers and Periodicals* (Philadelphia, Pa.: N. W. Ayer & Son, Inc., 1941–45). I am indebted to my colleague Neil Guthrie for providing me with this valuable information.

11. See, for example, Deborah Lipstadt, *Beyond Belief: The American Press and the Coming of the Holocaust, 1933–1945* (New York: Free Press, 1986); Richard Breitman, *Official Secrets: What the Nazis Planned, What the British and Americans Knew* (New York: Hill and Wang, 1998); Haskel Lookstein, *Were We Our Brother's Keepers? The Public Response of American Jews to the Holocaust 1938–1944* (New York: Vintage Books, 1985); David S. Wyman, *The Abandonment of the Jews: America and the Holocaust, 1941–1945* (New York: Pantheon Books, 1985); Rafael Medoff, *The Deafening Silence* (New York: Shapolsky Publishers, 1987).

Jewish Artist

1. Jacob Beller, "An Artist's War on Hitler: An Interview with Arthur Szyk," *The Southern Israelite*, 21 April 1944, 14.

2. Joseph P. Ansell, "Art against Prejudice: Arthur Szyk's Statute of Kalisz," *Journal of Decorative and Propaganda Arts* 3 (fall 1989): 48.

3. In personal documents, Szyk's birth date is usually given as June 3, 1894, reflecting the Old Style (Julian) calendar then in use in tsarist Russia. According to the New Style (Gregorian) calendar, his birth date is June 16, 1894.

4. S. L. Shneiderman, "From *tosafist* Yom Tov to a Łódź *Wunderkind*," *Der Morgen Zshurnal*, 14 May 1944, 6.

5. Ansell, "Arthur Szyk: Life and Work," 73.

6. See, for example, Richard I. Cohen, *Jewish Icons: Art and Society in Modern Europe* (Berkeley: University of California Press, 1998), especially chaps. 4–6; Susan Tumarkin Goodman, ed., *Artists of Israel: 1920–1980* (New York: The Jewish Museum, 1981); Ezra Mendelsohn, ed., *Art and Its Uses: The Visual Image and Modern Jewish Society*, vol. 6 of *Studies in Contemporary Jewry* (New York: Oxford University Press, 1990); Susan Tumarkin Goodman, ed., *Russian Jewish Artists in a Century of Change 1890–1990* (Munich and New York: Prestel, 1995); Katharina Sabine Feil, "A Scholar's Life: Rachel Wischnitzer and the Development of Jewish Art Scholarship in the Twentieth Century" (Ph.D. diss., Jewish Theological Seminary of America, 1994).

7. Szyk continued this trend in France by publishing two volumes of Jewish humor entitled *Le Juif Qui Rit* (Paris: Albin Michel, 1927).

8. For a discussion of this trend in Zionist art, see Rachel Arbel, *Blue and White in Color: Visual Images of Zionism, 1897–1947* (Tel Aviv: Beth Hatefusoth—Nahum Goldmann Museum of the Jewish Diaspora, 1996), 66–70. For more on E. M. Lilien, see Alfred Werner, "The Tragedy of Ephraim Moses Lilien," *Herzl Year Book* 2 (1959): 92–112; and Milly Heyd, "Lilien and Beardsley: 'To the pure all things are pure,'" *Journal of Jewish Art* 7 (1980): 58–69.

9. S. L. Shneiderman, "Artistic Longing for *Eretz Israel*," *Der Morgen Zshurnal*, 25 June 1944, 6; Szukalak (*Łódźkie rysunki Artura Szyka*, 53) states that the trip to Palestine was sponsored by the *Lodzher Morgenblat*, one of Łódź's Yiddish newspapers.

10. S. L. Shneiderman, "Artistic Longing for *Eretz Israel*." On Boris Schatz and the Bezalel Institute, see Alfred Werner, "Boris Schatz: Father of an Israeli Art," *Herzl Year Book* 7 (1971): 395–410; Cohen, *Jewish Icons*, 213–18; and Ygal Zalmonia, "History and Identity," in *Artists of Israel*, Goodman, ed., 27–30.

11. On Bałachowicz, see Marek Cabanowski, *General Stanisław Bułak-Bałachowicz* (Warsaw: Muzeum Niepodleglosci, 1993). On the rumors of his attitude toward the commission of crimes against Jews, see Boris Savinkov Papers, International Institute of Social History, Amsterdam.

12. See Shneiderman articles in *Der Morgen Zshurnal*, 20 and 27 August; 3, 10, 17, and 24 September; and 1 October 1944.

13. For information on this group, see Jerzy Malinowski, "The *Yung Yiddish* (Young Yiddish) Group and Jewish Modern Art in Poland 1918–1923, " *Polin* 6 (1991): 223–30; and Yehiel Yeshaia Trunk, "Łódź Memories," ibid., 262–87.

14. This interpretation can be found in Mortimer J. Cohen, *Pathways through the Bible* (1946; reprint, Philadelphia: Jewish Publication Society of America, 1952), 478.

15. Arbel, *Blue and White in Color*, 86.

16. S. L. Shneiderman, "When the Soviets Made War with Poland," *Der Morgen Zshurnal*, 27 August 1944, 6; Ansell, "Art against Prejudice," 48.

17. Julia Szyk, unpublished memoirs, 13, Arthur Szyk Society, Burlingame, Cal.

18. Yaakov Shavit, "Politics and Messianism: The Zionist Revisionist Movement and Polish Political Culture," *Studies in Zionism* 6, no. 2 (1985): 232–33.

19. Pierre Benoit, *Le Puits de Jacob* (Paris: Albin Michel, 1927); Ansell, "Arthur Szyk: Life and Work," 75.

20. Ludwig Lewisohn, *The Last Days of Shylock* (New York: Harper & Brothers, 1931). On Lewisohn's life and writings, see Seymour Lainoff, *Ludwig Lewisohn*, Twayne's United States Authors Series, TUSAS 435 (Boston: Twayne Publishers, 1982); and Ralph Melnick, *The Life and Work of Ludwig Lewisohn*, 2 vols. (Detroit: Wayne State University Press, 1998).

21. For an interesting discussion of Szyk's *Statute of Kalisz*, see Ansell, "Art against Prejudice."

22. See Jabotinsky's handwritten article on Arthur Szyk, dated November 22, 1931, for the Russian language newspaper, *Rassviet*, A1/7/121, Jabotinsky Institute, Tel Aviv. I want to thank my wife, Yelena Luckert, for providing me with a summary translation of this document.

23. Shavit, "Politics and Messianism," 237.

24. No doubt Sokolow was personally interested in the *Statute*. Born in Poland, he was fascinated by Polish Jewish history and had published several studies on the subject. Ironically, he had even written a literary work on Szyk's ancestor, Rabbi Yom Tov Lippmann Ben Nathan Halevi Heller. See Simcha Kling, *Nachum Sokolow: Servant of His People* (New York: Herzl Press, 1960), 40, 57.

25. See Vladimir Poliakoff's essay in *Exhibition of Illuminated Manuscripts and Water Colours by Arthur Szyk (Polish Illuminator)* (London: International Art Galleries, 1933), 4–5.

26. "The Statute of Kalisz: Speeches by Polish Ambassador and Mr. Nahum Sokolow at Opening of Arthur Szyk Exhibition," *Jewish Telegraphic Agency Bulletin*, 31 May 1933, 5.

27. Quoted in Harry Salpeter, "The Human Touch," *Jewish Daily Bulletin* (New York City), 18 February 1934.

28. Ibid.

29. Only one swastika remains in the finished artwork. I am indebted to my colleague Laura Surwit for making this discovery.

30. Ansell, "Arthur Szyk: Life and Work," 80.

31. Yerushalmi, *Haggadah and History*, pl. 13.

32. For a more in-depth discussion of this motif, see Michael Berkowitz, "Art in Zionist Popular Culture and Jewish National Self-Consciousness, 1897–1914," in Mendelsohn, ed., *Art and Its Uses*, 6: 12–18.

33. Abraham Edelheit, *The Yishuv in the Shadow of the Holocaust: Zionist Politics and Rescue Aliya, 1933–1939* (Boulder, Colo.: Westview Press, 1996), 61–62.

34. Ibid., 69.

35. Laurence Weinbaum, "Jabotinsky and the Poles," *Polin* 5 (1990): 162, 166.

36. On Jabotinsky's negotiations with the Polish government, see Weinbaum, "Jabotinsky and the Poles"; idem., *A Marriage of Convenience: The New Zionist Organization and the Polish Government 1936–1939*, East European Monographs, no. 369 (Boulder, Colo.: East European Monographs, 1993); and Jerzy Tomaszewski, "Vladimir Jabotinsky's Talks with the Representatives of the Polish Government," *Polin* 3 (1988): 276–93.

37. Salpeter, "The Human Touch."

38. "The New Illuminated Haggadah: An 'Everlasting' Book: Historic Production by an English Press," *Jewish Chronicle* (London), 31 March 1939, 28.

39. *Pictures on Exhibit* 4 (June 1941): 8.

40. Hoffberg, "Portrait of an Artist-Warrior."

Wartime Caricaturist

1. Mary Bragiotti, "Szyk Makes the Axis Writhe," *New York Post Weekly Picture Magazine*, 3 June 1944.

2. Thomas Craven, "Arthur Szyk and the War," *An Exhibition of Illuminations and War Satires by Arthur Szyk* (Philadelphia Art Alliance, 1945).

3. Arthur Szyk, letter to the editor, *Free Europe* (London), 26 January 1940.

4. "Polish War Satires: Miniatures by Mr. Szyk," *The Times* (London), 11 January 1940, 9.

5. Hoover Institution, "Polish Art Exhibitions, General 1940–1941," Polish Ambassador to Great Britain (45013), box 81, file 81-1.

6. On British propaganda policy in the United States, see Susan A. Brewer, *To Win the Peace: British Propaganda in the United States during World War II* (Ithaca, N.Y.: Cornell University Press, 1997); and Nicholas John Cull, *Selling War: The British Propaganda Campaign against American "Neutrality" in World War II* (New York: Oxford University Press, 1995). For documents relating to British propaganda policy in the United States, see Foreign Office records, FO 371/24228 and 371/24229, Public Records Office, London.

7. Hoover Institution, "Polish Art Exhibitions."

8. Brewer, *To Win the Peace*, 39.

9. Richard W. Steele, "Preparing the Public for War: Efforts to Establish a National Propaganda Agency, 1940–41," *American Historical Review* 75, no. 6 (October 1970): 1640–53.

10. Arthur Szyk to Julian Tuwim, January 17, 1941, no. 3075, Department of Manuscripts, Muzeum Literatury im. Adama Mickiewicza w Warszawie.

11. Roger W. Straus, Jr., introduction to Arthur Szyk, *The New Order* (New York: G. P. Putnam's Sons, 1941).

12. On Nye, see Justus D. Doenecke, ed., *In Danger Undaunted: The Anti-Interventionist Movement of 1940–1941 as Revealed in the Papers of the America First Committee* (Stanford, Cal.: Hoover Institution Press, 1990); and Steven Alan Carr, *Hollywood and Anti-Semitism: A Cultural History Up to World War II*, Cambridge Studies in the History of Mass Communication (New York: Cambridge University Press, 2001).

13. On the OWI's goals, see Clayton R. Koppes and Gregory D. Black, "What to Show the World: The Office of War Information and Hollywood, 1942–1945," *Journal of American History* 64, no. 1 (June 1977): 87–105; and Sydney Weinberg, "What to Tell America: The Writers' Quarrel in the Office of War Information," *Journal of American History* 55, no. 1 (June 1968): 73–89.

14. See, for instance, the discussions in Richard H. Minear, *Dr. Seuss Goes to War: The World War II Editorial Cartoons of Theodor Seuss Geisel* (New York: New Press, 1999), 117–21; John W. Dower, *War Without Mercy: Race and Power in the Pacific War* (New York: Pantheon Books, 1986); and Sam Keen, *Faces of the Enemy: Reflections of the Hostile Imagination* (San Francisco: Harper & Row, 1986).

15. "War Cartoonist Flays Enemy with Hatred," *Montreal Canadian Standard*, 18 July 1942.

16. See, for example, the comments and images in George H. Roeder, Jr., *The Censored War: American Visual Experience During World War Two* (New Haven: Yale University Press, 1993).

17. See Ungar's comments on this particular piece, "Justice Illuminated," 22.

18. Szyk to Tuwim, November 1940, Muzeum Literatury.

19. *Daily Mirror* (New York City), 10 April 1941.

20. Baigell, "Jewish Artists in New York," 6–8.

21. Struthers Burt, introduction to *Ink & Blood: A Book of Drawings by Arthur Szyk* (New York: Heritage Press, 1946), 3.

Action—Not Pity

1. The slogan "action—not pity" served as the watchword for the Bergson group, and it appeared on many of their advertisements.

2. For a discussion of the relative lack of violence in American Jewish imagery of the Holocaust in the 1940s, see Baigell, "Jewish Artists in New York," 4.

3. For contemporary information on both these cases, see *The Brown Book of the Hitler Terror and the Burning of the Reichstag* (New York: Alfred A. Knopf, 1933), 237–39, 279–80.

4. Vladimir Jabotinsky, *The War and the Jew* (New York: Dial Press, 1942), 31.

5. Ibid., 103.

6. *Zionews*, 1 September 1942.

7. Jabotinsky, *The War and the Jew*, 234.

8. For information on Szyk's activities in this organization, see *Jewish Chronicle* (London), 1 March 1940, 12; 8 March 1940, 12, 14; 12 April 1940, 22; 26 April 1940, 12; 24 May 1940, 11.

9. On the sometimes tumultuous relationship between Jewish organizations and the Polish government-in-exile, see David Engel, *In the Shadow of Auschwitz. The Polish Government-in-Exile and the Jews, 1939–1942* (Chapel Hill, N.C.: University of North Carolina Press, 1987) and idem., *Facing a Holocaust: The Polish Government-in-Exile and the Jews, 1943–1945* (Chapel Hill, N.C.: University of North Carolina Press, 1993).

10. Idem., "The Frustrated Alliance: The Revisionist Movement and the Polish-Government-in-Exile 1939–1945," *Studies in Zionism* 7, no. 1 (1986): 11–36.

11. On the efforts of the Jewish Agency and other established Zionist organizations, see Arye Bruce Saposnik, "Advertisement or Achievement? American Jewry and the Campaign for a Jewish Army, 1939–1944: A Reassessment," *Journal for Israeli History* 17, no. 2 (1996): 193–220. For a critical view of Saposnik's arguments, see Rafael Medoff, "Who Fought for the 'Right to Fight'? A Response to Arye Bruce Saposnik's Article on the Campaign for a Jewish Army, 1939–1944," *Journal of Israeli History* 18, no. 1 (spring 1997): 113–27.

12. For a discussion of Jewish fears in Palestine for Palestine, see Yoav Gelber, "The Defense of Palestine in World War II," *Studies in Zionism* 8, no. 1 (1987): 51–82.

13. For more information on the proliferation of Szyk's image of Trumpeldor, see Joseph P. Ansell, "Arthur Szyk's Depiction of the 'New Jew': Art as a Weapon in the Campaign for an American Response to the Holocaust," *American Jewish History* 89, no.1 (March 2001): 123–34.

14. Ibid., 130–34.

15. From the program issued by the Emergency Committee to Save the Jewish People of Europe, *Save Human Lives: The Show of Shows* (1944), 34.

16. Wyman, *The Abandonment of the Jews*, 61.

17. Monty Noam Penkower, *The Holocaust and Israel Reborn: From Catastrophe to Sovereignty* (Urbana and Chicago: University of Illinois Press, 1994), 61.

18. For more information on these events, see Wyman, *The Abandonment of the Jews*, 71–73.

19. Yitshaq Ben-Ami, *Years of Wrath, Days of Glory: Memoirs from the Irgun*, 2d ed. (New York: Shengold Publishers, Inc., 1983), 250.

20. The entire September 30 speech appeared in *New York Times*, 1 October 1942, sec. 1. The text pertaining to his "prophecy" reads as follows:

On September 1, 1939, in the Reichstag, I expressed two facts: first, after this war had been forced upon us, no power of arms and no period of time shall ever be able to force us upon our knees; secondly, in case Jewry causes the outbreak of an international world war for the extermination of other Aryan peoples, then not the Aryan peoples, but Jewry will be eradicated.

They have drawn nation after nation into this war. The stringpullers of the psychopath of the White House have actually accomplished an evil which nobody will be able to mend. . . . Antisemitism is growing, and every nation that enters this war will come out of it an antisemitic State. Jews laughed in Germany when I prophesized something. I don't know if they laugh still, or if they have forgotten to laugh. But I can assure them they will forget to laugh everywhere. I will be right in this prophecy too.

On October 2, 1942, Szyk's drawing appeared in the *New York Post*.

21. Szyk never knew exactly what happened to his mother and brother. After the war, he composed this dedication:

In March 1943 my beloved seventy-year-old mother, EUGENIA SZYK, was taken from the ghetto of Łódź to the Nazi furnaces of Maidanek. With her, voluntarily went her faithful servant, the good Christian, JOSEFA, a Polish peasant. Together, hand in hand, they were burned alive. In memory of the two noble martyrs I dedicate my pictures of the Bible as an eternal Kaddish for these great souls.

See dedication page in Cohen, *Pathways through the Bible*.

22. On *We Will Never Die*, see Christian Kuhnt, "Drei 'pageants'—ein Komponist: Anmerkungen zu *The Eternal Road*, *We Will Never Die*, und *A Flag is Born*," in *Kurt Weill: Auf dem Weg zum "Weg der Verheißung,"* eds. Helmut Loos and Guy Stern (Freiberg am Breisgau: Rombach, 2000), 219–34; and Jürgen Schebera, "'Awakening America to the European Jewish Tragedy. . .': Sechs Jahre nach *The Eternal Road*: Ben Hecht/Kurt Weills Massenspiel *We Will Never Die* von 1943—Vorgeschichte und Wirkung," in ibid., 255–63.

23. The Committee for a Jewish Army of Stateless and Palestinian Jews circulated these proposals in the following full-page newspaper advertisements: "Mr. Hull, Mr. Eden—Allies for Humanity—Can You Not Hear the Message of Your Peoples? Action–Not Pity Can Save Millions Now!," *New York Post*, 15 March 1943, 15, and "Action—Not Pity Can Save Millions Now! Extinction or Hope for the Remnants of European Jewry?—It Is for Us to Give the Answer," *Gary [Indiana] Post-Tribune*, 19 March 1943, 11.

24. For documents relating to the conference, see "Concerning the Campaigns for a Jewish Army; To Save the Jewish People of Europe and the Establishment of a Hebrew Republic in Palestine," Palestine Statehood Committee Papers, Yale University, Sterling Memorial Library Manuscripts and Archives, Manuscript Group 690, reels 4–5.

25. See Aaron Berman, "American Zionism and the Rescue of European Jewry: An Ideological Perspective," *American Jewish History* 69 (March 1981): 329–59.

26. Menachem Begin, *The Revolt*, rev. ed. (New York: Nash Publishing, 1978).

27. See, for example, the full-page advertisement in the *New York Times*, 5 October 1943. For a further example of Bergsonite views on Palestine, see Pierre van Paassen, *The Forgotten Ally* (New York: Dial Press, 1943).

28. Less than three weeks after it first appeared in *PM*, Szyk's image reportedly reemerged on placards carried in a march to New York's City Hall to commemorate the first anniversary of the Warsaw ghetto uprising. *Der Morgen Zshurnal*, 19 April 1944, 1 (photo caption).

29. On the American Committee of Jewish Writers, Artists, and Scientists, see Shimon Redlich, *Propaganda and Nationalism in Wartime Russia: The Jewish Antifascist Committee in the USSR, 1941–1948*, East European Monographs, no. 108 (Boulder, Colo.: East European Monographs, 1982), 104–107, 115–25; see also the FBI files on the American Committee of Jewish Writers, Artists, and Scientists, FOIPA No. 0936492-000/190, Federal Bureau of Investigation, Washington, D.C.

30. See their joint statement, "We Face the Common Enemy Together," in *Jews Have Always Fought for Freedom* (New York: National Reception Committee to the Delegation from the USSR, 1943), 1.

31. On Gropper and Ben-Zion's versions of *De Profundis*, see Baigell, "Jewish Artists in New York," 5–6.

32. For a discussion of this topic, see Ruth Mellinkoff, "Cain and the Jews," *Journal of Jewish Art* 6 (1979): 16–38.

33. Burris Devanney, "Kenneth Leslie: A Biographical Introduction," www.arts.uwo.ca/canpoetry/cpjrn/vol05/devanney1.htm, 10.

34. On Gottlieb, see Larry Silver, "Jewish Identity in Art and History: Maurycy Gottlieb as Early Jewish Artist," in *Jewish Identity in Modern Art History*, ed. Catherine M. Sousloff (Berkeley: University of California Press, 1997), 87–113. On the image of Jesus in Jewish and Holocaust art, see Ziva Amishai-Maisels, "The Jewish Jesus," *Journal of Jewish Art* 9 (1982): 85–104, and her *Depiction and Interpretation*, (New York: Pergamon Press, 1993), chap. 3. Ironically, at the same time that Jewish artists were reclaiming Jesus, some racist authors, like Houston Stewart Chamberlain, and later some Nazis were denying his Jewish origins, seeing him as an "Aryan" engaged in deadly combat with the Jews; on Chamberlain's views, see his *Die Grundlagen des neunzehnten Jahrhunderts*, 2 vols. (Munich: Verlagsanstalt F. Bruckmann, 1909), 221ff; on Hitler's views of Jesus, see H.R. Trevor-Roper, ed., *Hitler's Secret Conversations 1941–1944* (New York: Farrar, Straus and Young, 1953), 63–65, 117–18, 586; see also the report of his speech of 18 December 1926 in *Hitler Reden, Schriften, Anordnungen, February 1925 bis Januar 1933*, ed. Bärbel Dusik (Munich: K. G. Saur, 1992), 2: pt. 1: 105–6; also Susannah Heschel, "'Jesus was an Aryan': Walter Grundmann and the Nazification of Christianity," in *From Prejudice to Destruction: Western Civilization in the Shadow of Auschwitz*, eds. G. Jan Colijn and Marcia Sachs Littell (Münster: Lit Verlag, 1995), 31–44.

35. According to David S. Wyman (*The Abandonment of the Jews*, 285, 406), the War Refugee Board made no final estimate for the number of lives that it helped to rescue and only referred to "tens of thousands." Wyman suggests that the numbers may have been as high as 200,000 Jews.

36. Szyk denounced these charges against Jabotinsky in his sharply worded "Message to the Memorial Meeting at Town Hall, N.Y., July 10, 1945 on the fifth anniversary of the death of Jabotinsky" (Jabotinsky Institute, P 342):

Like all great prophets, this one [Jabotinsky] was without honor among his own people and in his own time. Reviled by the other Jewish leaders, he nevertheless clung tenaciously to his beliefs. Today, five years after his ill-timed death, we find these same leaders exploiting those beliefs vigorously, as their own.

All this reminds me that when the composer Rossini died, his nephew wrote a funeral march in memory of his uncle and brought the music to Meyerbeer for his opinion. Said Meyerbeer: "It's all right, but I would have preferred it if you had died and Rossini had written the funeral march."

As one who has devoted his entire life to the fight against Fascism, I have deeply resented the foulest charge ever made against a great man, the charge that Jabotinsky was a Fascist. This bit of vilification I shall never forgive.

37. Stephen S. Wise to Peter H. Bergson, 4 June 1941, Palestine Statehood Group Papers, reel 1, frame 116.

38. Harry S Truman to Peter H. Bergson, 7 May 1943, ibid., frame 184.

39. Sara E. Peck, "The Campaign for an American Response to the Nazi Holocaust, 1943–1945," *Journal of Contemporary History* 15 (1980): 380. For FBI activities, see its files on the Emergency Committee to Save the Jewish People of Europe, FOIPA No. 0936488-000/190, and the New Zionist Organization, FOIPA No. 0936493-000/190, Federal Bureau of Investigation, Washington, D.C.

40. Pierre van Paassen, "The Irgunist Hoax" (letter to the editor), *The Protestant* (April 1944): 41–43.

41. *New York Post*, 27 March 1945.

42. For an interesting discussion of these two representations, see Cohen, *Jewish Icons*, 224–29.

43. On the circulation of Hirszenberg's image of the Wandering Jew, see ibid., 227.

44. Cited in Herbert Parzen, "The Roosevelt Palestine Policy, 1943–1945," *American Jewish Archives* 26, no. 1 (April 1974): 60.

45. For a copy of Harrison's letter and Bergson's response, see Palestine Statehood Committee Papers, reel 1, frames 668, 670; the report appeared in the press at the end of September, e.g., *New York Times*, 30 September 1945, sec. 1, 38.

46. For an examination of the Bergsonites' use of the American Revolution metaphor, see Rafael Medoff, "Menachem Begin as George Washington: The Americanizing of the Jewish Revolt Against the British," *American Jewish Archives* 47, no. 2 (fall/winter 1994): 185–93.

47. Hoffberg, "Portrait of an Artist-Warrior."

48. On the *Smyrna*, see Ze'ev Venia Hadari, *Second Exodus: The Full Story of Jewish Illegal Immigration to Palestine, 1945–1948* (London: Vallentine Mitchell, 1991), 111–13, 286–87.

49. Ben Hecht, *Child of the Century* (New York: Simon and Schuster, 1954), 566–67

INDEX

136